The Ceramic Art of Japan

OF THE books on Japanese ceramics that have appeared in the West, few indeed (if any) have been designed primarily for the collector—particularly the collector of modest means. Moreover, the earlier books—those which were published during the several decades after Japan was opened to the West—are now out of date. Hugo Munsterberg's latest work, *The Ceramic Art of Japan*, effectively answers the need for a new book on the subject and at the same time supplies the collector, as well as the layman whose interest is more general, with the background necessary for an appreciation and understanding of this splendid Japanese art.

As Mr. Munsterberg expresses it in his preface: "The study of Japanese ceramics, to which Captain Brinkley and Professor Morse had made such a significant contribution by the turn of the century, has unfortunately been neglected in the West during the last fifty years, and it is only recently that the unique beauty of these wares has been rediscovered. Fortunately, Japanese scholars have investigated the field very thoroughly during the intervening years. One result of this research is that these older books, although pioneering ventures in their own day, are now completely outdated. In the present book an attempt has been made to bring our knowledge up to date and to include such subjects as prehistoric wares, folk pottery, and the wares of present-day potters."

A glance at the chapter titles of the book will show its scope:

(continued on back flap)

the reader to an appreciation of Japan's ceramic art. For both the collector and the non-collector, the abundance of illustrations, many of them in color, will provide an aesthetic treat.

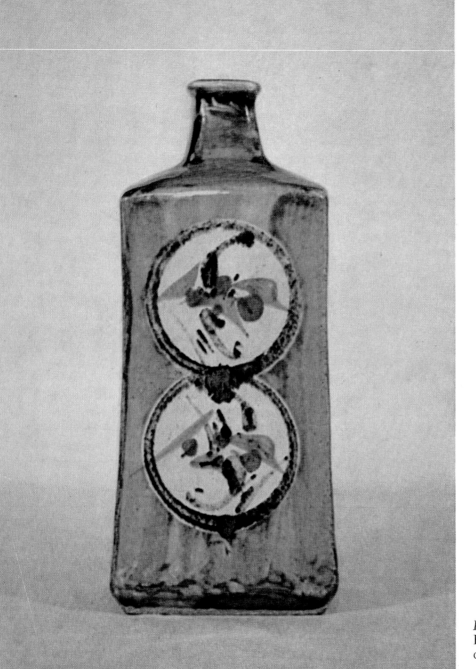

Frontispiece. Vase by Kawai
Kanjiro. Showa period. Yuasa
collection, Tokyo.

HUGO MUNSTERBERG

The Ceramic Art of Japan

A HANDBOOK FOR COLLECTORS

Charles E. Tuttle Company: Publishers
Rutland, Vermont & Tokyo, Japan

EUROPEAN REPRESENTATIVES

For the Continent:
Boxerbooks, Inc., Zurich

For the British Isles:
Prentice-Hall International Inc., London

Published by the Charles E. Tuttle Company
of Rutland, Vermont & Tokyo, Japan
with editorial offices at
15 Edogawa-cho, Bunkyo-ku, Tokyo

Copyright in Japan, 1964
by Charles E. Tuttle Company

Library of Congress Catalog
Card No. 63-20586

First Printing, 1964

Layout of illustrations by S. Katakura
Book design and typography by Kaoru Ogimi

PRINTED IN JAPAN

To Bernard Leach
whose life and work
has been a bridge
between East and West

Table of Contents

List of Illustrations

Preface

The Study of Japanese ceramics, to which Captain Brinkley and Professor Morse had made such a significant contribution by the turn of the century, has unfortunately been neglected in the West during the last fifty years, and it is only recently that the unique beauty of these wares has been rediscovered. Fortunately, Japanese scholars have investigated the field very thoroughly during the intervening years. One result of this research is that these older books, although pioneering ventures in their own day, are now completely outdated. In the present book an attempt has been made to bring our knowledge up to date and to include such subjects as prehistoric wares, folk pottery, and the wares of present-day potters.

No book of this type would have been possible without the advice and help of my Japanese colleagues, who throughout my study gave me generously of their counsel and to whose writings I constantly referred. Among these I would like to mention Mr. Sakutaro Tanaka of the Tokyo National Museum, Mr. Fujio Koyama of the Cultural Treasures Property Commission, Mr. Tadanari Mitsuoka of the Yamato Bunkakan in Osaka, Mr. Ryoichi Fujioka of the Kyoto Museum, Mr. Shinzo Sato of the Osaka Museum, Mr. Giichiro Kato of the Itsuo Bijutsukan, and Mr. Takeshi Nagatake of the Saga Cultural Affairs Office. My thanks are also due to the numerous museums and private collectors for their generous permission to reproduce works in their collections and to the photographers who supplied the plates. Finally I wish to express my thanks to my former students Mr. Masakata Kanazawa and Miss Emiko Ishikawa for their help in translating Japanese material and acting as my guides in visits to potters and kiln sites, and to Dr. and Mrs. David Kornhauser, Mrs. Robert Lang, and my wife for helping me to get the manuscript ready for publication.

Hugo Munsterberg

NEW PALTZ, NEW YORK

Periods in Japanese Art History

Jomon:	ca. 5000 B.C.–ca. 200 B.C.
	(in northern Japan, ca. A.D. 500)
Yayoi:	ca. 200 B.C.–A.D. 200
Grave Mound:	ca. A.D. 300–600
Asuka:	552–646
Nara:	646–794
Heian:	794–1185
Kamakura:	1185–1333
Muromachi:	1334–1573
Momoyama:	1573–1615
Early Edo:	1615–1703
Middle Edo:	1703–1800
Late Edo:	1800–1868
Meiji:	1868–1912
Taisho:	1912–1926
Showa:	1926–present

Map of Major Japanese Kilns

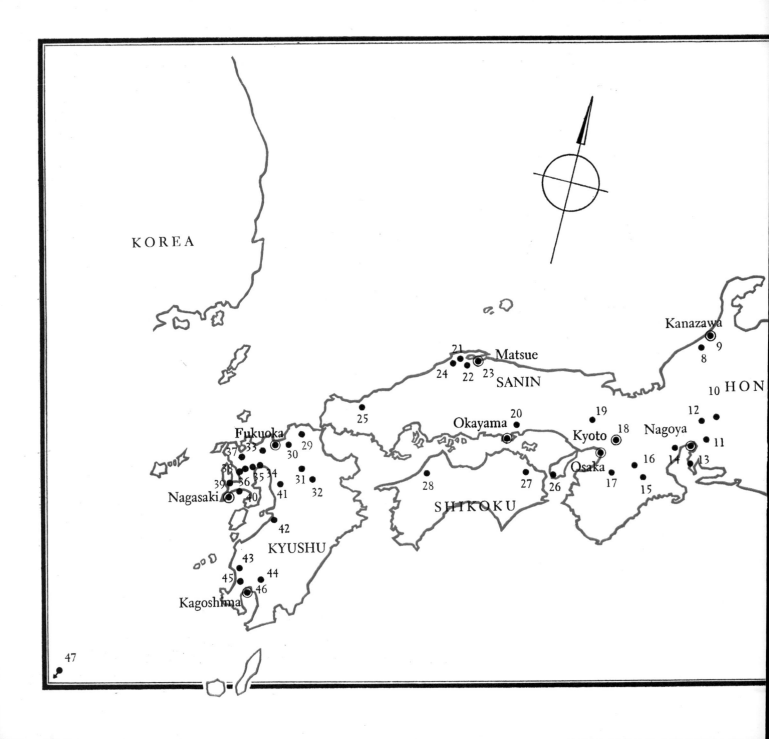

KOREA

Kanazawa
9
8
10 HON

21 Matsue
24 22 23 SANIN
25
19
20 Okayama
18 Nagoya
12
Kyoto
Fukuoka
11
37 33
30 29
16 14 13
38
Osaka
17
15
39 36 35 34
28
27 26
31
40
41 32
Nagasaki
42
SHIKOKU
KYUSHU
43
44
45 46
Kagoshima

47

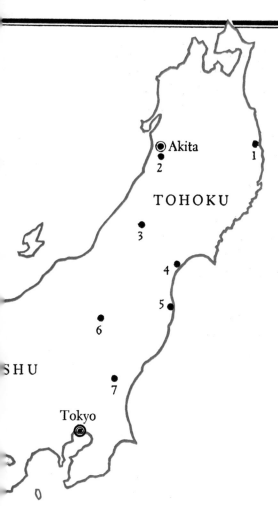

Map of Major Japanese Kilns

1	Kuji	24	Izumo (Rakuzan)
2	Naraoka	25	Hagi
3	Shinjo	26	Awaji
4	Tsutsumi	27	Sanyo
5	Soma	28	Tobe
6	Hongo	29	Agano
7	Mashiko	30	Takatori
8	Kutani	31	Koishibara
9	Ohi (in Kanazawa)	32	Onda
10	Mino	33	Karatsu
11	Seto	34	Shiraishi
12	Inuyama	35	Takeo
13	Tokoname	36	Arita (Kakiemon, Nabeshima)
14	Banko	37	Imari
15	Iga	38	Mikawachi
16	Shigaraki	39	Nagayo
17	Akahada	40	Utsutsugawa
18	Kyoto (Awata, Kiyomizu, Raku)	41	Shodai
19	Tamba (Tachikui)	42	Yatsushiro
20	Bizen (Imbe)	43	Hirasa
21	Fujina	44	Ryumonji
22	Yumachi	45	Naeshirogawa
23	Sodeshi	46	Tateno (in Kagoshima)
		47	Tsuboya (in Okinawa)

The Ceramic Art of Japan

I On Collecting Japanese Ceramics

COLLECTING is a passion as old as mankind. The cave men of the Paleolithic period collected beautiful stones and shells, and their Neolithic descendants made magnificent pottery vessels not only for use but no doubt also for enjoyment. Pride of ownership, delight in the beauty of form and design, the economic value of fine works of art—all these factors were probably as important in those ancient times as they are today. Coming from a family of collectors who could never resist acquiring still another beautiful object, whether it was a Chinese bronze, a Japanese teapot, a Persian carpet, or a fine piece of old furniture, the author can well understand this passion, and it was with secret satisfaction that he heard about a collector of Chinese ceramics who stayed in Berlin during the persecution and bombing rather than part with his beloved collection; and another collector, also from Berlin, who starved during the terrible postwar years rather than sell any of his priceless treasures. Such is the joy of collecting for those who love beautiful objects.

There have been many collectors of Japanese ceramics, and today, with an ever-growing interest in Japan, there are no doubt many others who would like to start collecting. For these people, the question arises as to what type of collection they should form: a question that must, of course, be determined by individual taste. Some people will be content to buy, more or less at random, a few objects that happen to appeal to them, but for those who want to form a significant collection, there is one general observation that can be made, and this is that it is best to concentrate on some particular aspect or type of ceramics. Some collectors, their interest awakened by a study of the tea ceremony (*cha-no-yu*), may collect nothing but tea utensils or perhaps concentrate entirely on tea bowls, as is not at all uncommon in Japan, where pieces connected with *cha-no-yu* are particularly prized

and in consequence often bring incredible sums. This specialization may be carried even further; for example, there are collectors who are interested in only a certain kind of tea bowl, such as Raku, and who try to get works by all the members of the Raku family. Naturally, this type of collecting is not only difficult but also next to impossible outside of Japan. Other collectors may have no interest in tea things at all, but prefer instead the crude and simple wares of the folk potters. This field offers excellent opportunities for the collector of modest means, since true master-pieces of folk pottery can be bought for very little, and a wealth of marvelous pots, still being made today, are readily available. Here again, the collector who wishes to limit himself to just one type of folk pottery has ample opportunity to do so, for one can form outstanding collections of the works of one particular kiln, such as Tamba or Onda, or one type of folk pottery, such as oil plates.

During the early years of Western contact with Japan, the most popular of the Japanese ceramics was porcelain, which, especially during the late seventeenth and the eighteenth century, was highly esteemed. Not only porcelain in general was collected, but also special kinds of porcelain such as Imari ware, Kakiemon, Nabe-shima, or Kutani as well as porcelain figures that to the Rococo connoisseur had a special attraction because of their exotic flavor. If the refinement and elegance of Japanese porcelains appealed to the age of Louis XV, many modern collectors, influenced by the contemporary interest in abstract and primitive art, have been drawn to the prehistoric pottery of Japan. The grave figures of the ancient tumuli known as *haniwa* and, more recently, the idols and jars of the Jomon period, are enjoying a tremendous popularity both in Japan itself and in America. In fact there are prominent collectors in both countries who collect nothing but these fascinating remnants of the earliest phase of Japanese civilization. However, since so many imitations have appeared on the market in recent years and since even the genuine pieces are almost invariably restored, it is a risky as well as a very expensive field.

A phase that so far has been ignored by most Western collectors is that of con-temporary Japanese ceramics. Certainly the Japanese potters are among the most outstanding in the world today, and by buying the productions of men like Hama-da, Kawai, Rosanjin, and Tomimoto, preferably direct from the artist out of his own studio, one is assured of getting not only the best quality but also genuine pieces. If one undertakes to collect the famous potters of the past such as Ninsei or Kenzan, as many Japanese and Western collectors have done, the dangers are great, for the majority of works bearing their seal or signature (some Japanese critics would say at least ninety percent) are school pieces or outright forgeries, since most of the really good genuine works are either in museums or private collections and hardly ever come on the market.

For a museum that wishes to form a representative collection, the best procedure would naturally be to try to get a few choice pieces from each period and type, ranging all the way from Jomon to modern and from the coarse peasant ware of

Hongo to the refined porcelains of Arita. If this seems too ambitious an undertaking, one could limit oneself to a particular period or some particular region or kiln such as the wares of the Kyoto area or the Karatsu ovens. For study purposes this type of highly specialized collection is of course the best, and local Japanese museums like those at Arita, which are restricted to the porcelains of that area, the one at Okayama, which specializes in Bizen ware, or the one at Seto, which has nothing but Seto ware, are very valuable for the scholar who wishes to gain a clear picture of the history of a particular kiln.

In forming such a collection it is of greatest importance to buy wisely and with care. Naturally it is very difficult to advise someone on where and when to buy, especially if one does not know what means the collector has at his disposal and whether he is buying in America or in Japan. However, if the collector has little knowledge of the subject and no experience, the safest practice is to buy from an established and recognized dealer. A firm that has been handling Oriental ceramics for many years, sometimes even many generations, will not knowingly sell any forgeries or badly damaged pieces, if only to preserve the reputation of the establishment. Of course even the most reliable and conscientious of dealers make mistakes, but they will usually be happy to exchange the object in question if it proves to be a forgery. It might also be argued that it would be wise, at least initially, to do business with one dealer only—a dealer who, in order to keep his customer and encourage him in his pursuit, will try to locate new pieces for the collector and give him a good buy if he can do so without any loss to himself.

For those who have limited funds and are therefore anxious to save money, going to secondhand or curio shops, especially if they have the good fortune to be able to buy in Japan itself, will prove preferable. But the first thing they must realize is that these stores guarantee nothing and often deliberately misrepresent some of the objects they sell. And it should always be remembered that to get something cheap is no bargain if one does not want the piece and it is no good to begin with. Yet bargains can be had, if one knows where to look and what to look for. Usually, of course, even in these establishments the storekeeper knows his stock and has himself paid a good price for works of outstanding merit, though sometimes a dealer may have a few good pieces that he is unfamiliar with or perhaps not interested in—pieces from a larger collection that he bought as a whole. In the case of Japanese ceramics, this may happen when a dealer buys a group of ceramics consisting largely of Chinese wares, which he wants, with a few Japanese pieces into the bargain. But by and large the bargain-basement collector, as one might call him, will get bargain-basement merchandise, for the dealer who handles dozens of pieces every day is obviously more of an expert than the amateur collector. There is one other occasion when it might be possible to buy very advantageously, and that is when a dealer needs cash, perhaps for some new purchase, or when he has had a piece for a long time and is anxious to dispose of it. The same may also be true of

a private person who has some pieces he wishes to dispose of, perhaps because he no longer needs them or because he has inherited them and is not particularly interested in them.

Probably the best place to pick up a real bargain (and also the best place to acquire worthless junk) is the auction room. Here it is important always to examine the pieces while they are on display before the auction actually takes place. It might also be wise to ask the advice of some experienced dealer or scholar ahead of time. Once you have placed your bid, it is too late to change your mind, for every auction purchase is final, regardless of what flaws may be discovered later on. Furthermore, the atmosphere of the auction room, with its excitement and fast pace, often tempts people to buy things they really do not want or prevents them from bidding for objects they would like to have but were too slow to bid for. Yet there is no question—especially if one happens to attend an auction where other people are not interested in what one has come for—that wonderful purchases can be made for relatively little money, and this, of course, is particularly true of objects that are not in fashion.

The question of taste and fashion has a great deal to do with the price an object is likely to fetch. *Haniwa*, which today are extremely fashionable and therefore bring very high prices, were readily available ten or twenty years ago at a fraction of their present cost, while Satsuma enameled wares, which fifty years ago were enormously popular among Western collectors and brought high prices, are practically worthless today. Unless the collector is so well-to-do that he does not have to consider money, it is best not to go in for something that is very fashionable, but rather to purchase some good wares that, though neglected at the time, are artistically outstanding and of permanent value. Today, for example, Japanese porcelains are relatively cheap, while cruder wares such as Shino and Oribe, which are closer to modern taste, are in great demand and therefore more difficult to get and more expensive when they do turn up. Here again, however, personal preference should be the primary consideration.

Japanese collectors like to buy pottery that has the seal and signature of a famous potter, and if the object in question is also wrapped in a fancy brocade bag and comes in an old-looking box, preferably with inscriptions attributed to famous artists or connoisseurs, then its price goes up astronomically. Although it is true that such a pedigree may often be helpful in tracing its history and may even prove that at one point it belonged to some noble family or famous tea master, by and large this kind of information has little to do with art and may even be quite misleading. For example, at least ninety percent of the works signed by Kenzan are not by him, and antique boxes, even if they and their inscriptions are genuine, are sometimes used for works that have nothing to do with the inscriptions. The best course is always to rely upon the quality of the object itself, to buy what is good because it is aesthetically pleasing, regardless of the inscription or the box. In fact some simple

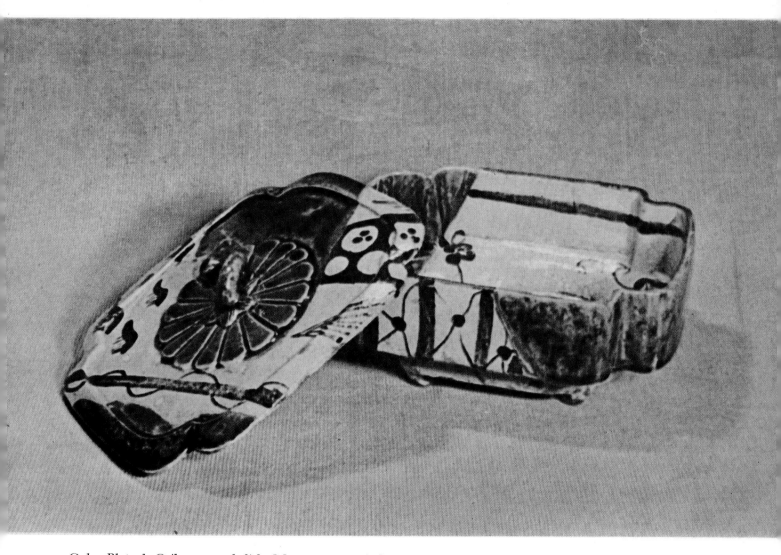

Color Plate 1. Oribe covered dish. Momoyama period.
Private collection, Japan.

object like the rice bowls of the Korean peasants is often the very ware that connoisseurs like the tea masters consider priceless today.

Finally, there is the persistent question about the daily use of art objects. The Japanese themselves keep good pieces in boxes until some special occasion, when they remove them from their covers to display them to a distinguished guest or use them in some ceremony like *cha-no-yu*. This may be a good thing and is no doubt responsible for the preservation of so many of the treasures of Japanese art over the centuries. The Westerner, however, having no such tradition, would do well to display his collection and, if possible, use it—perhaps not every day but certainly on special occasions, for pottery is essentially a utilitarian art. The collector himself will benefit most by doing so, for not only will he derive pleasure and satisfaction from seeing the pieces used, but also he will develop a better feeling for their shapes, glazes, textures, and colors. Only by actually handling ceramics can their true nature be understood.

2 The Appreciation of Japanese Ceramics

IT HAS often been said that the Japanese civilization is the most artistic that mankind has ever evolved. If this statement refers to the aesthetic sensibility of the Japanese rather than to their artistic achievement, then it is certainly true. Nowhere else has the creation of something beautiful ever permeated all aspects of life as thoroughly as in Japan. Every phase of existence, even the simplest activity of daily life, is regarded as an opportunity for aesthetic expression. In the West, we think of art primarily as architecture, sculpture, and painting, with the crafts usually playing a secondary role, but in traditional Japan no such clear distinction was ever made. The reed matting covering the floor in the Japanese house, the texture and character of the wood used in the ceiling, the bamboo utensils, the kimono of the elegant lady, the flower arrangement in the tokonoma, the lacquer tray on which the cake is served, the decanter out of which the saké is poured—all these and many other purely utilitarian objects, made by craftsmen and designed for use, are considered works of art and evaluated as such. What European critics have often dismissed as the decorative or minor arts were considered the very essence of art by the traditional Japanese, and such well-known artists as Korin did not hesitate to use their talents to design beautiful kimonos, lacquer boxes, or plates.

The very first Westerners who came to Japan spoke with astonishment of the value attached to the utensils used in connection with the tea ceremony or *cha-no-yu*. The tea caddies especially, though quite unimpressive in appearance, were highly treasured, and the Jesuit father Luis Frois, writing in the late sixteenth century, tells us that the most valuable teacups and tea jars were prized so greatly that their worth was equal to that of precious jewels in Europe. He also says that the military dictator of the time, Oda Nobunaga, had formed a large collection of

tea utensils, partly the gifts of his retainers and partly his own costly purchases. It was through such collections, he goes on, that families became known; they were considered prosperous and lucky because they owned such treasures.

Another contemporary account is found in a letter of the Jesuit priest Luis d'Almeida, dated 1565: "It is customary with the noble and wealthy Japanese, when they have an honored guest who is on the point of leaving, to show him their treasures as a sign of esteem. These treasures consist of utensils they use in drinking a certain powdered herb called *cha*, which is very pleasant to those who are accustomed to drink it. Their way of doing so is to grind half a handful of leaves of this herb in a porcelain bowl, after which they drink them infused with very hot water. For this purpose they use some very old iron kettles, as also the vessel wherein they put the water to rinse the porcelain bowl, and a little tripod whereon they put the lid of the iron kettle so as to avoid placing it on the mats. The caddy in which they place the *cha* leaves, the spoon with which they scoop, the ladle which they take the water from the kettle, and the stove—all these utensils form the jewelry of Japan, in the same way as rings, necklaces, and ornaments of magnificent rubies and diamonds do with us. And they have experts who appraise these utensils, and who act as brokers in selling and buying them. Thus they give parties to drink the herb (of which the best sort costs about nine or ten ducats a pound) and to display these utensils, each one as best his wealth and rank will allow. These parties are given at special houses, only used on such occasions, which are marvels of cleanliness."

Many anecdotes are told about the enormous value attached to these little tea caddies or *cha-ire*. They were often given by rulers to their generals and officials in recognition of special merit or to celebrate some happy occasion. They were presented as a tribute by retainers to their lord, and stories are told about how a lord would sell such priceless treasures during a time of famine so that he could buy rice for his subjects. One of the most famous of these stories is that of the clerk who was sent to China, where he fell in love with a beautiful courtesan upon whom he squandered all his master's money. When he left, she gave him a tea jar reported to be of great value. This the faithless clerk presented to his master, a rich merchant of Osaka, who was so delighted with it that he forgave the clerk his misdeeds and restored him to his former position. Another well-known story is that of the lord who, besieged in his castle and facing certain defeat, cut open his stomach and hid a precious tea jar in it so that it would not be destroyed. It is also said that the famous military dictator Hideyoshi presented Ieyasu, the founder of the Tokugawa dynasty, with a tea jar called Shirakumo or White Clouds, and that at another time Ieyasu sent Hideyoshi, after one of his victories, the tea jar Hatsuhana or Early Spring Flower, as a reward and token of his esteem.

Such treasured tea jars and tea bowls, as this account suggests, were given personal names and have often been handed down from generation to generation. The

most precious of them were usually wrapped in gorgeous brocade bags, placed in triple boxes, and guarded by officials especially appointed to look after them. The value attached to them was of course not purely artistic but also historical, for the fact that these jars and bowls were first presented to their owners by such famous men as Nobunaga or Hideyoshi, or had been used at such celebrated occasions as the cherry-blossom party at the Sambo-in of the Daigo-ji or the great tea party at the Kitano pine grove in Kyoto, naturally increased their prestige.

The names given to these celebrated tea utensils were usually taken from their shapes, from their markings or their glazes, or from one of their owners. For example, there is a famous tea caddy called Kyogoku Bunrin Cha-ire, which means the apple-shaped tea caddy owned by Lord Kyogoku. The most famous of all tea caddies is the one mentioned above known as Hatsuhana Katatsuki, the first word meaning early spring flower and the second describing a certain broad-shouldered type of jar. Its first owner was no less a person than the great fifteenth-century art patron, the Ashikaga Shogun Yoshimasa, and among its later owners were Nobunaga, Hideyoshi, and Ieyasu, the three outstanding rulers of modern Japan. Among numerous well-known tea bowls, one of the most valuable is the one called Fujisan, which was made during the early seventeenth century by the famous calligrapher, potter, and swordsman, Hon'ami Koetsu, as a dowry for his daughter. It is so named because the grayish-white glaze suggests the snow on top of Mt. Fuji, and the dark gray of the lower part recalls the mist at the foot of the mountain shortly before daybreak.

The value of these old and famous pieces was already legendary during the sixteenth century, when the rise of the tea ceremony created a great demand for fine old tea caddies, tea bowls, and other utensils required for it. Many of the best were actually imported from China or Korea, where they had been considered quite ordinary wares. Others were made by the most notable Japanese potters, such as the members of the Raku family in Kyoto or the descendants of the Seto potter Kato Toshiro, who is generally credited with having established the Japanese ceramic industry. Some of these pieces have been handed down in the same families for many generations and are today considered priceless heirlooms and national treasures.

As early as 1585 the Jesuit Father Frois reported that the king (that is, the daimyo) of Bungo paid as much as 14,000 ducats for an old jar, while a jar broken into three pieces brought 1,400 ducats. The Italian writer Gualteri, describing the arrival of the Japanese mission in Rome in 1586, relates that old tea caddies, tea bowls, and iron kettles brought incredibly high prices—as much as four or five thousand gold ducats or even more. Father d'Almeida reports that in Kyoto there was a man who owned a tea caddy valued at 30,000 ducats, and Antonio de Morga, writing in 1609, says that very ancient pottery jars of dark-brown color and poor appearance, with inscriptions and seals, were avidly collected by the Japanese, packed in bro-

cade bags, and sold for 2,000 taels—this at a time when money was much rarer and far more valuable than it is today.

This high evaluation of ceramics has continued right down to the present day in spite of all the changes that Japanese culture has undergone. For example, a celebrated tea caddy, not much more than three inches·in height and covered with a brownish glaze of varying intensity, was sold in the Sakai sale for the sum of 200,000 yen, which at the time was equal to 100,000 dollars and is the equivalent of at least twice that much in today's dollars. Many Western authors have called such prices ridiculous, and so they might be if their artistic merit alone were considered. They certainly prove, however, that the Japanese, like the Chinese, put the best productions of their potters on an equal footing with the finest works of their painters, not to mention sculptors and architects. A famous tea caddy known as Kitano Katatsuki was bought by the Mitsui family in 1922 for no less than 159,000 yen—worth at least that number of dollars in terms of today's purchasing power. Yet another tea bowl in a Tokyo sale brought the fantastic sum of 167,000 yen. Equally amazing were the prices reached at the sale of the Maeda collection by auction in 1925, in which a simple Oribe *cha-ire* brought 57,000 yen, while other tea caddies went for prices such as 47,910 and 36,900 yen. One could cite other surprising prices paid for rare pottery objects that are remarkable from an aesthetic point of view and have significant historical associations as well. Harada Jiro, in his book *A Glimpse of Japanese Ideals*, mentions several other astonishing cases. A celadon flower vase one foot high brought 135,000 yen, and an offer of 100,000 yen for a tea bowl owned by a Kyoto temple was refused with the characteristic reply that the bowl could always bring enough money to rebuild the temple, should occasion arise. Such tea bowls were considered as precious as gold or land and sometimes were actually exchanged for castles or preferred to an extension of a lord's domain.

Granted that these exceptional prices were paid by the devotees of the tea ceremony and were not ordinary occurrences, it still remains a fact that in Japan the art of the potter has enjoyed a prestige that it has never attained in the West. The best of Japanese porcelains, especially the finest Kakiemon and Nabeshima wares, are valued very highly, although the prices they bring never equal those paid for tea utensils. It is not unknown for a Japanese to sell his property in order to buy one precious piece of ceramic ware, as much for an investment that will withstand all fluctuations of the economy as for its intrinsic aesthetic value. Even during the recent postwar period, when the future of Japan was so uncertain, people who had money to invest often would prefer a valuable bowl or jar to stocks or real estate as a safer form of investment. As soon as the Japanese economy began to recover, the price of such art objects at once began to go up, with the result that really fine pieces of Japanese ceramic wares have never left the country, since no West-

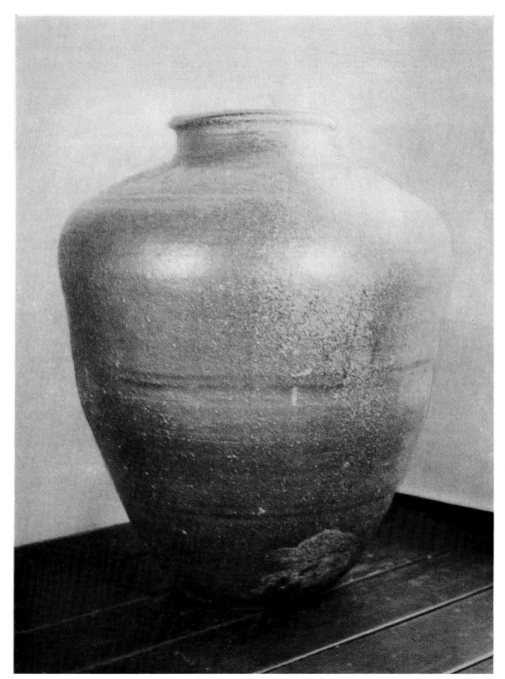

Color Plate 2. Bizen jar. Momoyama period. Collection of Dr. Okabe, Tokyo.

erners have ever been willing to pay (even for the masterpieces of Japanese pottery) the kind of prices that Japanese collectors have always been willing to offer.

The high sum paid for celebrated pieces of old ceramics finds its counterpart in sales of contemporary art, for the famous modern potters such as Hamada Shoji, Kawai Kanjiro, Kitaoji Rosanjin, and Tomimoto Kenkichi are highly esteemed in a way no potter can hope to be in Europe or America. Their names are well known not only by other potters but also by art lovers and even by the general public. Articles and books are published about them, and large exhibitions of their work are held in the leading department stores and art galleries of Tokyo, Kyoto, and Osaka. Even the government recognizes their contribution to the national culture by giving them the title of "living cultural assets," paying them pensions, and awarding them prizes. Their works are sold at high prices and in quantity, so that, unlike potters in the West, they are able to live off their output instead of being forced to teach or make industrial art. The reason for this is, of course, that Japanese culture has never made the unhappy distinction between the so-called fine arts and the industrial or decorative arts. The potter has always been considered a true artist with a real place in the art world and Japanese society; consequently, the products of his hand and mind have been sought after as much for their intrinsic aesthetic appeal as for their usefulness to the people who buy them.

In the West, Japanese ceramics have been collected almost from the beginning of the period when the first direct contact between Japan and Europe was established. Interestingly enough, at different times very different types of Japanese wares have been admired by European and American connoisseurs. There are three distinct periods in the taste for Japanese pottery. The first comprises the last part of the seventeenth and the first half of the eighteenth century, when the vogue was for fine Japanese porcelains of the Kakiemon and Imari variety. The second period, which was the last quarter of the nineteenth century, witnessed a veritable craze for things Japanese; this was when the first gaudy Satsuma ware and later the tea-ceremony paraphernalia found their ardent champions. The third period is the present, when simple folk ware and prehistoric ceramic sculpture are greatly admired.

The first Japanese ceramics were probably brought to Europe by the Portuguese during the late sixteenth century, but it was only when the Dutch East India Company took up this trade that it began to flourish. Even then, it was not until 1659 that the export of Japanese porcelains really began to be of any consequence. The first shipment of such porcelains consisted of blue-and-white wares in the Chinese tradition: porcelains that actually replaced the Chinese products themselves while that country was in turmoil owing to the advent of the Manchus and the end of the Ming rule. These Japanese imports proved very popular in Amsterdam, where they brought high prices. In fact, they were so successful that the famous Dutch

ceramists of Delft began to imitate the blue-and-white wares, and the Dutch traders who had established themselves at Hirado in 1609 and at Deshima in the harbor of Nagasaki Bay in 1641 were able to impress European taste on the Japanese manufacturers, so important had the European market become for Japan.

Even more admired were the refined Kakiemon porcelains, with their delicate designs executed in colored enamels, and the highly ornate and colorful Imari wares, so called because they were exported from the port of Imari, although they were actually made at the famous ceramic center of Arita. These beautiful and highly decorated porcelains, corresponding so well to the rather ornate taste of the Baroque and Rococo periods, became very fashionable. Great collections were formed in Europe, the most famous and most extensive of which is the one in Dresden put together by August the Strong, king of Saxony, between 1694 and 1715. It is said that the king's enthusiasm for his collection was so great that he even exchanged soldiers for porcelains. Even if this story is a legend, it indicates the great value that connoisseurs of the time attached to Oriental ceramics. In fact, the demand for Japanese porcelains during the eighteenth century led to their imitation by the leading European porcelain factories, which began making porcelains in the Kakiemon and Imari styles. The most famous of these is, of course, Meissen in Saxony, but French factories such as Chantilly, St. Cloud, and Vincennes, and English ones at Chelsea, Worcester, Derby, and Bow all made porcelains with Japanese designs. The imitations were often so excellent that it is sometimes difficult to tell them from the export ware made in Japan itself.

During the second half of the eighteenth century, under the influence of the Neoclassic movement, interest in Japanese porcelains declined, and for about a hundred years there was little enthusiasm for Japanese things. It was not until Japan was opened up by Commodore Perry in 1854 that she and her art once more occupied the attention of the West. But this time it was not only the porcelains but all aspects of Japanese culture that aroused interest and enthusiasm. The movement became so marked during the last quarter of the century that it has been referred to as the age of *japonaiserie*. Artists such as Whistler, Manet, Degas, Monet, and Van Gogh were deeply influenced by Japanese art, especially by the woodblock prints or ukiyo-e. Toulouse-Lautrec actually dressed up as a samurai, and Lafcadio Hearn wrote his unforgettable books about Japan, books that have probably done more than anything else to familiarize the Western world with Japan and her people.

As for ceramics, it was largely the great expositions that introduced Europe and America to Japanese work in this field. The first major showing of Japanese wares took place at the Universal Exhibition of 1867 in Paris, to which the Prince of Satsuma had sent some works produced in his domain. But it was not until 1878 that all types of Japanese ceramics were shown, this time at the Trocadéro during the Universal Exhibition of that year. Even more important was the group of

ceramics sent by the Tokyo Ministry of Public Instruction to the Paris Universal Exhibition of 1889. In America, Japanese ceramics were shown in several major expositions, including the Centennial Exhibition held in Philadelphia in 1876, Chicago's World's Columbian Exposition of 1893, the Louisiana Purchase Exhibition held in St. Louis in 1904, and the Panama-Pacific International Exhibition, which took place in San Francisco in 1915.

During this same period, private collectors began to buy Japanese ceramics, and dealers started to show them. In Paris, where Cernuschi formed a collection of Japanese pottery, bronzes, and wood carvings around 1875, there were many other collectors of Japanese wares—Alphonse Hirsch, the writer Edmond Goncourt, Gonse, Gillot, Guimet, and Burty. The best known of the dealers was Bing, who, with the help of the Japanese expert Hayashi, was instrumental in introducing Japanese art to the European public. In England the most famous collector was James Bowes, who formed a large collection of highly ornate modern wares. Others like Sir Rutherford Alcock had already preceded him. In America too there were several active collectors, in particular Professor Edward Morse, who went to Japan during the early Meiji period in order to teach zoology at Tokyo Imperial University and there assembled his huge collection of Japanese pottery, now in the Boston Museum of Fine Arts.

Various writers also devoted themselves to this subject. The most scholarly was probably the Englishman Augustus Franks, whose work on Oriental porcelain and pottery, first published in 1878 and appearing in a second revised edition in 1880, was a pioneering venture. In France, Jacquemart discussed Japanese pottery in his books on ceramics published in 1862 and 1873; later, Louis Gonse dealt with it in his *L'Art Japonais* of 1883. A more sumptuous though by no means as reliable publication was Audsley and Bowes's big two-volume work on Japanese ceramics (1875), which, if no testimonial to their taste or knowledge, is certainly a telling one to their enthusiasm. Finally, the best books on the subject were Franks' *Japanese Pottery*, a catalog of the collection in the Victoria and Albert Museum, first published in 1880 and reprinted in 1906; Morse's meticulous catalog of the vast collection in the Boston Museum, published in 1901; and Brinkley's volume on Japanese ceramics in his *Japan: Its History, Arts, and Literature*, also published in 1901.

The enthusiasm of these early connoisseurs of Japanese ceramics, which today seems really unbelievable, led to such excesses as Jacquemart's attributing to Japan translucent porcelains which, according to him, were older than those of China and dated from the pre-Christian period. Bowes, who also attributes the invention of porcelain to Japan, goes so far as to say that the Chinese could not have given the Japanese any practical or artistic instructions "since their own arts and manufactures were equal, and in most cases superior, to those of the latter." Gonse too denies that China had any influence on Japanese ceramics and says that in the

field of ceramics Japan occupies one of the leading positions, if not the leading one. It was only at the end of the century, when the magnificent ceramic production of China had been more thoroughly studied, that the true relationship between these two great Oriental traditions was better understood.

What is even more amazing than these opinions is the fact that they were based largely upon the knowledge of cheap export ware, for it was the gaudy and often outright vulgar Satsuma wares, with their rich gold decorations and depictions of Japanese legends, that formed the basis for this enthusiasm. Even Brinkley, who on the whole had a more balanced judgment, says: "In the field thus newly opened to Western collectors, the first place has by common consent been assigned to the faience of Satsuma. In decorative excellence other wares of Japan equal and even excel this beautiful faience, but in combined softness and richness it has no peer." Soon, however, many different types became known. The dealer Bing introduced Raku ware and the works of such famous potters as Ninsei and Kenzan; Philip Burty collected Bizen pottery; and Gonse praised Kutani and Kyoto *yaki*. It was not until the end of the century, however, that Morse began to attack Bowes's views, pointing out that true Japanese taste ran towards the subdued potteries cherished by the tea masters rather than the highly decorated faiences made for export to European countries.

Since the controversy between these two ardent collectors and vituperous authors is one of the most interesting chapters in the cultural history of this period, it may be of some value to quote part of the exchange. After Morse had sharply attacked Bowes's magnum opus and had bluntly said that all the supposed masterpieces in the Bowes collection (later turned into a museum) were nothing but the most tasteless modern export ware, and that the authentic Japanese ceramics were to be found in the crude pottery valued by the tea masters, Bowes came back with the following reply: "The *chajin* (tea master) was born into the world an unforetold and unexpected Messiah. His predecessors were so innocent of any share in his evolution that they desecrated the objects of his worship. For at Seto, the great center of Japanese keramic manufacture, the experts of the thirteenth and four-teenth century threw into their dust bins piles of distorted and blistered cups, bowls, and pots, which, in their silly ignorance, they conceived to be disgraces to the tech-nical skill of the time, and parodies of the potter's art. The rejected treasures the *chajin*, two hundred years later, disinterred from the dirt and placed among the gems of the cult. . . . To him their shrivelled shapes and blotched surfaces sug-gested beauties imperceptible to the profane crowd. It humiliates us to confess that the faculty of comprehending these things was denied us." And in another place he says: "The rude undecorated pottery of the middle ages has exercised a strange and unaccountable fascination upon the native mind, always prone to venerate whatever is ancient, and has led connoisseurs to ignore the beauty of the noble works produced during the past two centuries. In this eccentric taste they have

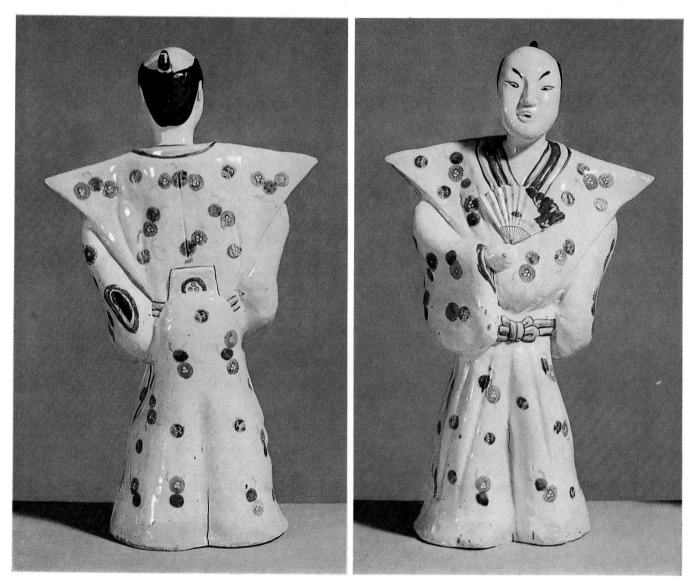

Color Plate 3. Imari figure of an actor. Early Edo
period. Collection of Mr. and Mrs. Walter Blumenthal,
New York. (Formerly in Klejman collection.)

been followed by some Western collectors, who have blindly accepted the faulty standard current in Japan."

The controversy between those favoring the taste of the tea masters and those preferring the colored porcelains and enameled faiences continues today. Brinkley, whose views on the whole are very balanced, nevertheless has this to say about the cult of the crude pottery wares admired by the tea masters: "The tea-clubs were the great patrons and preservers of this conservative orthodoxy. They carried their severe idealism to a point entirely beyond the range of ordinary intelligence. Their aesthetic affectation became a mystery unfathomable even by themselves. Yet their influence survives even now, and has left its mark upon every branch of art, especially the keramic. The crude, homely potteries of Bizen, of Karatsu, of Shino, of Iga and many other kilns, when placed side by side with the exquisite faiences of Satsuma and Kyoto, show how often Japan did violence to her own natural genius in deference to the dictates of an artificial and perverse dilettantism. If foreign influence at first threatened to vitiate her taste, it will probably atone for this crime by finally discrediting the cramping canons of the *cha-no-yu* cult."

With the discovery of the older and in some ways greater ceramic tradition of China in the early years of the twentieth century, Japanese art was neglected for almost fifty years, during which time this controversy died down. The truth is that there was some merit in both Morse's and Brinkley's contentions, for the crude wares of the *chajin* and the highly finished porcelains of Arita each have their own beauty.

Strange as it may seem, after a generation of neglect followed by years of war and bitter hatreds, it was the American occupation of Japan that led to a renewal of interest in Japanese culture and art. Interestingly enough, it was not the colored porcelains of the Arita kilns or the ornate wares of Satsuma and Kyoto, and not even the austere tea utensils which aroused this renewed enthusiasm for the ceramic production of Japan, but the coarse potteries of the folk kilns. Under the influence of the famous Japanese connoisseur and author Yanagi Soetsu and the American art historian and curator Langdon Warner, Western scholars, museum curators, artists, and, above all, potters began to collect *mingei*, or folk-art ware, which also had a profound influence on contemporary pottery in America, England, and Scandinavia. At the same time well-known modern Japanese potters such as Hamada, Kawai, Rosanjin, Kaneshige Toyo, and Kato Hajime gave lecture demonstrations and exhibitions in America, and young American potters went to Japan for study and inspiration.

Representative of still another phase of Japanese ceramics that has now found ardent admirers were the idols and vessels of the prehistoric period—above all, the primitive figures from the grave mounds of the fifth and sixth centuries. If at one time no fashionable home was complete without its Ming vase or K'ang-hsi bowl, today it is more likely that a *haniwa* head or horse, sometimes of recent date, will

greet the visitor. Here again, the joy at a new discovery has no doubt distorted our perspective, but every age has always re-evaluated the past in the light of its own tastes, and it is a tribute to the richness of the Japanese ceramic heritage that each generation is able to find new and exciting phases in the art of Japan.

3 Types of Ware, Uses, and Seals

CERAMICS are found among the earliest remains of the Jomon civilization, which, according to the most recent carbon-14 datings, is believed to reach back as far as five thousand years before Christ. Thus the history of Japanese ceramics covers a span of many millenniums during which a great variety of wares was produced. Usually one distinguishes three main divisions within ceramics: earthenware, stoneware, and porcelain. Another term frequently employed is pottery, usually meant to include only earthenware and stoneware, though in Britain the word pottery at times means ceramics in general—that is, anything made of clay. Originally the term no doubt meant anything made by the potter in a pottery, but this is no longer the commonly accepted usage in America today. In Japanese *yaki*, meaning baked wares, is the generic term including all types of ceramics, so that one talks of Raku-yaki, meaning pottery made by the Raku family, or Kyo-yaki, meaning wares made in Kyoto. The other common term in Japan is *mono*, meaning ware or something made, which is used in conjunction with another word, such as *setomono*, meaning ware made at Seto.

It is often very difficult to distinguish between the various types of ceramics, since there are porcelaneous stonewares, earthenwares which are almost like stoneware, and variations which do not fall into any clear category. For general purposes, however, it may be said that earthenware is pottery which is porous to some degree, has been fired at a low temperature, and is opaque. There is a good deal of variety within this class, from the crude and primitive vessels shaped by hand and baked in an open fire to very refined earthenware made on a potter's wheel, fired in highly developed ovens, and ornamented with glazes. Glazed wares of this latter type are often designated by special names such as faience, a term originally derived from the ware made at Faenza in Italy and used to describe a soft earthenware covered

with a lead glaze. Stoneware differs from earthenware insofar as it has been fired at a higher temperature (somewhere between 1200 and 1400 degrees) so that it vitrifies. In this heat the particles of which the clay is composed melt and form a harder and more homogeneous mass. It is therefore nonporous and strong, with a ringing sound if the body is not too coarse and the glaze not too thick. Porcelain, which was developed at a later date than pottery, and which came originally from China and was not produced in Japan until the seventeenth century, is similar to stoneware but more refined, with a much purer body, and above all translucent. The term itself was originally given to the Chinese wares when they were first brought to Europe by the Portuguese. It derives from the Italian word *porcellane* —from *porcella*, Italian for cowrie shell, which porcelain was believed to resemble because of its whiteness and smooth surface.

Today in Japan these three types of ceramics are all used extensively, but originally the Japanese employed bamboo, wood, and lacquer vessels for most purposes, and pottery only on special occasions. As modern industry has enabled manufacturers to produce hard white porcelaneous ware cheaply and in great quantity, this product, usually referred to as china, has become very popular and, except in rural areas, has replaced earthenware and wood for daily use. In spite of this development of a large-scale ceramic industry using modern industrial methods, there are still an astonishing number of local kilns that continue to make all kinds of coarse pottery.

The process by which ceramic ware is made consists of three stages. First, in what is called the clay state, the vessel is shaped out of moist clay. Then it is fired for the first time, this being called the biscuit state, and is painted with the colors that are to appear under the glaze. Next the glaze is applied, and the vessel is fired again at a higher temperature. If it is to be gilded or decorated with overglaze enamels, it is fired once more in a muffled kiln at a low temperature. This last step is necessary only for enameled wares, one or two firings being sufficient for ordinary earthenware and stoneware. Traditionally wood, charcoal, or coal is used for firing, but in modern times electricity, oil, and gas kilns have also been introduced, though wood, especially pine, is still quite common in the local kilns.

There are roughly two kinds of kilns in Japan: the bank or climbing kiln, which is built on a slope, and the bottle kiln. The former type, originally from Korea and very popular with Japanese potters, may have as many as twenty chambers through which the heat passes. In its most primitive form, the bottle kiln, which is also called an updraught kiln, consists of a covered trench leading to a chamber formed by a circular wall. The unglazed pots are piled on a raised perforated floor, and the top is covered except for an opening to let out the smoke. A wood fire is then made at the mouth of the trench, and the flames bake the ware. The duration of the firing varies greatly, ranging from a few hours for an open firing up to two weeks for the largest climbing kilns. All sorts of factors such as the nature of the material,

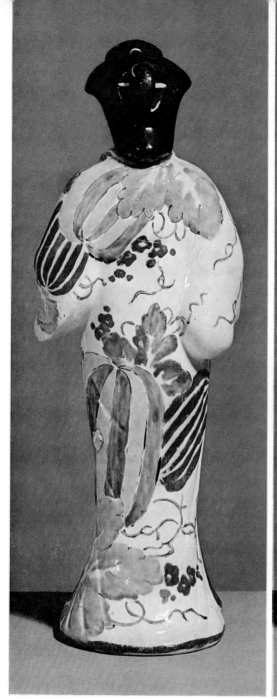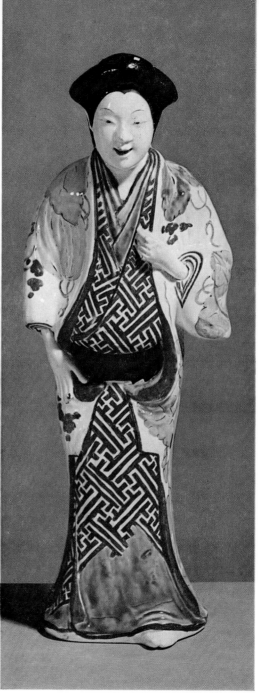

Color Plate 4. Kakiemon figure of a lady. Early Edo period. Collection of Mr. and Mrs. Walter Blumenthal, New York. (Formerly in Klejman collection.)

the type of kiln, the quality of the fuel, the weather, and the skill of the stoker will determine its duration.

Many technical considerations are involved in making fine ceramics, but since this book is not a potter's manual, being intended chiefly for the layman interested in ceramics as an art form, it is upon the artistic aspects that the emphasis will be placed. In a sense, one can say that pottery is basically a kind of abstract sculpture, for in looking at a vessel we consider it from the point of view of form, texture, decoration, and color, just as we do with a piece of sculpture. In fact, the terms used to describe the different parts of the vessel—the foot, belly, shoulder, neck, and lip—are all taken from the human body, which again implies a relation to sculpture. They also suggest that a really beautiful shape must have an organic and vital quality, and it is not pure chance that the soft swelling curves of vessels have recalled the female form to primitive people. In analyzing the total effect, the vessel must be considered as an organic whole rather than a group of individual parts. Basically the ingredients entering into the potter's calculations are the clay, the pigments, and the glaze, but it is the way these raw materials are used that determines the character and quality of the pot. This is largely dependent upon the potter's skill and his artistic sensitivity, yet even he himself may be uncertain just how he attained a particular effect that he may be unable to repeat.

It is possible to look at Japanese ceramics from a purely aesthetic point of view, which is what modern collectors both in Japan and in the West often do, but there can be no question that almost all of these productions were originally intended for use. In fact, many of the vessels that today have been declared national treasures were at one time nothing but common household utensils. Clay objects of one kind or another are so common in Japan that they are found in every phase of Japanese life. There is one type of vessel, however, that is very popular in the West but is never found in Japan, and that is the ornamental vase. There are flower vases, usually modest in appearance so as not to distract attention from the flowers or branches, but since the traditional Japanese house has no ornamental tables, mantelpieces, or cabinets, there would be little point in a vase with a merely decorative function. The only ceramic piece that is intended solely for display is the ornamental statuette known as the *okimono*, usually in the shape of a household deity, an elegant lady, or an animal, but even this is rather exceptional.

Of the many types of vessels in use, the ones connected with tea are perhaps the most common, for the Japanese love to drink tea on any and every occasion. Both cups and teapots are usually made of some type of ceramic ware, often of great beauty in design and workmanship. The teapots are made in two shapes: either as *dobin*, which has a movable bamboo handle arching over the top, or as *kyusu*, which has the handle (a straight, hollow projection) set at right angles to the spout. The Western teapot with handle and spout in a straight line is made only for export and for Western-style tea sets. The cups are usually small and never have

handles. Here again, the Western teacup in Japan is made only for foreign taste. Other utensils connected with the brewing and serving of ordinary tea are the brazier on which the water is boiled and the bowl for rinsing.

Next to tea the most important beverage as far as ceramics is concerned is saké, the Japanese rice wine, which from ancient times has formed an important part of every festival in Japan. While beer, a Western importation, is poured from glass bottles and drunk in glasses, saké is served in tiny cups made of pottery or porcelain. In the Shinto marriage ceremony three lacquer cups of the same shape are used, each of a different size so that the three can be fitted one into another. Shinto shrines also use saké cups on other occasions. Saké today is usually poured out of a small bottle with a narrow neck, but in earlier times large jars were used. Before the introduction of glass bottles, saké was kept in these large jars and poured into decanters, but this custom is now found only in rural areas.

The artistic center of the Japanese house is the tokonoma, a raised alcove for the display of hanging scrolls, flowers, incense burners, and *okimono*. All kinds of ceramic objects may be found in the tokonoma. The scrolls may have porcelain end pieces, and the vases and bowls used for flower arrangement are almost always made of some kind of pottery, as are the boxes or *kogo* containing incense and the incense burners, called *koro*. These boxes and burners are often made in the form of animals, fish, fruits, and flowers, showing a lively imagination in contrast to the vases, which are usually simple and subdued. Next to the tokonoma is the *chigai-dana*, which consists of built-in shelves resembling a cabinet. Ordinarily it was here that the art treasures, including ceramics, were placed, unless the family was very rich and kept a special fireproof storehouse called a *kura*.

Among the ceramics looked upon as treasures, the most important are those connected with the tea ceremony, which differ in shape and design from the wares used for ordinary tea. All the objects used in the *cha-no-yu* can be made of pottery, and the greatest care is lavished upon them. First and foremost is the tea bowl or *chawan*, which varies considerably in shape, depending upon the type of tea ceremony performed, the time of year, and the occasion. Next in importance is the tea jar or tea caddy called *cha-ire* or *chaki*, a small jar with an ivory lid and a body that is usually made of pottery with a blackish or brownish glaze. Although plain in design and small in size, these *cha-ire* are sometimes valued highly and may bring incredible prices, as we have noted. Then there is the water jar, a large covered vessel called the *mizusashi*, and the *kensui*, a bowl used for waste water. The incense container and incense burner, the cake plate, dishes for several meals, and trays may also be made of ceramics.

Although less valued from an artistic point of view, far more common are the numerous ceramic articles used in the kitchen. There are big jars for holding water or *miso*, a kind of fermented bean soup eaten for breakfast; and there are many different sorts of bottles and jugs used for oil, vinegar, and sauces. Bowls and

shallow dishes are kept for various kinds of food; casseroles are common; and there are jars for pickled radishes, vessels for steaming rice, covered dishes for fish and meat, and all kinds of plates. Once the food is brought to the table, innumerable small dishes are needed, for a Japanese meal consists of many different kinds of food served in small quantities. First there would be covered bowls for soup and rice, then shallow receptacles for fish, tiny dishes for pickles and other such delicacies, deep cups for *soba* or Japanese noodles, and other cups for soy sauce. Also typically Japanese are the oblong dishes for *sushi*, a favorite concoction consisting of rice, seaweed, and raw fish, as well as the boxes consisting of tiers of trays which are used to serve special delicacies offered at New Year's.

Another household utensil often made of pottery is the charcoal brazier or *hibachi*, which is the center of the Japanese house during winter because it serves to warm the room, heat water for tea, and provide a place around which the family can gather. Little pottery ovens that can be carried around by one person are also usually made of ceramics. Up to Meiji times, lamps with oil plates were made of pottery, as were various smoking utensils such as the tobacco jar, the receptacle for the ashes, and the vessel used for coal to light the pipe. Tiny lamps of pottery were set in front of the Shinto and Buddhist altars along with pottery dishes holding many kinds of offerings. The writing desk, too, frequently contained pottery objects such as the rest for the brushes, the paperweight, and the water container with a small hole to add water to the ink. Other articles made of pottery were incense burners, small boxes or jars for cosmetics, and vessels for burning herbs to drive insects away.

Besides these various domestic utensils, ceramics were also used for roof tiles and for ornamental pieces on top or at the border of tile roofs. These were often very beautiful in design and color, especially in the old Buddhist temples, and contributed greatly to the splendor of the building. In modern times ceramics have been used for such things as toilets, plumbing, and electricity, an aspect of production which today forms a major part of the industry.

The diversity of Japanese ceramic products corresponds to the great diversity of pottery centers. There are, of course, certain traditional manufacturing towns such as Seto, Arita, Kutani (near Kanazawa), and Kyoto, but what helps to make the ceramic production nearly unique is the existence of numerous local kilns. It has been estimated that ten thousand kilns have been in operation at one time or another, some run by individual potters, others by small groups, and still others on a large scale. In fact, this emphasis on individuality is one of the aspects of Japanese pottery that have made such an eminent critic as the German museum curator and scholar, Ernst Grosse, place Japanese ceramics above those of China and Europe.

The confusing number of these small kilns, added to the multitude of amateurs who bake their own pottery in private ovens, makes it extremely difficult to identify

Japanese wares, even if they are supplied with a seal or inscription. Informative as these may be, it must always be borne in mind in using them as guides that the Japanese may have made the same type of ceramic ware at one kiln for many generations, if not for centuries, sometimes still employing the same ancient seal. Besides this, it must be remembered that they do not hesitate to copy the seals and signatures of famous older potters, and that they are perhaps the most skillful forgers in the world. It is for this reason that vessels bearing such famous names as Kenzan or Ninsei are almost always copies or outright forgeries, and it is thus very difficult to identify Japanese wares. Only experience in handling many fine pieces over a long period of time can teach one to evaluate them with any degree of certainty.

If this is understood, the marks and seals painted or impressed upon Japanese ceramics can often be helpful. Many pieces may have no such inscriptions, and when they do, especially the porcelains, they have Chinese ones which are of no help in identifying the ware. The inscriptions that are found may give the name of the artist or the tea master who admired this type of ware, the name of the factory at which it was produced, the name of the kiln or studio, the town or province in which it is located, or the *nengo* or era during which it was produced. Of course all this information is never found on one piece, since no more than one or two of these marks or seals are usually present. Even these are not as easy to identify as might be thought, for one single potter may use a great many different signatures, while several generations of the same family may use the same seal. For example, the famous Edo-period potter Kenzan may sign himself Ogata Shinsho, Sansho, Shinzaburo, Shoko, Suiseido, Shisui, Reikai, Toin, or in several other ways. The seal or identifying mark may be easy to read when dealing with well-known kilns such as Kutani or famous names like Raku, but it may be next to impossible to identify when one is confronted with some small local kiln, obscure or short-lived, that went out of existence years ago. Reference books on seals and marks may be helpful, but even the most complete cannot possibly list all the signs which might occur. Other identifying marks may be poetic or auspicious characters, such as *fuku* or happiness commonly found on Kutani ware, or wealth or honor or long life. Period names do not occur very frequently on Japanese wares, and if they do—on the porcelains, for example—they refer to Chinese reigns usually of the Ming dynasty and have no relationship whatsoever to the piece in question. Furthermore, most Japanese ceramics have no identifying marks at all. This is certainly true of all prehistoric pottery, all the early historical wares, and all folk pottery. Even a famous modern potter like Hamada never uses a signature, since he thinks that the quality of the work itself will speak.

The collector faced with such a complicated situation usually does best to buy what he likes, and not to worry too much whether the piece in question is really by the famous Kenzan the first or one of his five namesakes or by some unknown

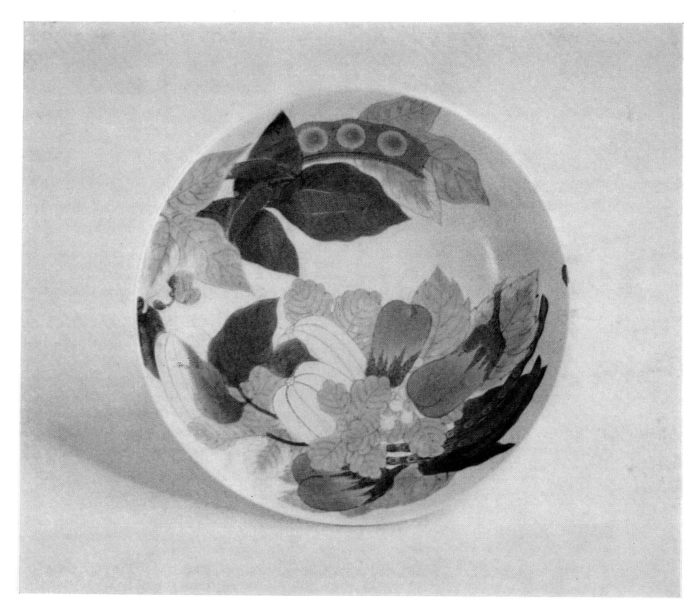

Color Plate 5. Nabeshima plate. Middle Edo period.
Collection of Dr. Okabe, Tokyo.

follower who worked in a similar style. Seal or no seal, chances are always against any piece casually bought by a Westerner being a masterpiece by a famous potter. First of all, the number of such masterpieces is very limited; second, most of them have been well known for many generations and have often been declared national treasures, so that they cannot be sold abroad. Furthermore, the big Tokyo and Kyoto dealers who would be likely to handle such pieces know their value and sell them only at prices no Western collector would pay. Under these circumstances, it seems best not to place too much confidence on seals and inscriptions even if they are present and can be identified, but to rely primarily on the quality of the piece itself.

4 The Ceramics of the Prehistoric Period

DURING the Neolithic period a Stone Age civilization known as Jomon flourished in the Japanese islands. The name means cord pattern, and it is used because many of the clay vessels made at the time have on their outer surface designs impressed by cord or string. Just who the people who made these vessels were or where they came from or when they flourished is not known with certainty. Scientific research into this phase of Japanese archaeology dates from 1879, when the American scholar Edward Morse, the well-known collector of Japanese pottery, published his work on the shell mounds of Omori. Modern research would tend to the conclusion that the Jomon people were not Japanese, but rather the ancestors of the Ainus, who are today found only in Hokkaido and the Kurile islands and are not of Mongol but of Caucasian stock. The most recent carbon datings suggest that they came to Japan some seven thousand years ago; their original home no doubt was the Asian continent, though just where they came from is not known. At one point they inhabited all of the Japanese islands, as can be seen from the discovery of Jomon remains in a great variety of places and from the Ainu place names still to be found in many parts of Japan. Gradually they were pushed north by succeeding immigrants and disappeared from the main island of Honshu by the fourth century A.D., although their descendants continued to live in Hokkaido and are found there today on isolated reservations.

The most lasting monuments to these people are the magnificent ceramics they created: products of an art that is quite unique and has no parallels on the continent. In fact, the Jomon idols are actually closer to the fertility deities of prehistoric Europe than anything else found in Asia, and this again suggests some Caucasian link. The pottery was always shaped by hand without the aid of the potter's wheel, frequently by the coiling method. The firing took place in the open

at temperatures between 400 and 500 degrees centigrade. The color of the early wares is reddish, while the later ones vary from gray to black. Some vessels are highly polished, and some are covered with red iron oxide or a lacquer substance, but most of them are plain clay. The best preserved are the ones made in northern Japan, while those from the south are almost always in fragments. The number of such fragments is tremendous, for shell mounds with pottery are found all over Japan. Even the complete vessels, or the ones that can be easily restored, number in the thousands. On the other hand, the idols or *dogu*, as they are called, are fairly rare; only about two hundred whole figures and at most a thousand fragments have been found so far. Further research, now being undertaken with all the latest techniques by Japanese archaeologists, will no doubt bring to light much additional material and enable us to date the pottery with greater accuracy than is possible today. Strangely enough, there is no direct continuity between the Jomon finds and any of the ceramics made in modern times, for the Ainus of today make no pottery. Some scholars, however, see similarity between the designs on Ainu carvings and textiles and those on Jomon pottery.

Since the pottery output of the Jomon period extended over such a long time—in fact, some five thousand years—and covered the entire country, the production naturally varies considerably from time to time and place to place. Scholars used to divide the Jomon age into early, middle, and late, but this proved such an oversimplification that a division into five periods has now been suggested, and the most recent tendency is to classify Jomon wares by type and by the region in which they are found. A great deal of work has been done along these lines in recent years, but much more remains to be done before a clear picture emerges. It appears that the earliest vessels often have pointed bottoms and flaring lips (*Plate 1*), while the shapes prevalent during the middle period are lower and wider. The latest works are similar but smaller in size (*Plate 2*). It is believed that these vessels primarily served utilitarian purposes. Still others may have been ritual vessels; certainly the idols were religious in character. The high point of Jomon ceramic art in the eyes of most scholars comes during the middle Jomon period with the Katsusaka vessels, so called after a site in Kanagawa Prefecture where they were found. The forms and designs of these objects are the boldest and most imaginative of all those in Jomon pottery and have a great appeal to the modern eye schooled in abstract art (*Plate 3*). The other outstanding phase of Jomon art is found during the late period in the works of the Kamegaoka style, common in northern Japan and named after a site in Aomori Prefecture. This phase shows a more refined and varied decoration.

The designs found on these vessels vary greatly but may be roughly divided into certain categories. Most typical are those made with the help of string or rope coiled out of rice straw which was impressed on the clay surface of the vessel. Sometimes designs were incised, punched, scraped, or carved with the help of a stick, a

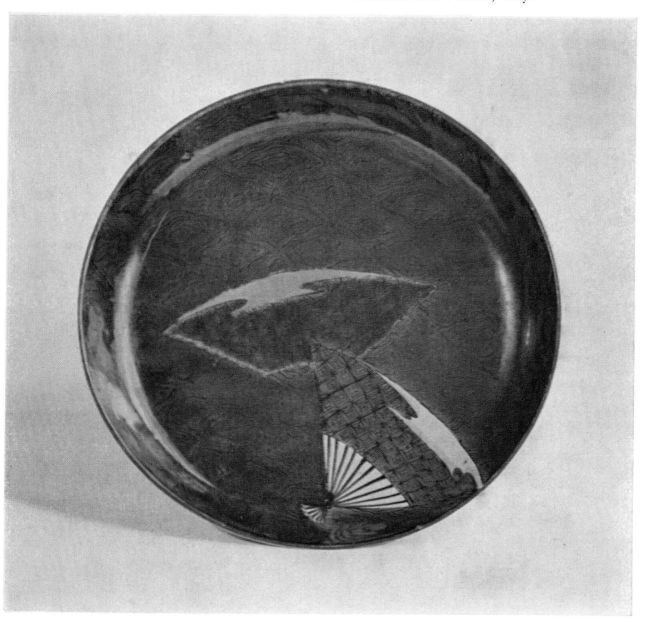

shell, or a nail. The surface of the vessel was sometimes smoothed, sometimes roughened, and in some early examples a stick carved with a design was rouletted over the surface to produce zigzag lines or some other such regular pattern. The most sculptural designs are found on the pottery of the Katsusaka type, which boasts loops and handles. The clay may even be carved in the shape of animals and human faces. Throughout the Jomon period the ceramics were of a remarkable strength and originality that made them outstanding among the ceramic productions of the Neolithic age.

The most fascinating of all the products of the Jomon potters are perhaps the idols which begin to appear during the middle Jomon period. Their height varies from two to seven inches. The earlier ones are simpler and more abstract and often have a strange affinity to the primitive art of Africa and to modern abstract sculpture (Plate 4). There is a magic and expressive quality about them that is truly remarkable and appeals to our modern taste. The subsequent ones that date from the late Jomon period are rounder and rather squat, with broad waists and heavy legs, and are covered with linear designs in form of spirals (Plate 5). They are often grotesque in appearance, especially their huge insect-like eyes, which no doubt had some magical meaning. All of the figures are female, and all were found at domestic sites, which suggests that they must have represented some sort of primitive goddesses who brought fecundity to the race and fertility to the fields. But whatever their original purpose—and even without knowing anything about it—we can appreciate them as powerful and imaginative sculptures of the first order.

The age following the Jomon period is referred to as the Yayoi period, after the name of the Tokyo district in which the first specimens of this new kind of earthenware were found in 1884. Just who the people responsible for this civilization were and what their origin was are not known, but there can be no doubt that they crossed from Korea and first landed in Kyushu. From there they gradually spread all over Japan, so that Yayoi pottery may be found in all parts of the country from the southernmost tip of Kyushu to the northernmost section of Honshu. The date of their arrival is not known with certainty, but since datable Chinese bronzes were found at burial sites of Yayoi origin, we can be certain that the new conquerors were already in Japan by the first century B.C. The finds may well suggest that they began to arrive during the second century of the pre-Christian era. Of course this does not mean that the Jomon culture ceased at once, but rather that the invaders, who possessed a technologically superior civilization, gradually superseded the older inhabitants and pushed them northward as they expanded their own territory. Historical records tell of battles with barbarians as late as the eighth century, so it is clear that this process took place over a long period of time. In contrast to the Jomon people, who were Caucasians, the Yayoi people were Mongols and must be looked upon as the direct ancestors of the present-day Japanese, though an admixture of Jomon racial stock no doubt can be found, since the defeated aborigines

became absorbed into the conquering race. Other invaders followed in subsequent centuries, but the Yayoi people can be looked upon as the true ancestors of the Japanese people.

The ceramics produced by them indicate a complete break with what had gone before. The Yayoi culture, being on a higher level, knew the potter's wheel and employed bronze and iron. Beyond this, a completely new and different artistic concept underlay this work. The pottery, for one thing, was fired at a much higher temperature and is therefore much harder than Jomon ware and has a smoother surface. Furthermore, the color is different, for Yayoi ware is usually yellow or light-brown earthenware, sometimes painted with red. But most marked is the difference in shape and design. The Yayoi pots are far simpler than those of the Jomon culture and show none of the individuality characteristic of the earlier vessels. They are usually pots, plates, or jars that no doubt served domestic as well as sacred purposes. A peculiar characteristic is that the bottom is often smaller in diameter than the mouth, which creates a strange off-balance effect (*Plate 6*). The beauty of the vessels depends almost entirely upon the form itself rather than on the designs, which are now subordinated to the form (*Plate 7*). They are never modeled in relief like the Jomon decorations but are severe and simple, consisting mainly of incised marks forming geometric patterns of parallel circular lines, meandering lines, broken or dotted lines, zigzag or herringbone lines (*Plate 9*). Although these decorations are extremely plain, the effect is one of great elegance and beauty of shape that makes these Yayoi wares outstanding productions of the potter's art. The closest analogies are found among the prehistoric wares of Korea, and there can be no doubt that this pottery culture is derived from the neighboring Asian mainland.

The Yayoi period, which lasted into the second century A.D., was followed by the Grave Mound period, so called because its most remarkable remains are the tumuli erected over the graves of the rulers and nobles. Some of the tombs, which are known as *misasagi*, are tremendous in dimension; that of the Emperor Nintoku, for example, was some 1620 feet in length and 90 feet in height and covered an area of 80 acres. In the tomb chambers archaeologists have found, among many other objects, pottery known as Haji ware, which is almost identical with Yayoi ware and suggests that this culture grew directly out of the Yayoi civilization (*Plate 8*). Its origin can probably be dated at some time during the third century, and it is believed that it continued into the seventh century, when the superior Buddhist civilization imported from Korea and later from China superseded it. While the Jomon ceramics have no connection with the later developments in Japanese ceramic history, the products of the Yayoi culture and the Grave Mound period represent the first stage of truly Japanese pottery, and many later developments are foreshadowed in these wares.

The most interesting—and artistically the most rewarding—discoveries at the

grave mounds were the clay figures known as *haniwa*, which were found surrounding them and on their tops. The number of such figures must have been very large, for it has been computed that the tomb of the Emperor Nintoku had over eleven thousand of them, with well over six thousand on the tomb itself and almost five thousand outside the moat. The term *haniwa* means earthenware placed in a circle, and this suggests that their essential function was that of surrounding and guarding the sacred resting place of the honored dead. Since the earliest ones are plain hollow cylinders with no figures or only the most rudimentary carving, and since many of them have holes through them, it has been suggested that these hollow posts originally supported a bamboo pole or a rope which served to separate the burial ground from the outside world. The development of the *haniwa* into sculptures may well be a later development influenced by China, where since Han times it had been customary to place clay figures in the tombs. However, in contrast to the Chinese usage, the *haniwa* were never placed inside the tombs, and they differ also very much in style, so that they represent a wholly new and original development.

The ancient chronicle of Japan, the *Nihonshoki* (or *Nihongi*), records that the clay grave figures were originally made because the emperor took pity upon the unfortunate people who were, according to custom, buried alive up to the neck with the corpse of the Prince Yamato-hiko. It says: "For many days they died not, but day and night wept and cried. At last they died and rotted. Dogs and crows assembled and ate them. The Mikado, hearing the sound of their weeping and crying, felt saddened and pained in his heart. He commanded all his high officers, saying: 'It is a very painful matter to force those whom one has loved during life to follow him to death and though it is an ancient custom, why follow it if it is bad? From now and henceforth plan so as to stop causing men to follow the dead.'" Later on, at the death of the empress, we are told, clay workers from Izumo were called and told to fashion clay figures of men, horses, and other objects as substitutes for the living sacrifices. The emperor was delighted with this procedure, and ever after, clay figures were used at burials. It is unlikely that the story as here related is true, but it may well have a historical basis. There can be no doubt that in ancient China human and animal sacrifice was practiced, for actual skeletons with severed heads have been found in Shang tombs, and we know that clay figures and, later, paper figures and paper money were substitutes designed to accommodate the dead in their afterlife. Similar conditions may have prevailed in prehistoric Japan, or the story may have derived from Chinese sources. In any case the figures certainly were not made as works of art with a purely aesthetic intent but had a cultural function closely connected with the worship of the dead rulers.

Among the thousands of *haniwa* found, there is a great variety of shapes and types. Most common are the human figures representing such diverse types as warriors in elaborate armor (*Plate 10*), huntsmen with hawks, a man playing a *koto*

(Japanese harp), dancers with raised arms, and ladies with necklaces *(Plate 11)*. Also numerous are the representations of animals, particularly horses that look like large toys *(Plates 12 and 13)*, monkeys, dogs *(Plate 14)*, and birds *(Plate 15)*. From an archaeological point of view, perhaps the most interesting of all are the models of houses *(Plates 16 and 18)* that resemble old Shinto shrines like those at Ise and Izumo and are the earliest documents for the history of Japanese architecture. Equally interesting are the models of prehistoric boats *(Plate 17)*. But the *haniwa* are important not only on account of their historical value in portraying the culture of the time; they are at the same time artistically of the first rank. There is about them a kind of naïveté and innocence *(Plate 19)* which, like that of all primitive art, has a particular appeal for the modern art lover. The forms reveal a superb mastery of plastic conception *(Plate 20)*, anticipating by many centuries what such men as Brancusi, Moore, and, above all, Noguchi are striving for. The artist, in creating them, always worked with the simplest means: plain unglazed reddish clay shaped usually in a cylindrical form with a wonderful feeling for suggesting the essence of the figure in the simplest way. The eyes and mouths are mere holes cut into the surface of the clay, but here again a very vivid lifelike effect is achieved *(Plate 21)*, showing how these artists were able to create the maximum of effect with the very minimum of detail. No wonder that these works have achieved such popularity in recent years and are now appreciated as one of the great artistic contributions of the Japanese people.

Even more important for the development of Japanese ceramics was a new type of pottery that came into existence during this age. It is called Sué ware after the Suebe people, who came from Kudara (Paekche) in Korea during the fifth century, and was no doubt of Korean origin. Another term employed for it was Iwaibe, meaning sacred ware, for it was used only for festivals, in contrast to the cruder form of Yayoi ware, known as Haji, which was used for domestic purposes. Sué ware may be distinguished from Yayoi and Haji by three main characteristics: it was fired at a far higher temperature (around 1200 degrees centigrade); it has a hard gray body; and it is sometimes decorated with a greenish natural-ash glaze. While the earlier wares had been baked in kilns erected on level ground, the new kilns were built on sloping ground, an idea derived from Korea. This type of kiln, called *ana-gama in* Japanese, made it possible to increase the heat vastly and was the forerunner of the multicompartment sloping kiln still in use today. Although originally a foreign importation, this type of pottery became one of the most characteristically Japanese wares and continued to be made right into the historical period; in fact, it may be said that traditional wares such as Tamba, Tokoname, Bizen, and Shigaraki are an outgrowth of this kind of prehistoric ware.

A great variety of shapes were used by the Sué potters, among them all kinds of jars, bottles, dishes, cups, and pots *(Plates 22 and 23)*. Most unique are the dishes with a high hollow foot into which triangular or rectangular openings were cut,

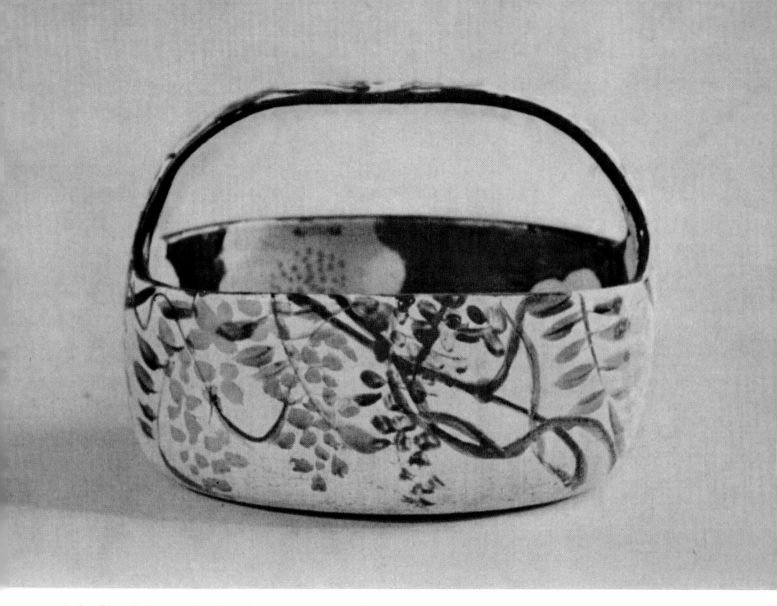

Color Plate 7. Kenzan bowl in shape of a basket. Middle Edo period. Collection of Dr. Okabe, Tokyo.

probably to let the smoke escape when the vessel was placed over a fire *(Plates 24 and 25)*. Sometimes these vessels also have sculptural decorations around their shoulders which may show human and animal figures such as huntsmen, soldiers, ships, and birds *(Plate 26)*. Since very similar vessels with the same type of figures are also found in Korea, this style too must be an importation from the mainland. Otherwise the designs on these wares are extremely simple, consisting of wave patterns drawn with a brush, a series of dots made with a comb, and incised circles and slanting lines. Although technically and historically of the very greatest importance for the further development of Japanese ceramics, these wares are artistically far inferior to those of the Jomon and Yayoi ages, which are among the most beautiful and most original artistic creations of the entire Neolithic period.

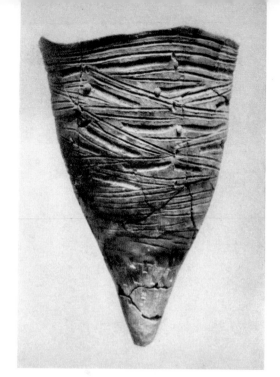

Plate 1. Vessel with pointed bottom. Early Jomon period. Musashino Museum, Tokyo.

Plate 2. Vessel with spout. Late Jomon period. Tokyo National Museum.

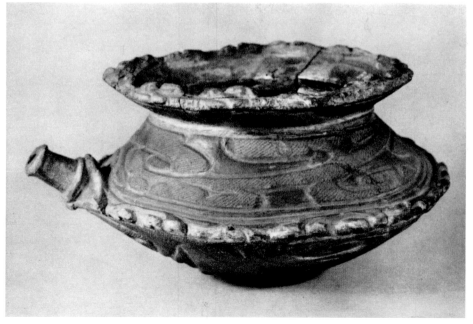

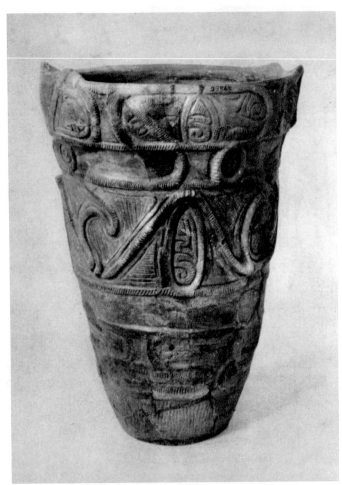

Plate 3. Urn with sculptured ornament. Middle Jomon period. Tokyo National Museum.

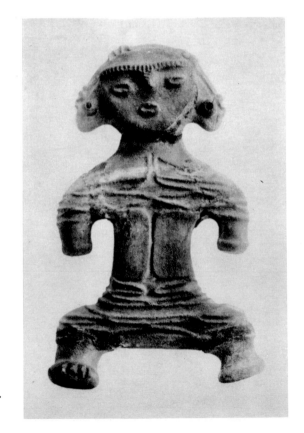

Plate 4. Clay idol. Late Jomon period. Kohigi collection, Tokyo.

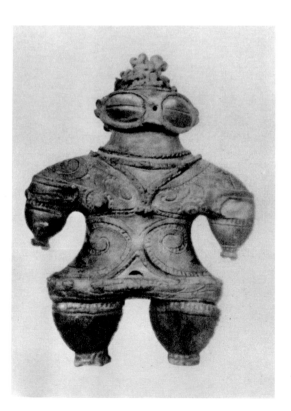

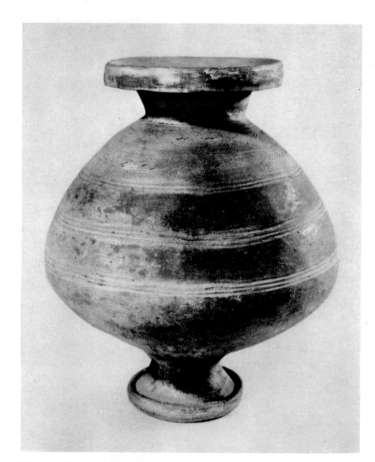

Plate 6. Pottery vessel. Yayoi period. Tokyo National Museum.

Plate 5. Female idol. Late Jomon period.
Collection of Tokyo University.

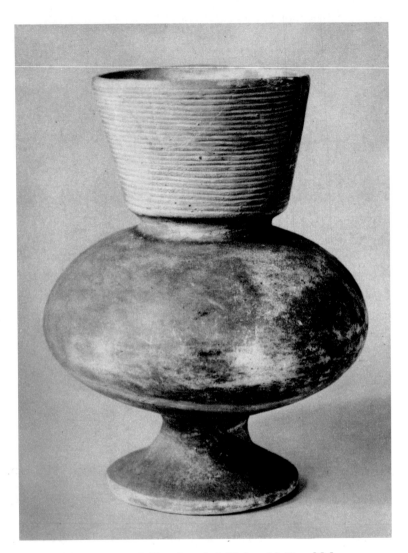

Plate 7. Pottery vessel. Yayoi period. Tokyo National Museum.

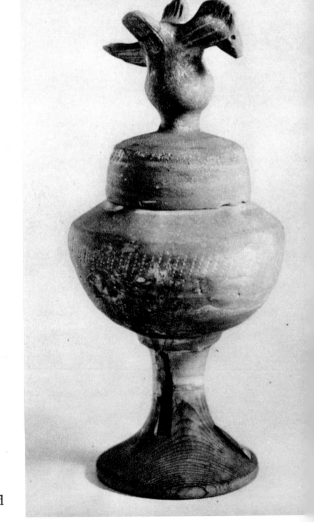

Plate 8. Haji vessel with bird cover. Grave Mound period. Tokyo National Museum.

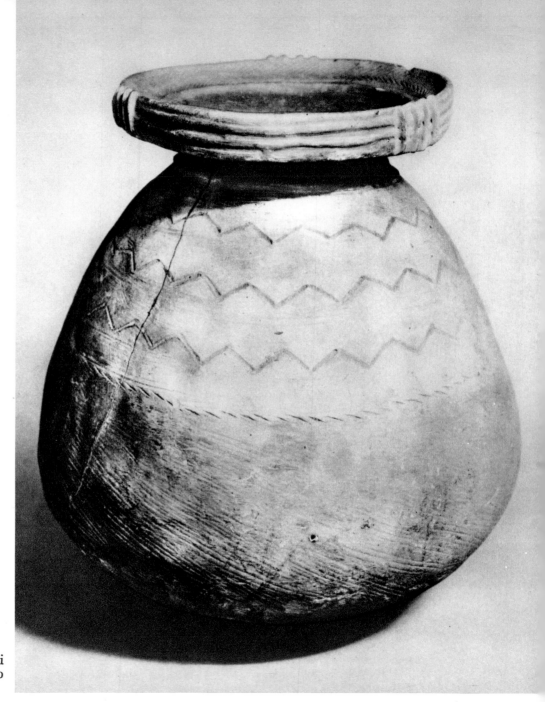

Plate 9. Red painted jar. Yayoi period. Collection of Kyoto University.

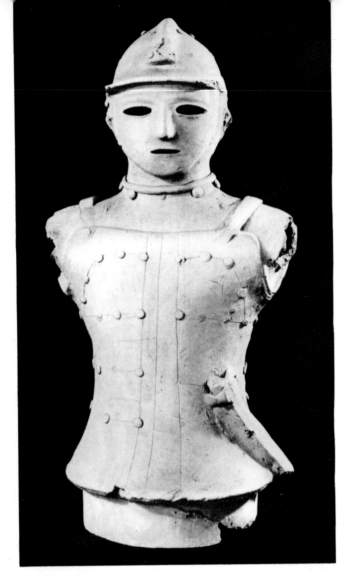

Plate 10. Haniwa warrior. Grave Mound period.
Tokyo National Museum.

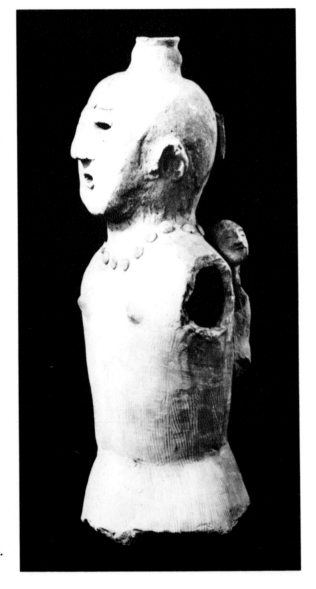

Plate 11. Haniwa figure of a lady. Grave Mound period.
Tokyo National Museum.

The Ceramic Art of Japan

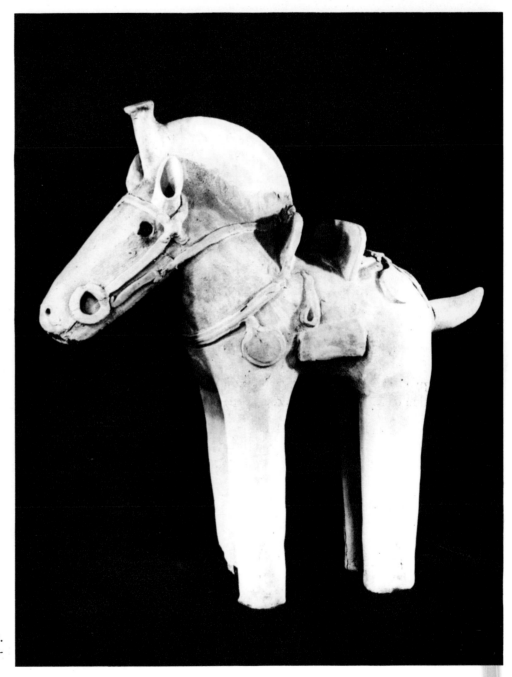

Plate 12. Haniwa horse. Grave Mound period. Tokyo National Museum.

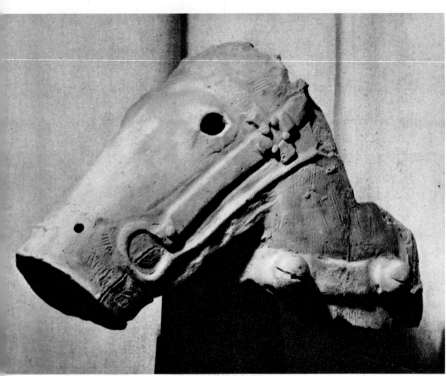

Plate 13. Haniwa horse. Grave Mound period. Collection of Mr. and Mrs. J. W. Alsdorf, Chicago.

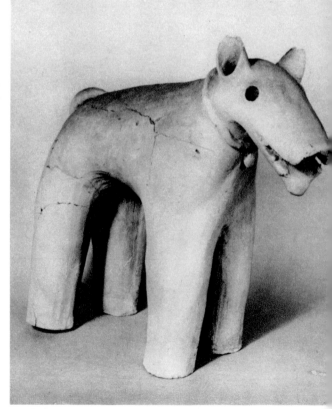

Plate 14. Haniwa dog. Grave Mound period. Tokyo National Museum.

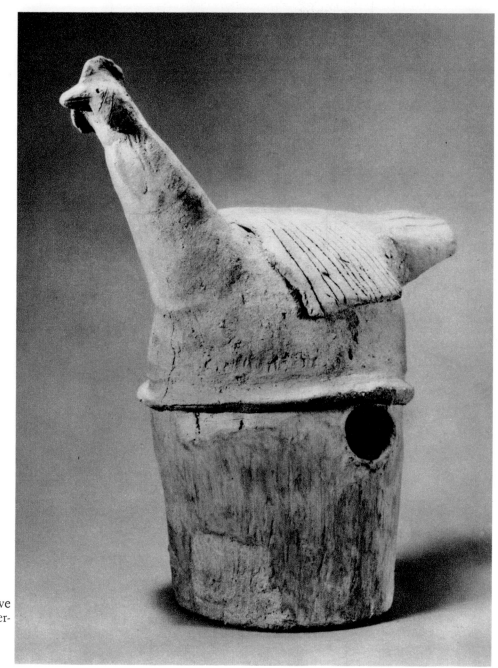

Plate 15. Haniwa bird. Grave Mound period. D'Arcy Galleries, New York.

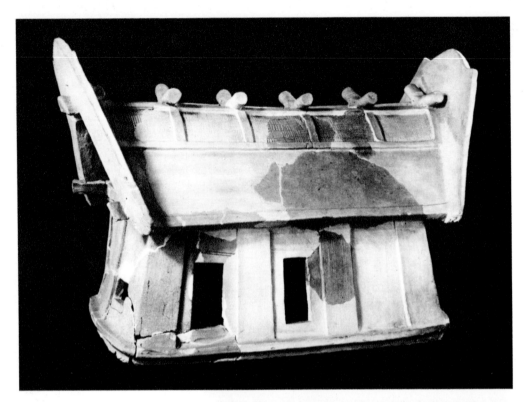

Plate 16. Haniwa house. Grave Mound period. Tokyo National Museum.

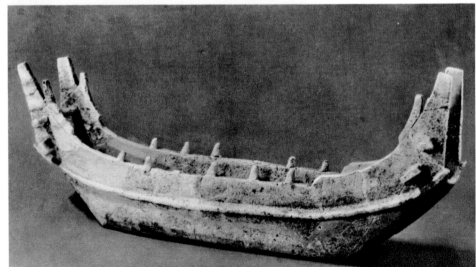

Plate 17. Haniwa boat. Grave Mound period. Tokyo National Museum.

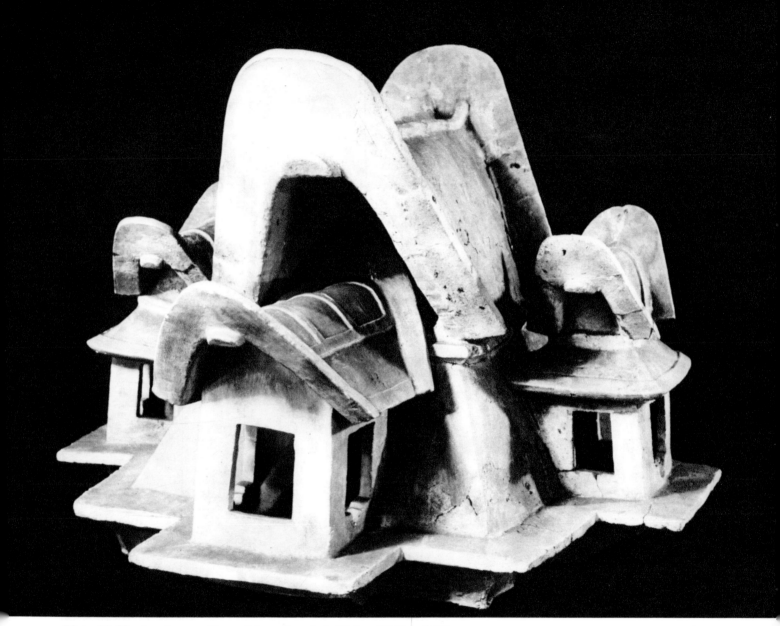

Plate 18. Haniwa house. Grave Mound period. Tokyo National Museum.

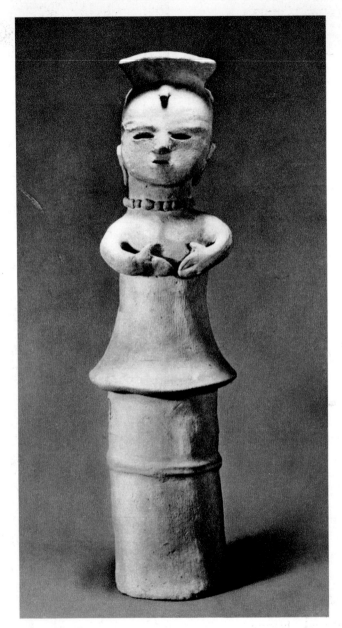

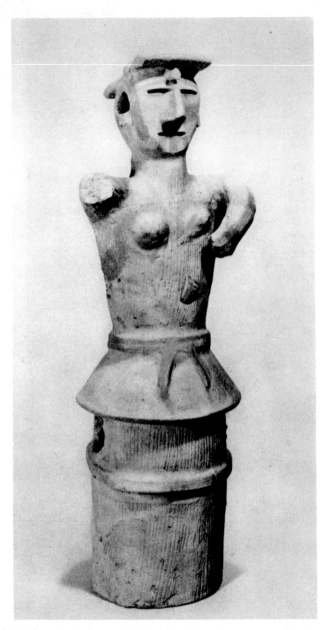

Plate 19. Haniwa figure of a lady. Grave Mound period. D'Arcy Galleries, New York.

Plate 20. Haniwa figure of a lady. Grave Mound period. Collection of Mr. and Mrs. J. W. Alsdorf, Chicago.

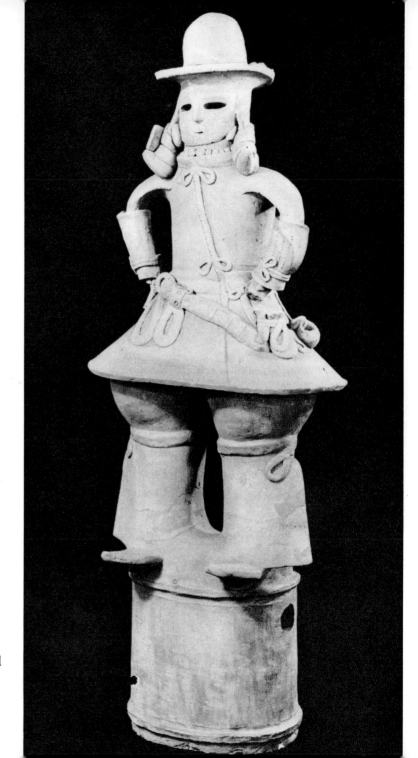

Plate 21. Haniwa warrior. Grave Mound period. Tokyo National Museum.

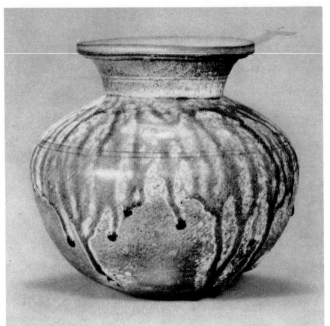

Plate 23. Sué jar. Nara period. Private collection, Tokyo.

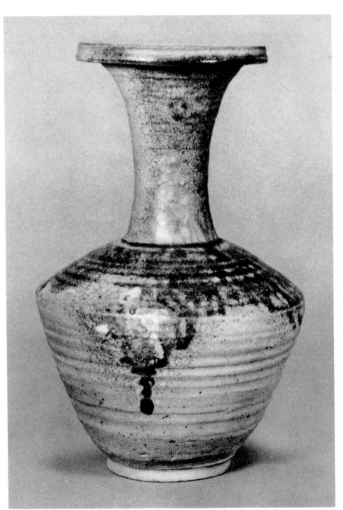

Plate 22. Sué jar with long neck. Early Nara period. Private collection, Tokyo.

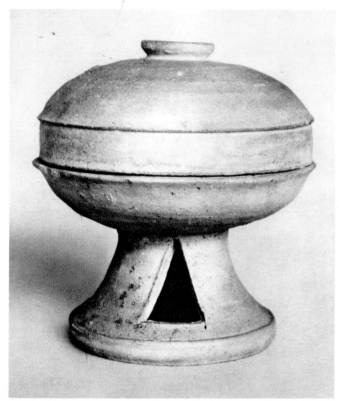

Plate 24. Sué covered dish. Grave Mound period. Tokyo National Museum.

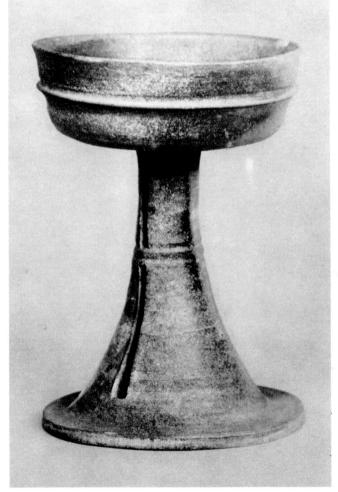

Plate 25. Sué cup with long stem. Grave Mound period. Tokyo National Museum.

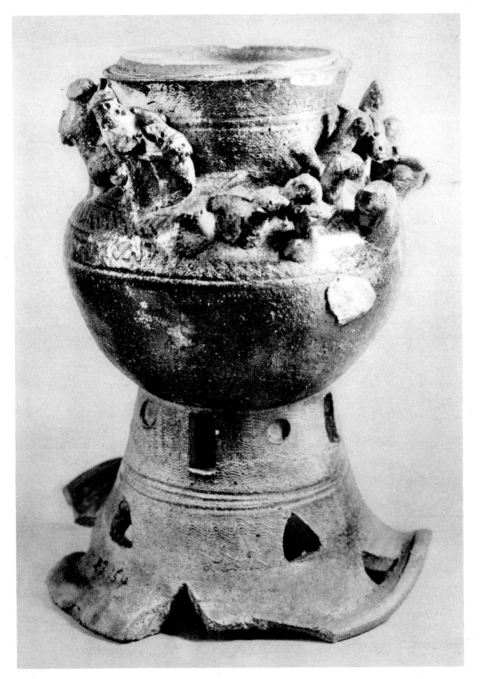

Plate 26. Sué jar with sculptured figures. Grave Mound period. Tokyo National Museum.

5 The Beginnings of the Japanese Ceramic Industry

FOR THE development of Japanese ceramics, as for practically every other aspect of Japanese culture, the decisive turning point came in A.D. 552, when Buddhist emissaries from Korea reached Japan. Although both Korean and Chinese immigrants had arrived before that time, and the pottery of the grave mounds and Sué ware had reflected continental influence, it was only now that the great civilization of China became fully known and began to transform the entire Japanese civilization. This contact at first took place with Korea, but under the famous Buddhist patron, the Prince-Regent Shotoku Taishi, direct contact was established with the Middle Kingdom itself. The first official emissaries were sent to China in 607, and during the following decades Japanese envoys, priests, interpreters, and students traveled between China and Japan. China had been reunited during these years after centuries of division, and, first under the house of Sui and then under the glorious rule of the T'ang dynasty (618–908), enjoyed unprecedented power and prosperity. Among the Koreans and Chinese sent to Japan were many artists and craftsmen who helped in the erection of the great Buddhist temples and the making of sacred images and paintings; young Japanese in turn were sent to the mainland to study the arts of the great culture that flourished there. Since the Chinese civilization of the day was probably the most highly developed and remarkable in the world, it was not surprising that it should exert a tremendous influence on that of the far more primitive and backward island country, and it would not be false to say that basically the Nara culture is a reflection of that of T'ang China.

The great influence of Chinese culture on Japan is particularly clearly seen in the art of the Asuka (552–646) and the Nara (646–794) age, so named for the location of the capitals of the respective periods. While very little pottery from the Asuka period has survived and what little there is would suggest that the ware of this age

was a further development of Sué ware, Asuka sculpture and architecture were deeply influenced by continental models. But with the Nara period the full impact of the marvelous pottery of T'ang China makes itself felt. The most important innovation is the introduction of colored glaze which could now be manipulated by the potter instead of being dependent upon the natural action of the ashes during the firing. Numerous ceramic objects from this period have been preserved in the Shoso-in, the storehouse of the great Buddhist temple of Todai-ji in Nara, and others have been excavated at temple sites, so that our knowledge of the ceramic history of this age is rather complete. Since the treasures of the Shoso-in were dedicated in 756, at the death of the Emperor Shomu, by his widow the Empress Dowager Komyo, we have an accurate dating of the objects that has proven helpful in reconstructing the history not only of Japanese but of Chinese ceramics as well. A detailed and accurate description of the articles deposited in the Shoso-in in honor of the great Buddha Vairocana was made at the time. Some ten thousand individual items have been counted in the entire collection, and what is most amazing is that this collection has remained *in situ* for some twelve hundred years with only the most minor changes taking place over the centuries. Because of this, the treasures of the Shoso-in represent the most remarkable study collection of ancient art objects from this period to be found in Japan or, for that matter, anywhere else in the world.

Among the numerous ceramic objects preserved in the Shoso-in, the most valuable pieces, both from an artistic and from a historical point of view, are the glazed pottery vessels, which number fifty-seven in all: twenty-five bowls, twenty-nine plates and dishes, one drum body, one vase, and one miniature stupa or Buddhist reliquary. This pottery was baked at a high temperature and glazed in green, yellow-brown, and white. Some of these wares are three-colored, as is common in T'ang ware, but most are either monochrome, green and yellowish brown, or green and white. The pattern usually consists of streaks and spots of color similar to those of T'ang ware. All together, three of the objects have three colors, thirty-four have two colors, and seventeen have only one color. Since these wares so closely resemble those made at the same time in China, a great deal of discussion has been devoted to their origin. Most Western scholars have tended to ascribe them to Chinese craftsmen and believe that they must have been brought to Japan as gifts from the T'ang court, while Japanese scholars, especially in recent years, have tended to think that they were made in Japan itself, either by Japanese craftsmen imitating Chinese models or by Japanese potters trained by Chinese immigrants. The evidence produced by Japanese scholars seems very convincing, for they point out that the clay used in the Shoso-in pieces is rough and grayish in contrast to the clay used in the Chinese wares and is also similar to the clay used in the roof tiles of the Nara period. Furthermore, the glaze is somewhat muddied—not clear and smooth like T'ang glaze: a reflection of the less developed technique of the Japanese potters. The

Shoso-in pieces also show a very painstaking and careful treatment in contrast to the freedom and boldness found in their Chinese counterparts, which again suggests unskilled copyists rather than mature and highly skilled potters. Other points made are that the Japanese used no cobalt but mostly green and that the shapes employed are very limited in comparison with the great variety found among the T'ang wares.

Additional pieces of the same type, which are also of very fine quality (*Plate 27*), have been excavated in tombs and at temple sites, but most of these are unfortunately in very imperfect condition. The most common among them are the green-glazed wares, which are found in many places (*Plate 28*). It would therefore appear that there had grown up during this period a native ceramic industry which, although it followed Chinese models, was able to produce colored glazed wares of its own. It is believed that the kilns were located in the neighborhood of Nara and Kyoto and that this pottery was manufactured primarily for the imperial court and Buddhist temples closely related to the imperial house. At the same time Sué ware continued to be made for daily use as well as for ceremonial occasions. This is clearly seen from the finds at the sites from this period in the northern and central sections of the country. Even in the collection of the Shoso-in some examples of this type of ware may be found.

The finds of green-glazed pottery and the presence of two- and three-color wares as well as Sué ware in the Shoso-in collection make it apparent that these two major types of pottery existed side by side during the Nara period. Sué pottery was common ware made at a variety of local kiln sites and was used widely throughout the country, while a more refined glazed ware represented the sophisticated modern Chinese taste of the court and was made only at special kilns near the capital and under the supervision of foreign craftsmen who introduced the style and the technique developed in T'ang China. Little connection seems to exist between the two kinds of pottery, although some of their shapes have certain similarities. It is interesting, however, to note that whereas Sué ware continued to be made at local kilns for many centuries and must be looked upon as the ancestor of such pottery as Iga, Shigaraki, Bizen, Tokoname, and Tamba, the three-colored wares died out when the Chinese influence began to wane.

The culture of the ninth century—the Jogan or early Heian period (so called because the capital was moved from Nara to Heian-kyo, the present Kyoto)—continued to reflect the influence of T'ang China. The few ceramics surviving from this period show that the green lead-glaze ware of the Nara period was still made, but the forms are fuller and rounder and less self-conscious. Numerous tiles from the imperial palaces and temples of the time indicate that the green-glazed pottery was also used in connection with architecture. At the same time Sué ware continued to be made as well, and hundreds of kiln sites where this type of ware was made have been found all over Japan, from Tohoku in the north to the tip of

Kyushu in the south. The development of the natural wood-ash glaze during early Heian resulted in the production of some splendid pieces (*Plate 29*).

In addition to these older methods of ceramic manufacture, a new type of ware, namely celadon, was introduced into Japan during this age. The place of its manufacture was Owari Province (now Aichi Prefecture), in the neighborhood of Seto, which was to become the center of the Japanese ceramic industry. These early celadons are therefore referred to as Owari *seiji* in contemporary records, but they could not have developed very much as yet, and it is doubtful if any of them have survived. This development was interrupted when the Japanese government in 898 decided to send no more embassies to China, since that country was in chaos and Japan felt that she had little to gain from continued intercourse with her erstwhile teacher. This later phase of the Heian period, lasting until 1185, is often referred to as the Fujiwara period after the ruling family of the time. Although a great age in many respects, especially in regard to painting and literature, this was a period of decline in the art of the potter, for the ceramics of the age were inferior in quality and crude in workmanship, while the art of lacquer flourished greatly.

With the establishment of the military dictatorship by Minamoto Yoritomo and the renewed contact with China, all this changed at once. The new age is known as the Kamakura period (1185–1333) because the capital was moved to the seaside town of Kamakura in eastern Japan, not far from the present-day Tokyo. It was during this period that the Japanese ceramic industry as we know it today was established, and that Seto, now a suburb of Nagoya, became the most important center of ceramic production. In fact, up to today the Japanese refer to all pottery as *setomono* or Seto ware. The impetus for the renewed vitality of Japanese ceramic production came once more from China, where in the meantime the Sung dynasty had come to power. In the eyes of most critics, the ceramic output of Sung China is the finest ever made, and it is not surprising that the Japanese should have been deeply impressed with the wonderful Sung celadons and other stonewares and porcelains that reached their shores. Collections of these wares were formed by Japanese enthusiasts, and even today many fragments of Sung vessels may still be found in the neighborhood of Kamakura and other cultural centers of the time. Among the Chinese wares the most popular were the celadons, such as *lung chüan*, known in Japan as *seiji* (blue-green porcelain) because of their greenish color; *yin-ch'ing*, known in Japan as *sei-hakuji* or white celadon, its whiteness being tinged faintly with blue or greenish blue; *chien*, a heavy, rather coarse brown-and-black stoneware called *temmoku* in Japanese and much prized by the tea masters; and white porcelains of the Ting type. Another kind of porcelain greatly admired at the time was the inlaid celadons made in Korea under the Koryo dynasty and therefore known as *korai* ware in Japan.

The ceramics produced at Seto under the Chinese impetus show the marked influence of the continental models but at the same time, especially in their designs,

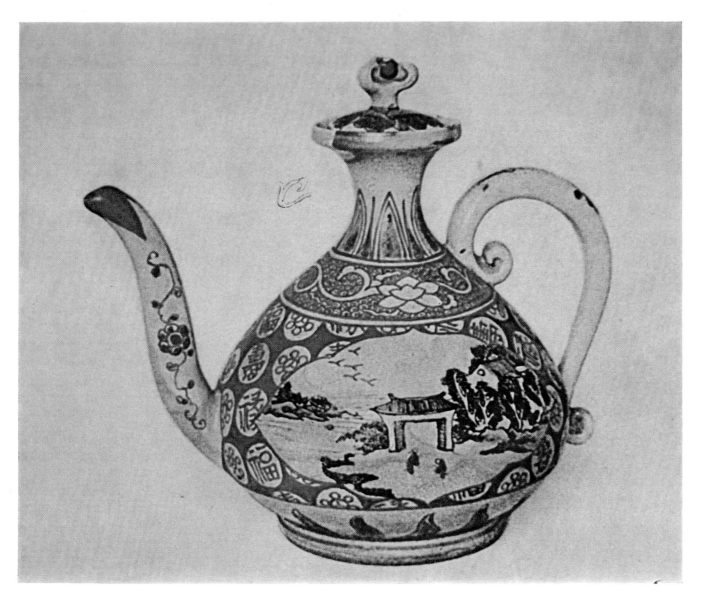

Color Plate 8. Banko ewer. Middle Edo period. Collection of Takeuchi Kimpei, Kanagawa Prefecture.

are very original. The glaze is usually yellow or amber, an imitation of celadon glaze that, because of the tendency to fire with oxidizing flames, was apt to turn yellow. It was therefore called Ki-Seto or Yellow Seto, and pottery of this name is still being made today in imitation of the old wares. At a somewhat later phase of the Kamakura period, green, brown, and blackish-brown glazes were developed, and it is the ware of this type that is known as Ko-Seto or Old Seto. This latter type of pottery is usually associated with the Seto kilns and continued to be manufactured there for many centuries; since it was produced on a large scale and distributed all over Japan, it became well known throughout the country. Most remarkable is the great variety of shapes employed by the Seto potters, including such popular vessels as jars of all types, pots, pitchers, bottles, vases, incense burners, tea bowls, and even figures in the form of lion-dogs which were placed as guardians in front of temples or shrines (Plate 31). From an artistic point of view the chief feature of these wares was the beauty of the designs incised on their surface (Plate 30). Most common are the floral designs of all kinds, such as lotus flowers, peonies, and chrysanthemums executed in bold linear patterns on the grayish-white body of the vessels and covered with a transparent glaze. Another technique employed was that of impressing upon the surface of the vessel designs showing abstract geometric patterns as well as floral forms (Plate 34).

Among the potters of the period the most famous is Kato Shirozaemon Kagemasa, better known as Toshiro. Japanese tradition has it that he was founder of the Japanese ceramic industry. Modern scholarship has tended to discredit this story and suggests that Toshiro, if he existed at all, lived at a much later date. This may well be so, though the enthusiasm for critical evaluation of traditional accounts often leads the younger Japanese scholars to disregard as mere legend stories that do have some basis in fact, even if they have become distorted and embroidered over the centuries. The facts are that Japanese ceramic manufacture did take a decided upturn during the thirteenth century; that this took place under Chinese inspiration; and that a potter family by the name of Kato worked in Seto for some twenty-seven generations, coming to an end only when the last descendant of Toshiro, Kato Soshiro (known as Shuntai), died in the tenth year of Meiji (1878), thereby closing this long and distinguished line of potters. It was his ancestor, according to tradition, who went to China in 1223 in the retinue of the priest Dogen and stayed there for six years visiting various kiln sites such as Jao-chou, Tz'u-chou, and above all Ch'üan-chou, where *chien* or *temmoku* ware was made. It is further reported that after his return he searched for a suitable place where porcelain clay could be found and settled down in Seto. He is therefore looked upon as the founder of the Japanese porcelain industry, and several *temmoku* tea jars are attributed to him. Even if these claims are exaggerated and the tea jars in question are of later date, which seems likely, the substance of the story may nevertheless be correct, although the first celadons were actually made during the Heian

period, and, strictly speaking, Toshiro cannot have been the founder of the Japanese ceramic industry.

Another kind of ceramic ware which flourished during the Kamakura period was the Tokoname ware made in the region of the Chita Peninsula south of Nagoya. It is a very naïve and artless pottery with soft broad forms and a natural wood-ash glaze that drips over the outer surface of the vessel in a very spontaneous and often beautiful way. The shapes employed are usually large water jars or other types of jars with wide mouths intended for the daily use of the ordinary people. Although Tokoname ware can be traced back to the later part of the Heian period, its finest productions were made during the Kamakura period; it also continued into later times and was much admired by the tea masters for its simple rustic charm (*Plate* 32). Other local kilns making common wares that began to flourish during the Kamakura period were Bizen and Shigaraki. The productions of the former kiln, which is located in Okayama Prefecture, are very similar at this early age to those of Tokoname, while the Shigaraki wares, which are made in Shiga Prefecture, are more severe in shape and design, often employing geometric incised designs consisting of parallel crossed lines (*Plate* 33). Whereas the Seto wares represented a more refined and highly developed kind of taste, these wares made at the local kilns were crude and unpretentious, but it is exactly for this reason that they appeal to us today.

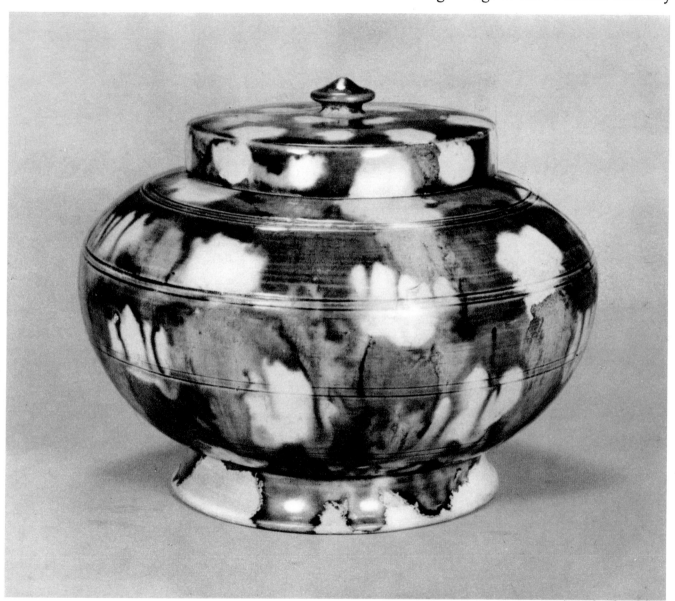

Plate 27. Three-colored jar. Nara period. Collection of the late Kobayashi Kokei.

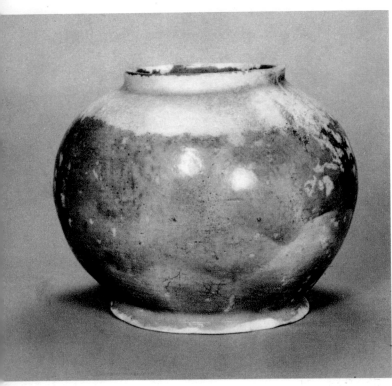

Plate 28. Green-glazed jar. Early Heian period. Kyoto Museum.

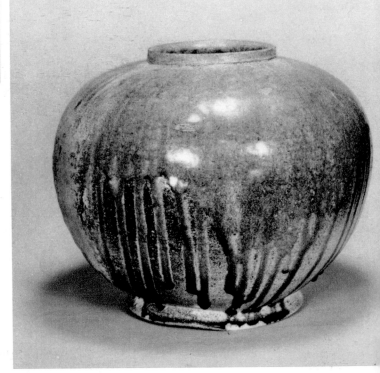

Plate 29. Jar with wood-ash glaze. Early Heian period. Private collection, Japan.

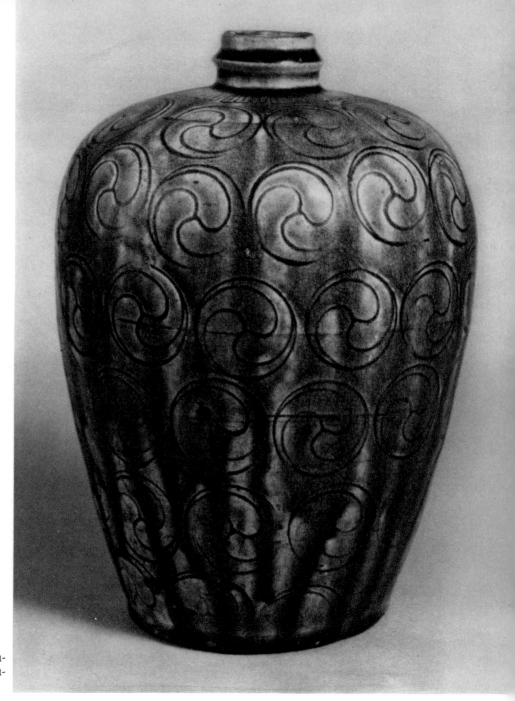

Plate 30. Brown-glazed jar. Kamakura period. Collection of Aso Takakichi, Tokyo.

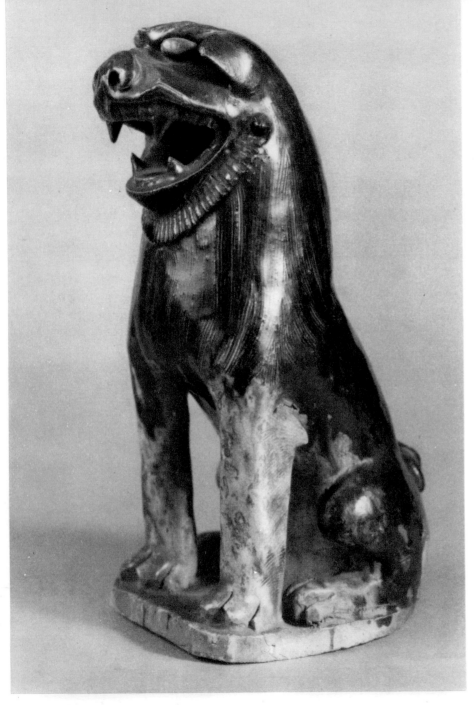

Plate 31. Seto figure of lion-dog. Kamakura period. Collection of Okabe Chokei.

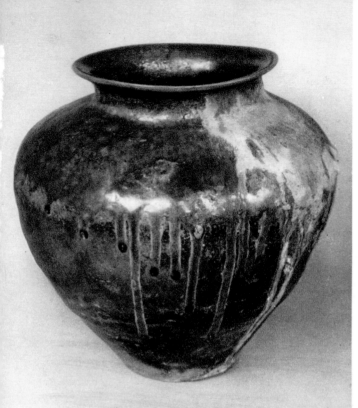

Plate 32. Tokoname jar. Kamakura period. Collection of Keio University, Tokyo.

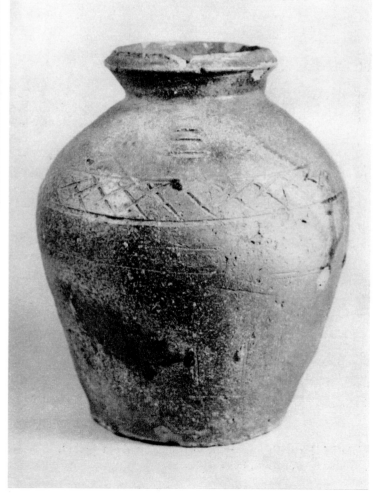

Plate 33. Shigaraki jar. Muromachi period. Collection of Matsunaga Yasuzaemon.

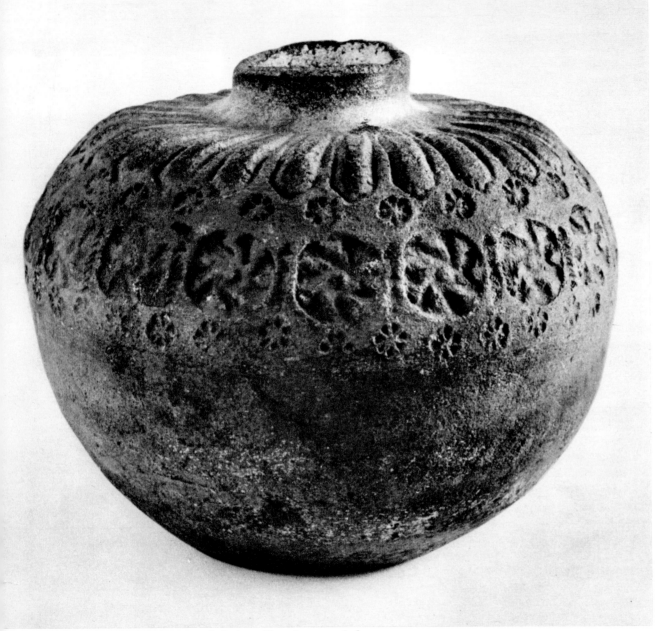

Plate 34. Jar with impressed design. Kamakura period.
Carlebach collection, New York.

6 The Tea-Ceremony Wares
of the Momoyama Period

THE MUROMACHI period (1334–1573), during which the Ashikaga shoguns ruled the country, was not very productive as far as ceramics were concerned. Civil war raged for much of the time, and a weak and ineffective rule proved disastrous. Only in the fifteenth century did Japan enjoy several generations of peace during which the arts flourished. Two of the Ashikaga rulers in particular, the shoguns Yoshimitsu (1358–1408) and Yoshimasa (1435–90), were great patrons of the arts, and it was under their encouragement that Chinese ink painting and Zen Buddhism became popular. The climax of this age of aesthetic refinement and luxury took place in the Higashiyama period, so called because the Silver Pavilion, which Yoshimasa erected as a place of retreat, was located in the Higashi-yama or eastern section of Kyoto.

From the point of view of the history of Japanese ceramics, the most important aspect of this cultural renaissance was a passion for the tea ceremony, which had become fashionable among the Kyoto aristocracy of the time. This development was to prove tremendously important for the Japanese ceramic industry, and it might well be said that the new impetus it received during the sixteenth and the early seventeenth century was due largely to this cult. During the Ashikaga period the tea implements were almost exclusively of Chinese origin, but the need for such utensils and the interest in ceramics that could be used in the tea ceremony proved to be a very powerful stimulus for the native industry as well. The center of the industry was located in Seto, and the style of this early Japanese tea ware closely followed that of the Chinese models (*Plates 35 and 36*).

It is difficult to summarize the tea ceremony or *cha-no-yu*, as it is called in Japan, in a few words. Japanese tea masters will tell you that it took them ten or twenty years to master it, and a large literature exists about it both in Japanese and in

Western languages. Romantic enthusiasts assert that it is one of the best aspects of Japanese culture, while others decry it as empty formality and meaningless ritual. In its simplest form it is merely the getting together of a few friends for the purpose of drinking powdered tea in a plain room and discussing the merit of the utensils employed. It derived from Zen Buddhism, and it was the Zen masters who introduced it from China. In Japan the Zen monk Shuko is credited with being the founder of cha-no-yu in its present form. Yet as the nobility took it up it became more elaborate, both in the ritual observed and in the objects used in performing it. The utensils employed by Yoshimasa are still preserved today under the name of Higashiyama pieces and are regarded as great national treasures. Among them are famous Chinese paintings by the great masters of the Sung and Yüan periods and tea bowls and tea jars like the famous Koga jar, which had been brought back from China in 1227 by the Zen monk Dogen. This close association between art and the tea ceremony has continued to the present day, and although many other artistic influences and fashions have prevailed since the Muromachi period, the taste of the tea masters has continued to exert a powerful influence on Japanese culture. It may best be described by the Japanese term wabi, which has the meaning of peaceful, simple, rustic, subdued—a spirit of restraint and lack of ostentation that permeates the thinking of the tea devotees and colors all of their artistic tastes.

While the Ashikaga tea devotees were largely to be found among the Zen priests and court circles, during the subsequent brief but tremendously important Momoyama period (1573–1615), the tea cult spread to the military classes and rich merchants. Most prominent among the chajin was Sen-no-Rikyu, still revered today as the most accomplished of all tea masters. His main maxims were to avoid all luxury and ostentation and to emphasize harmony, reverence, purity, and calm. Once when someone asked Rikyu what the mystery of the tea ceremony was, he replied in characteristic Zen fashion: "You place the charcoal so that the water boils properly, and you make the tea to bring out the proper taste. You arrange the flowers as they appear when they are growing. In summer you suggest coolness and in winter cosiness. There is no other secret." Quiet simplicity and naturalness were what he was always striving for, both in the tea ceremony itself and in the utensils used in connection with it, and it was he who was responsible for choosing the simple Korean peasant rice bowl for the drinking of the powdered green tea. Rikyu, in contrast to the later tea masters, cared nothing for antiques or rare and valuable items but was quite content to use any bowls that were handy, provided they corresponded to his standard of beauty. Once when he came across a group of noblemen examining tea vessels in Hideyoshi's palace and discussing their age and value, Rikyu interrupted them with these words: "Really, sirs, this is most unbecoming talk. The connoisseurship of tea vessels consists in judging whether they are interesting and suitable for their purpose or not, and whether they combine well or badly with each other, and has nothing to do with their age at all. This is

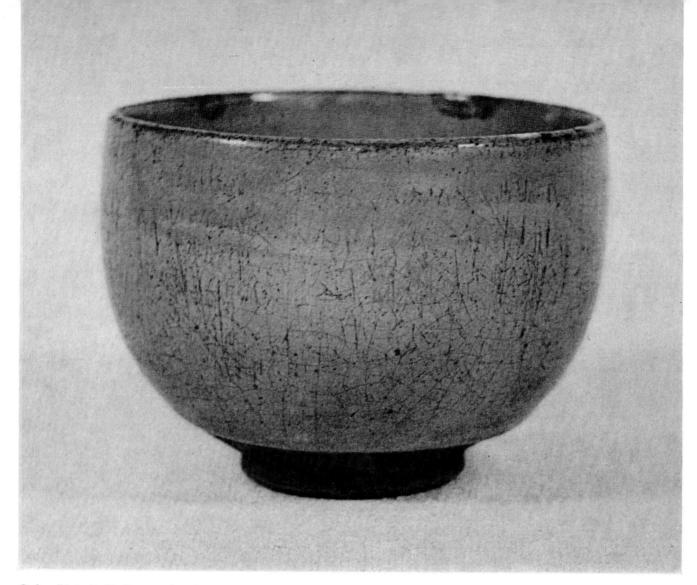

Color Plate 9. Fujina tea bowl. Late Edo period. Collection of the author.

the business of curio dealers and ought to be beneath the notice of men of taste."

The reason *cha-no-yu* proved so important for the development of the Japanese ceramic industry was that many of the utensils in the tea ceremony were made of pottery or porcelain. First of all was the *chawan* or tea bowl itself, which could take many different shapes, depending on the occasion and the potter. A large tea bowl was usually employed for the thick pasty tea known as *koicha*, while a smaller one was used for *usucha*, a thinner foamy tea. Shallow bowls were preferred for the summer, while deep and heavy bowls were preferred for the winter. Next to the *chawan*, the most important vessel was the tea jar or *cha-ire*, also called *chaki*. It is a small jar, usually made of pottery with an ivory cover, in which the green tea powder is kept. Whereas the *chawan* is always made of ceramic ware, the *cha-ire* may also be made of lacquer. These two are the most important, but numerous other ceramic utensils may be employed. There is the *mizusashi* or water jar, a receptacle for fresh water used while making the tea, often made of heavy coarse pottery; the *koboshi* or *kensui*, a low, broad basin used for waste water; and the *futaoki*, a small piece of pottery, bamboo, or metal which serves as a rest for the ladle or cover of the kettle. In addition to these articles for the serving of the tea itself, there are numerous other ceramic pieces used in connection with the tea cult. There are the trays, cake dishes, and covered bowls for the light meal or *kaiseki* served before the tea; there are the vases for flower arrangements which are usually placed in the tokonoma or suspended from a post; there are the little incense containers and incense burners often in the shape of an animal or plant; and there are the tools and pots for making the fire. All of these may be made of ceramics and are often of great beauty. The most celebrated utensils with specific names and long histories are known as *meibutsu* and regarded as national treasures by the Japanese people because of their historical association as well as their artistic excellence.

At first all the utensils used for *cha-no-yu* were of foreign (largely Chinese) origin, and to this day some of the most famous tea bowls and tea jars are Chinese and are therefore referred to as *karamono* (from *kara*, meaning Chinese or foreign). Interestingly enough, the small jars that now serve as tea caddies were originally used as receptacles for oil, medicine, and perfume. They are of dark-brown or persimmon color and possess that subdued elegance admired so much by the tea masters. Japanese tea jars are usually referred to by the name either of the potter or the kiln at which they were made, while those of Chinese origin are classified by shapes, such as *katatsuki* or shouldered jar, *nasubi* or eggplant, *shiri-fukure* or bulging bottom, *bunrin* or apple, *uri* or melon, and *taikai* or great ocean. The Chinese tea bowls are usually either *chien-yao* (*temmoku* in Japanese) or celadon and are beautiful to look at but do not lend themselves as well to tea drinking as the softer Japanese wares. The Japanese admired particularly the *temmoku* stoneware bowls with silvery spots known as oilspots and thick purplish glaze often mottled with brown.

The other country from which the Japanese imported ceramic wares for the tea ceremony was Korea. In fact, no other tradition has exerted such a strong influence on the ceramic taste of the tea masters. The wares they admired were actually not intended at all for the tea ceremony but were ordinary rice bowls used by the Korean peasants. It was exactly this quality of simplicity and coarseness that appealed to Rikyu and his followers and that made these cheap wares—produced in roughly constructed kilns by poverty-stricken people—so attractive to the *chajin*. These bowls are usually uneven and completely unsophisticated, the natural accidents of firing often misshaping the form and marring the glaze, but it was precisely this quality that the tea masters liked so much.

Both Nobunaga and Hideyoshi, the famous military dictators of this age, were passionate devotees of *cha-no-yu* and patrons of Sen-no-Rikyu. They were also avid collectors of precious tea utensils and gave elaborate parties to which the most prominent men of the time were invited. How important the tea ceremony was in the eyes of these great military leaders is best indicated by the fact that Hideyoshi found time to hastily build a tearoom at Yamazaki and drink tea while he was engaged in an important military campaign, and we are told that many of his officers carried tea bowls and tea jars with them when they went to war so that they could prepare and drink tea on the battlefield. There were also numerous occasions when generals were rewarded with the gift of a celebrated tea jar instead of a sum of money or a fief.

Most spectacular of all the famous entertainments were Hideyoshi's tea parties, the grandest of which took place at Kitano near Kyoto in 1587, when all the tea masters of Japan were invited, all the famous utensils were shown, and all people without distinction of class were welcome to come and bring their utensils. Some five hundred and fifty tea masters assembled in a one-mile-square area and vied with each other in the mastery of their art and the display of their treasures. Immense crowds of spectators watched the proceedings, and Hideyoshi himself appeared and made tea with his own hands. After serving it to some special guests, he made the rounds of the various tea masters and tasted their tea as well, without regard to their rank or possessions. The event was scheduled to last some ten days to enable people from all over the empire to attend, but a military rebellion broke out in Higo, and Hideyoshi was forced to terminate the meeting. Even the one-day affair aroused joy and enthusiasm among the people.

The increased demand for tea-ceremony utensils could soon no longer be satisfied through Chinese importations, and Japanese potters began to make *cha-no-yu* wares during the late Muromachi and the Momoyama period. Since there had been an old tradition of making glazed wares at Seto, this town, not far from the present-day industrial city of Nagoya, became the center of the activity. During the second half of the sixteenth century Seto potters began making bowls and tea jars in imitation of imported Chinese ones. The glaze of the *cha-ire* was usually brown,

varying in tone from light to dark, and the shapes also imitated those of the continental models *(Plate 37)*. The tea bowls showed a greater variety, those of *temmoku* and thick white glaze being the most popular. Up to that time tea bowls had only been made for use in Zen temples and at court, but now they were made specifically for use in the tea cult.

With the advent of the Momoyama period, this development found enthusiastic encouragement on the part of the military rulers of the time. We are told that Nobunaga himself made the rounds of the Seto kilns and appraised their products, selecting six potters for special honors and designating them as the Six Masters of Seto. The most important type of tea-ceremony wares now developed at Seto were Ki-Seto or Yellow Seto and Seto-Guro or Black Seto. The first was an improved version of the light yellow-glazed wares of the Kamakura period with a thicker opaque glaze and simple incised designs partly colored in green and brown *(Plates 38–40)*. The shapes are varied, including all types of bowls, dishes, incense containers and burners, vases, and even water jars in the shape of drum bodies. This pottery is outstanding both for the subtle beauty of its color and for the elegance of its designs. Black Seto on the other hand consisted largely of tea bowls which, through their simple strong shapes and deep black color, achieve a powerful effect *(Plate 41)*. Both of these wares are referred to as Seto ware, but they are actually made at the Mino kilns in present-day Gifu Prefecture, which are located near Seto and are considered part of the Seto establishment.

The most original contribution of the Mino kilns, looked upon by many critics as the finest tea-ceremony pottery, are the Shino and Oribe wares, Although both of these continued to be made during the Edo period, they were at their best during Momoyama and early Edo, for later wares show a marked decline. Shino ware is supposed to derive its name from that of the famous tea master Shino Shoshin, who was the first to recognize its great beauty. It is a heavy, coarse pottery with a thick creamy white glaze of wonderful attractiveness *(Plate 42)*. Particularly fine also are the freely rendered abstract designs of flowers, plants, and landscapes *(Plates 43 and 44)*. These are executed in brownish iron glaze and add greatly to the over-all effect. A great number of shapes are found among the Shino wares, but the tea utensils such as bowls, water jars, dishes, plates, flower vases, and incense containers are the most common. In addition to the plain white and the painted or E-Shino, there are two other kinds of Shino: Nezumi-Shino (Gray Shino) and Beni-Shino (Red Shino). Both of these are engraved wares in which the white paste is covered with a dark-brown slip upon which delicate patterns are incised and shown in white. After this the white glaze is applied, making it appear gray or, in the case of Beni-Shino, reddish by the addition of a reddish glaze. Particularly fine are the shallow dishes with bird and grass designs, which combine beauty of color and shape with an elegant abstract design *(Plates 45 and 46)*.

Oribe, which is closely related to Shino and developed out of it, is unique for

the boldness of its designs and the lovely green glaze which usually covers half the surface of the vessel. It is named after the famous tea master Furuta Oribe, who succeeded Rikyu as the arbiter of taste. Combining strength with decorative beauty, Oribe ware is very typical of the Momoyama period and is perhaps the most characteristically Japanese of all the tea wares. The earliest Oribe pieces can hardly be distinguished from Shino and are therefore called Shino-Oribe, but the mature Oribe wares, especially those with brilliant abstract designs known as E-Oribe (painted Oribe), are very distinct from Shino or any other type of ware *(Color Plate 1)*. Their most remarkable feature is their free and inspired decorative design, which is executed in brown oxide and employs all kinds of patterns taken from flowers, grasses, fruits, landscapes, textiles, and geometric figures *(Plates 47 and 48)*. The shapes in which Oribe ware was fashioned were many, including such unusual ones as candleholders representing early European visitors to Japan *(Plate 49)*, incense burners in the form of owls, covered bowls shaped like fans, and cake dishes in the shape of baskets *(Plates 50 and 51)*. In addition to the regular Oribe there are two special kinds of Oribe that proved popular: Black Oribe or Kuro-Oribe *(Plate 52)*, which is covered with a black glaze, and particularly Ao-Oribe, in which a bright-green copper glaze covers the entire body of the vessel. The patterns on this type of Oribe were usually engraved on the surface. Finally there is another type of Oribe which, though less common, is greatly admired by connoisseurs of Japanese ceramics—namely, Aka-Oribe or Red Oribe. For this ware a light-brown clay or a combination of brown and white clay patched together is used. On the brown ground the pattern is painted in white over which lines are drawn with brown oxide, while brown is used for the designs on the white ground. Part of the vessel may also be covered with a green glaze, as in Ao-Oribe. The technique employed in these wares is very intricate, but the result is often excellent.

The most famous of all Japanese tea-ceremony ceramics are the Raku wares, which were made by a family of Kyoto potters. The name Raku derives from a golden seal presented by Hideyoshi to Jokei, the second potter of the line, in memory of his father Chojiro. As its inscription, this seal bore the character *raku* (pleasure), the second component of the name of Hideyoshi's gorgeous palace, Jurakudai, where Chojiro had worked. All members of the main line of this famous family of potters used the Raku seal on their wares. So far there have been fourteen generations of Raku potters to carry on the tradition. In addition to the main kiln or *hongama*, there have been several collateral kilns, known as *wakigama*, where Raku ware is made.

The origin of the family is uncertain, but it is believed that Chojiro's father came from Korea and married a Japanese woman. It was the son of this immigrant who was the first great Raku potter and went by the name of Chojiro (1515–92). He was honored by the great tea master Sen-no-Rikyu by being given the master's own family name of Tanaka and being asked to make tea bowls for him. In the

eyes of Japanese critics, Raku reached its high point with Donyu, the third potter of the line, who was popularly known as Nonko (1599–1656). After that, it is usually conceded, Raku ware began to decline, although many of the tea utensils made during the next hundred years were still of good quality. It is always amazing to think that members of the same family have been making tea bowls of the same kind for over four hundred years and that the thirteenth potter of the line, Raku Seinu, died only in 1944. Though it has not been possible to maintain the same degree of artistic excellence over all these years, the very fact of such a tradition assures a measure of taste and craftsmanship that a more individualistic culture cannot guarantee.

The wares produced by this family have always been intended for the tea cere-mony, although the earliest members of the family also made roof tiles. Among the shapes produced, the most common and most admired are the tea bowls (*Plates 53–56*). Other types of vessels that have been made by the Raku potters are incense containers, tea jars, flower vases, and water jars (*Plate 58*). Individual pieces of Raku ware often have their own names, such as Big Black, which is considered Chojiro's masterpiece, Mellow Persimmon, Gold Moon, Five Mountains, and Fuji-san. The history of many of these pieces is recorded, so that they are valued for cul-tural and historical associations as well as for their intrinsic aesthetic appeal. There are three main types of Raku ware: Black Raku (the most common variety), Red Raku, and White Raku. The first has a thick brownish-black glaze (*Plates 57 and 59*); the second is reddish orange (*Plate 60*); and the third has a thick white glaze (*Plate 61*).

One of the characteristics of Raku ware is that the glaze is applied in many thin layers and allowed to flow down, often leaving part of the body exposed. A favorite device is to have the top layer of the glaze stop in wavy lines about halfway down the side. This is called curtain glaze or *makugusuri*. The quality the tea masters most value in Raku is its softness and its shape—so ideally suited for sipping tea. It is kneaded by hand and fired at a very low temperature, making a soft, light type of pottery. The shape is ideal for holding in one's hand, and the texture is pleasant to touch. The rim of the mouth and the base are irregular and natural, and this quality too is esteemed by the tea masters. The wall of the bowl is thick, so that it does not become too hot when handled. The shapes are strong and simple, especial-ly in the early pieces, yet elegant at the same time. Although indebted to Korea and China, Raku ware is unique, and it expresses the spirit of *wabi* to perfection.

Another type of pottery that originated during the Momoyama period and was favored by the tea masters was Karatsu ware. Of all the tea wares discussed here, it is the most Korean in style. In fact, one type of Karatsu, marked by the use of two different colored glazes, is called Chosen Karatsu or Korean Karatsu (*Plate 62*). The shapes, designs, and techniques employed by the Karatsu potters are indeed very close to those of the wares of the Yi dynasty. This is not surprising, for Karatsu is

a port in northern Kyushu not far from Korea, and a number of Korean potters were brought there by one of Hideyoshi's generals after the military expeditions to Korea in the late sixteenth century. Actually the pottery called Karatsu was made at a variety of local kilns and therefore differs greatly in glaze and design. Most famous and most characteristic are the E-Garatsu or Picture Karatsu wares, which have painted designs showing grasses, reeds, grapes, wisteria, and geometric patterns painted in brown oxide over a whitish slip (*Plates 63 and 64*). These designs are executed in a very free, spontaneous style and have a great appeal, especially to our modern taste. Derived no doubt from similar Korean designs, they are nevertheless distinctly Japanese in their decorative quality and their elegance.

Another kind of Karatsu had a thick white glaze like that of Shino and was therefore called Seto Karatsu, while a loquat-colored ware was known as Oku-Gorai. Also derived from Korea is the inlaid ware known as Mishima Karatsu, on the surface of which delicate designs showing flowers, plants, and birds are carefully incised and inlaid with white clay. Still another characteristically Korean device is that of using brush marks and comb-scratched patterns, which create very interesting and varied surfaces. This type of pottery is called Hakeme (Brush Mark) Karatsu. The best of these wares were made during Momoyama and early Edo, but Karatsu ware continued to be made up to modern times, the bulk of the production being intended for ordinary use.

With their preference for the crude and rustic, the tea masters soon discovered the unique beauty of the traditional wares made at the local kilns. In such wares they found the very essence of the *wabi* spirit, and they therefore commissioned the potters to make vessels for the tea ceremony. Outstanding among the traditional wares was the Bizen ware made at Imbe, not far from Okayama. The best period for Bizen is the late sixteenth and the early seventeenth century, and productions from this age are now referred to as Ko-Bizen or Old Bizen. Bizen is a hard brick-red stoneware without glaze that depends entirely upon its strong, simple shape and beauty of natural color for its effect (*Color Plate 2*). The shapes employed are those used for *cha-no-yu*, such as tea bowls, water jars, and plates (*Plates 65 and 66*). Particularly admired were the pieces with a delicate linear pattern on their surfaces achieved by covering part of the vessels with salt-dampened straw before baking. This type of Bizen is known as *hidasuki* ware.

Even cruder were the rustic wares of Iga and Shigaraki, two neighboring pottery villages located in the prefectures of Mie and Shiga. These wares are made of coarse clay containing much sand, which leaves marks on the surface, and are partly covered with a thick bluish-green glaze. The forms are crude and irregular, but the effect is powerful (*Plate 67*). The shapes preferred are flower vases and water containers, since the coarseness of the ware did not lend itself to the making of tea bowls.

The two other local kilns that became favorites of the tea devotees were Tamba

in what is now Hyogo Prefecture, and Tokoname, in Aichi Prefecture. Tamba is perhaps best known for its heavy brown bottles and pepper jars—very popular during the Edo period—while Tokoname wares were mostly large jars made of rough clay in strong shapes and interesting textures.

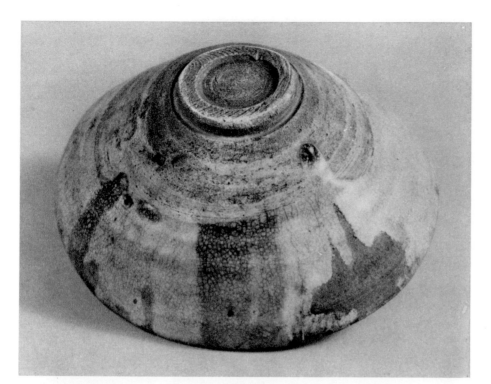

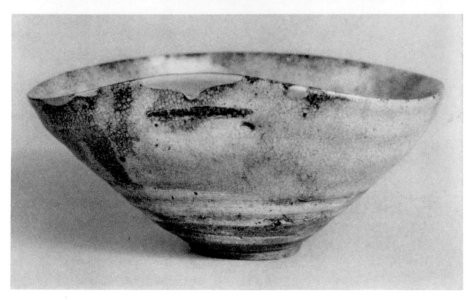

Plate 35. Yellow Seto tea bowl. Muromachi period. Collection of Nishida Yoshitaka.

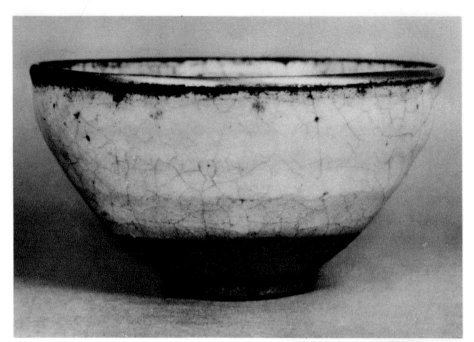

Plate 36. White *temmoku* tea bowl. Muromachi period. Private collection, Japan.

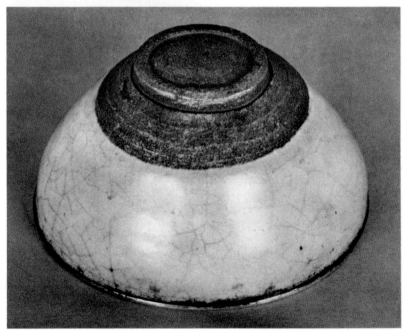

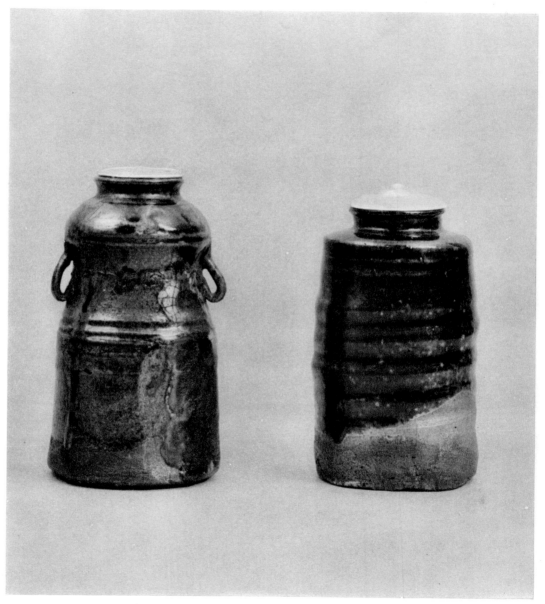

Plate 37. Tea jars in Shino-Oribe (left) and Seto (right) style. Momoyama period. Collection of T. Rosenberg, New York.

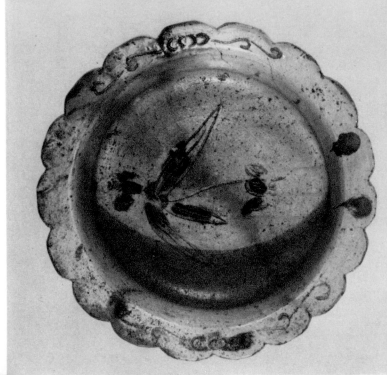

Plate 38. Yellow Seto dish. Momoyama period. Collection of Yoshizawa Saburo, Tokyo.

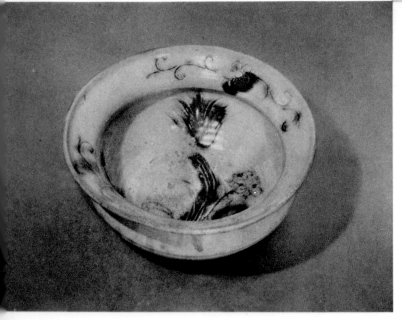

Plate 39. Yellow Seto bowl. Early Edo period. Itsuo Museum, Osaka.

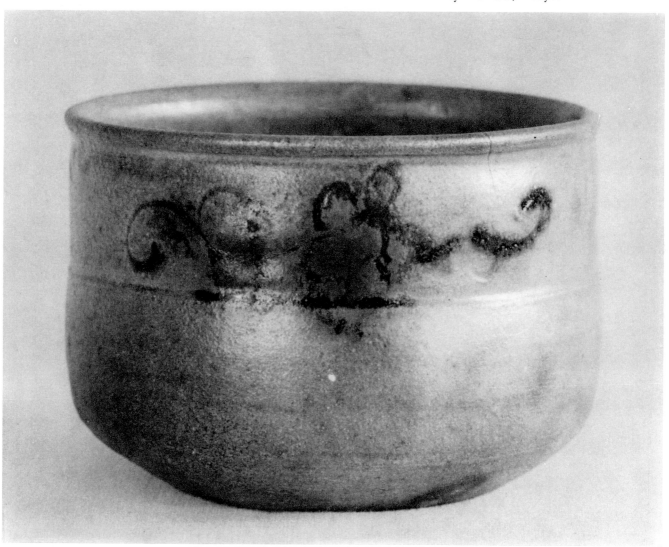

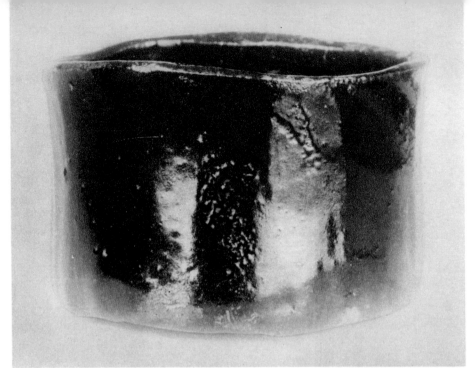

Plate 41. Black Seto tea bowl. Momoyama period.
Collection of Morikawa Kan'ichiro.

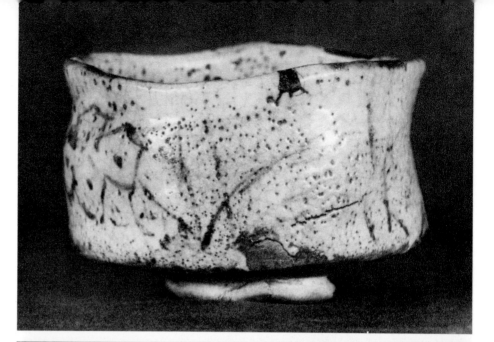

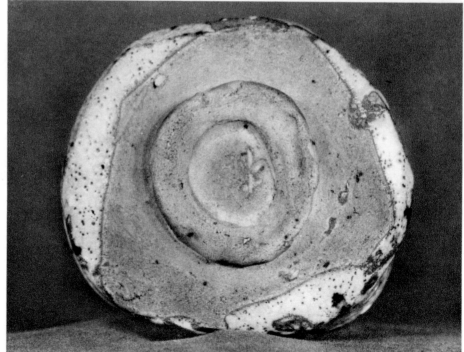

Plate 42. Shino tea bowl. Early Edo period. Collection of the Seikado Bunko, Tokyo.

　　Tea-Ceremony Wares

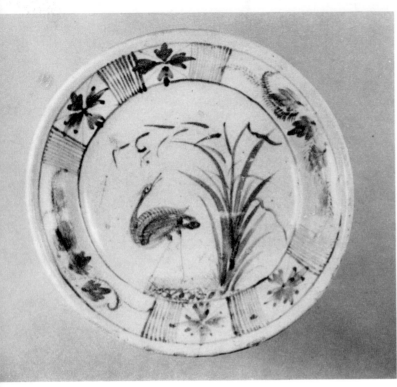

Plate 43. E-Shino plate. Momoyama period. Collection of the Marquis d'Ajeta, Rome.

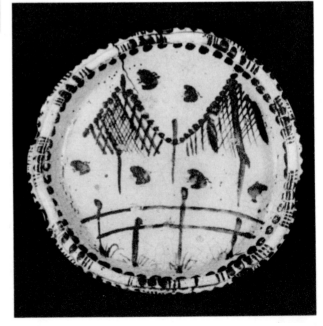

Plate 44. E-Shino dish. Momoyama period. Collection of Sabane Sotaro.

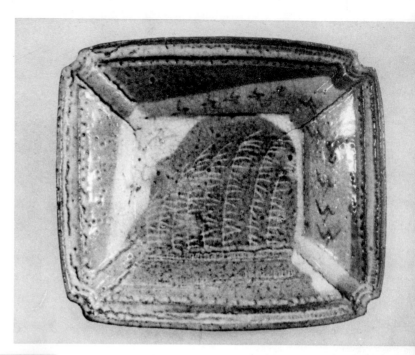

Plate 45. Gray Shino dish. Momoyama period. Tokyo National Museum.

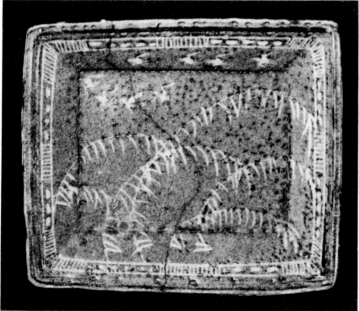

Plate 46. Gray Shino dish. Middle Edo period. Museum of Fine Arts, Boston.

Tea-Ceremony Wares

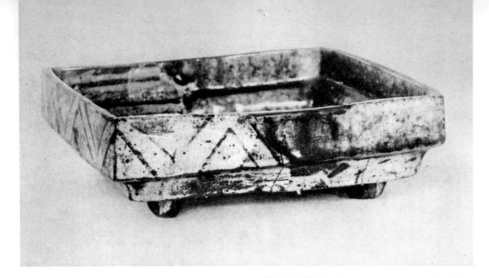

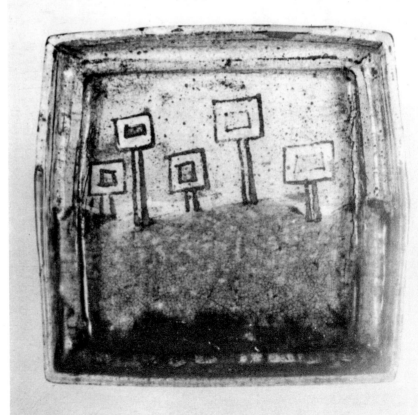

Plate 47. Oribe dish. Early Edo period. Collection of Akutagawa Hiroshi, Tokyo.

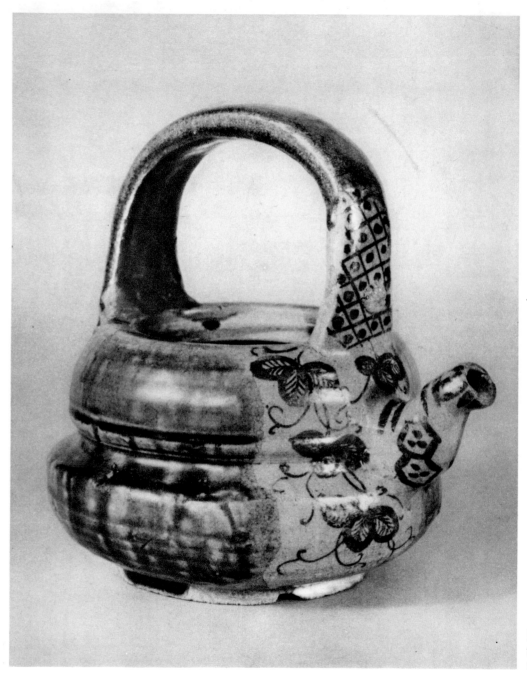

Plate 48. Oribe pot. Momoyama period. Uchiyama collection.

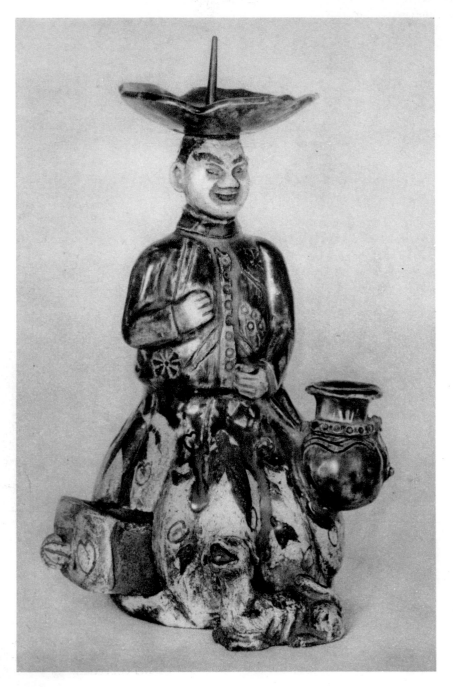

Plate 49. Oribe candleholder. Late Edo period. Tokyo National Museum.

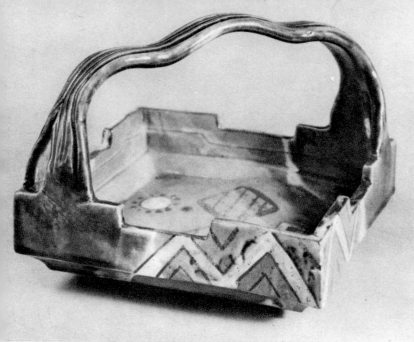

Plate 50. Oribe dish with handle. Momoyama period. Collection of Nakajima Yozo.

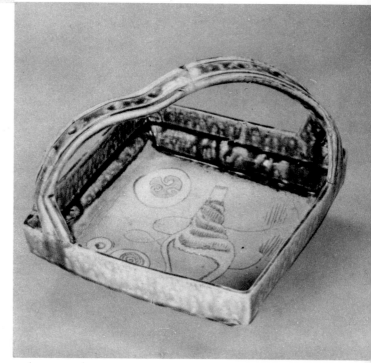

Plate 51. Oribe dish with handle. Momoyama period. Collection of the Marquis d'Ajeta, Rome.

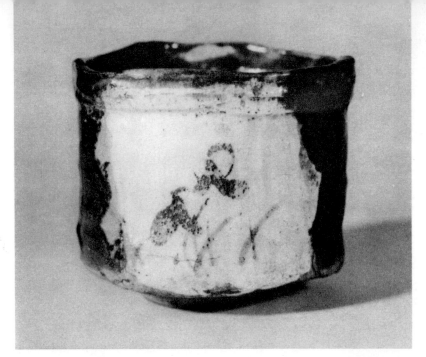

Plate 52. Black Oribe tea bowl. Early Edo period. Itsuo Museum, Osaka.

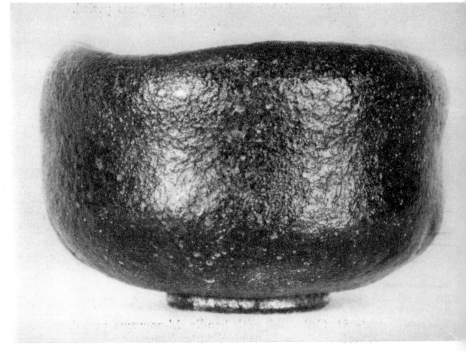

Plate 53. Raku tea bowl by Chojiro. Momoyama period. Collection of Hosokawa Goritsu, Tokyo.

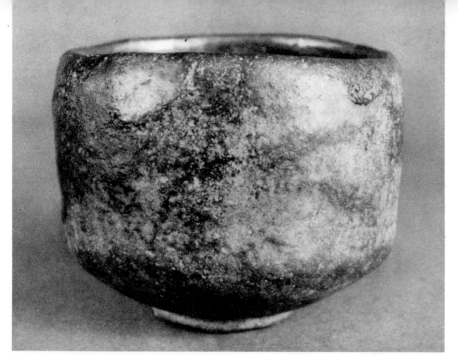

Plate 54. Raku tea bowl by Chojiro: "Ayame." Momo-yama period. Private collection, Japan.

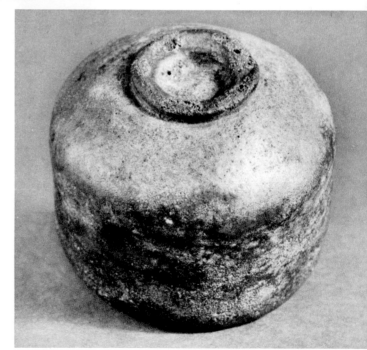

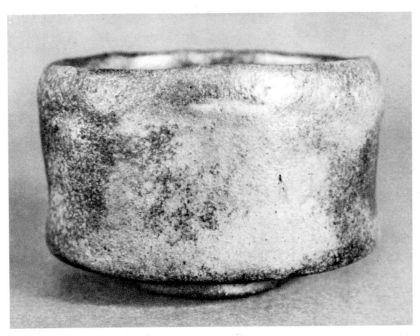

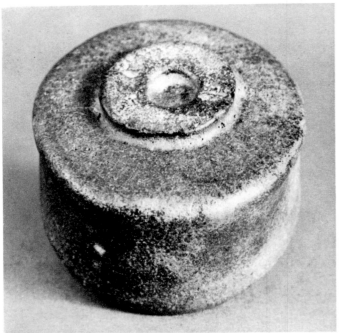

Plate 55. Raku tea bowl by Jokei. Momoyama period. Private collection, Japan.

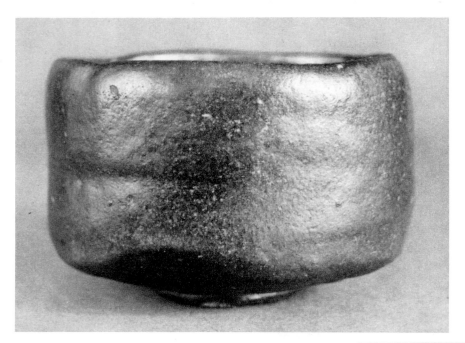

Plate 56. Black Raku tea bowl by Chojiro: "Shunkan." Momoyama period. Collection of Mitsui Kodai.

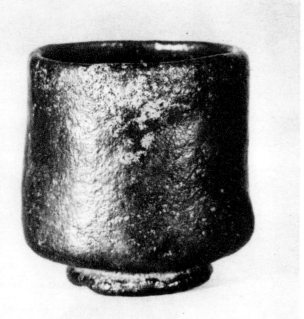

Plate 57. Raku tea bowl by Chojiro. Momoyama period. Itsuo Museum, Osaka.

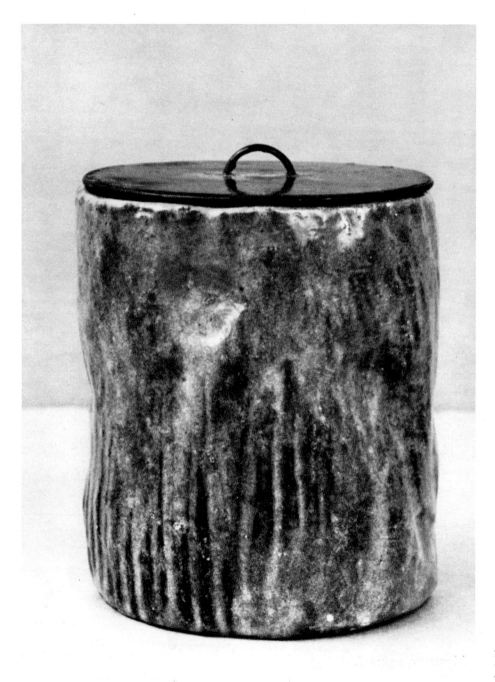

Plate 58. Red Raku water jar. Middle Edo period. Collection of T. Rosenberg, New York.

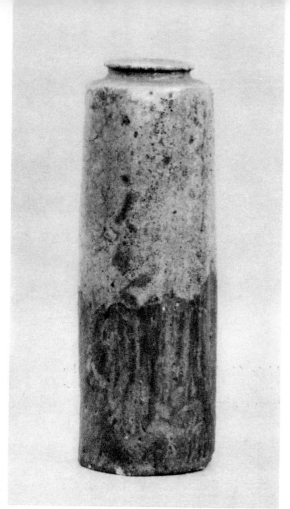

Plate 60. Red Raku tea jar by Sanyu. Middle Edo period. Collection of T. Rosenberg, New York.

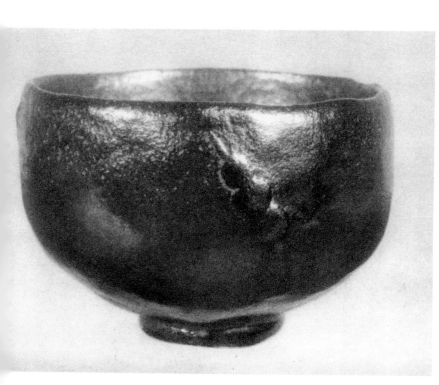

Plate 59. Raku tea bowl by Chonyu. Middle Edo period. Tokyo National Museum.

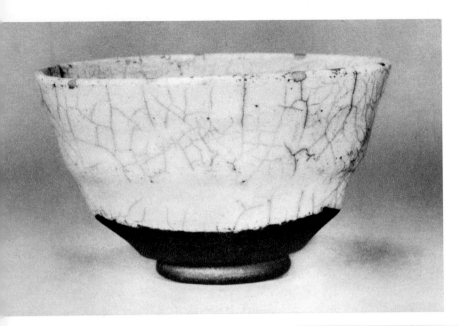

Plate 61. White Raku tea bowl by Jokei. Early Edo period. Private collection, Japan.

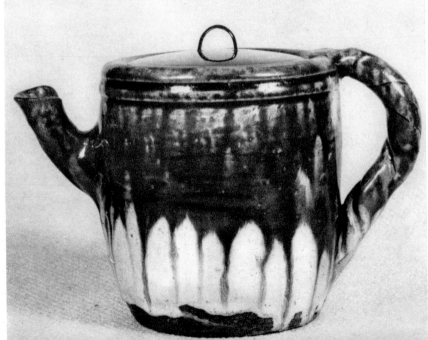

Plate 62. Chosen Karatsu water pitcher. Momoyama period. Freer Gallery of Art, Washington.

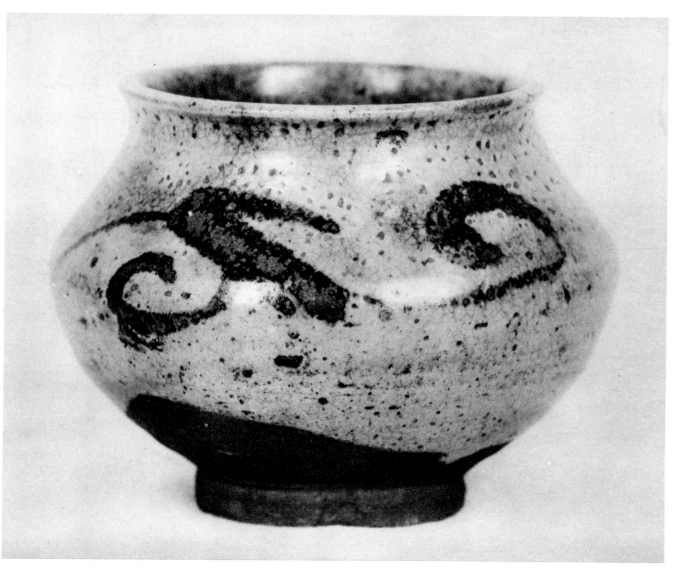

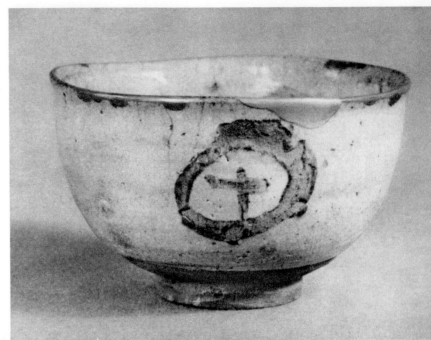

Plate 64. E-Garatsu tea bowl. Early Edo period. Collection of Idemitsu Sukezo, Tokyo.

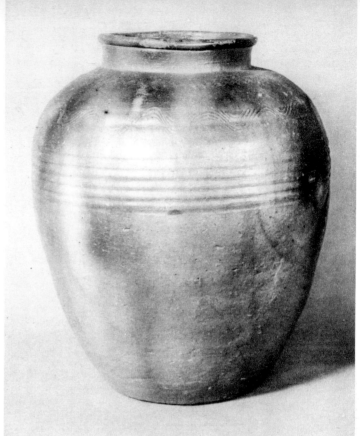

Plate 66. Bizen jar. Momoyama period. Tokyo National Museum.

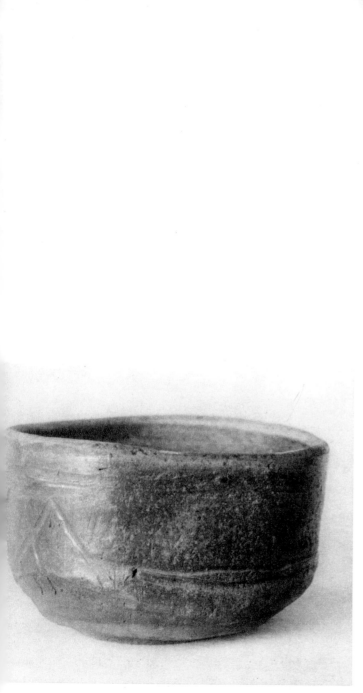

Plate 65. Bizen tea bowl. Momoyama period. Private collection, Japan.

Tea-Ceremony Wares

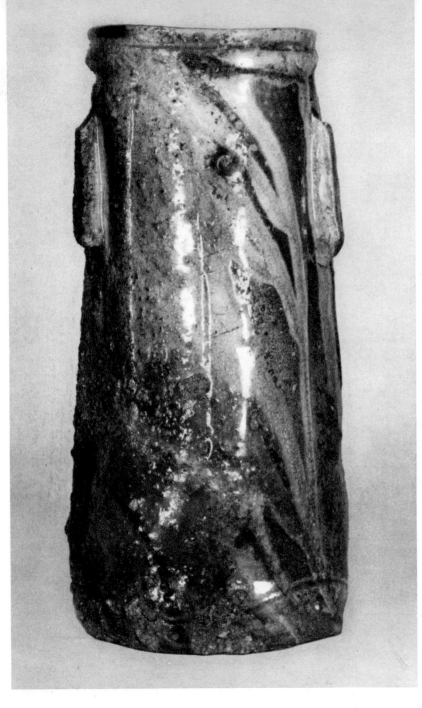

Plate 67. Iga flower vase. Momoyama period. Private collection, Japan.

7 Japanese Porcelain

OF ALL the various kinds of Japanese ceramic wares, the porcelains are those that the Westerners learned to appreciate first. In fact, to this day the most extensive collection of early Japanese porcelains is the one in Dresden formed by King August the Strong of Saxony during the late sixteenth and the early seventeenth century. The enthusiasm for Japanese porcelains in Europe, especially during the Rococo period, was such that all the main European porcelain factories, such as Meissen, Chantilly, and Worcester, imitated Japanese wares. The Japanese themselves have traditionally regarded pottery as artistically more significant, and the tea masters, with their cult of the simple and unsophisticated, have had little use for the refined and more finished porcelains. Certain types of the finest porcelains, notably the best of Kakiemon and Nabeshima, as well as Old Kutani, have been valued highly, but the bulk of porcelain production, especially the Imari wares that foreigners have admired so much ever since the seventeenth century, have until modern times found few collectors among the Japanese. At least one Japanese scholar, Yamane Yuzo of the Kyoto Museum, in writing on Japanese porcelains, suggests that if it had not been for the enthusiasm of Western collectors, these wares would have been completely neglected, like the ukiyo-e woodcuts, which were only restored to national favor after European and American art lovers had discovered their unique beauty. Be this as it may, Japanese porcelains, though never the rival of the Chinese, do now enjoy great popularity not only among Westerners but also in Japan itself.

The origin of porcelain in Japan, like so many other significant developments in the history of Japanese ceramics, is due to Korean influence. It was a Korean potter by the name of Li Sanpei, better known by his Japanese name of Kanae Sampei, who was the first to discover white porcelain clay in Japan. Like so many others of

his countrymen who were skilled in making ceramic wares, he had been brought to Japan after Hideyoshi's Korean expedition by Lord Nabeshima, the daimyo of Hizen. In 1616, after a search of several years, he discovered kaolin, the special kind of clay needed for making porcelain, at Izumiyama, near Arita, in what is today Saga Prefecture in Kyushu. This event was greatly welcomed, for the Japanese had been importing Chinese and Korean porcelains and were very eager to make their own. The advantage of this new type of ware lay not only in its greater beauty but also in its hard, fine paste, its durability, and its pure white color. The earliest of these Japanese porcelains imitated Korean wares of the Yi dynasty very closely, but later specimens show the influence of the Chinese porcelains of the Ming and later also of the Ch'ing period. First the Japanese made blue-and-white wares called *sometsuke* which had blue designs executed in cobalt under the glaze. These wares were very close to their Chinese models in both design and shape, and it is often difficult to distinguish between the two. Generally speaking, however, the Chinese wares are finer in body and glaze, and their blue is very pure, while at first the Japanese copies were rougher and had a less pure body and a blue less clear and deep. Gradually the designs became Japanized, and the quality of the wares improved until the mature product of this type was of very fine quality. Although enameled porcelains in bright colors were made after a generation or two, blue-and-white wares continued to be made and are still being produced today.

The center of Japanese porcelain production during this period was the town of Arita in northern Kyushu. Arita, in fact, has continued to be one of the great ceramic centers right down to the present day. The ware produced here and in the neighboring villages (for the whole district became very active in the manufacture of porcelains) is usually referred to as Imari ware after the nearby port from which these porcelains were shipped to other parts of Japan and exported to foreign countries. It was this kind of ware that was sent to Europe and to other parts of Asia by the Dutch East India Company and aroused such enthusiasm abroad that even the Chinese imitated Imari designs for their own export trade. Many different kinds, shapes, and patterns are found among Imari porcelains, reflecting the differences among the various kilns that produced them and the periods from which they date. Some writers such as Morse and Brinkley have suggested that Imari ware was largely export ware, designed wholly for Western taste and not attractive to the Japanese, but this is not true. Of course there were some types of porcelain made to specifications for the Dutch export trade and employing Western shapes and designs, but the great bulk of Imari wares at all times was made for the Japanese market and reflects an aspect of Japanese artistic sensibility directly opposite to that found in the tea ceremony. Certainly the splendid and ornate textile designs of the Edo period, the ornate gold and inlay lacquers, the gorgeous screens with gold backgrounds, all reflect the same taste found in the colored Imari porcelains.

It just happened that this love of ostentation matched the European taste of the seventeenth and eighteenth centuries, but this does not mean that it is any less truly Japanese.

The earliest phase of Imari production extended to the end of the seventeenth century, culminating in the Genroku period (1688–1703), which is well known for its love of the lavish and the gorgeous. The body of early Imari wares is often impure because of the coarse quality of the clay, and the colors are often clouded. Nevertheless, the effect of these porcelains is highly decorative and sometimes quite splendid (*Plates 68 and 70*). The designs are usually taken from textile patterns and cover the whole surface of the vessel (*Plates 69 and 71*). Many of them follow Chinese models (*Plates 72 and 73*), while others are entirely Japanese. The taste reflected is not that of the aristocracy but rather that of the rich merchants. Interestingly enough, there are even pieces that show scenes from daily life resembling those seen in the early ukiyo-e prints (*Plate 74*). Interesting also are the decorative figures representing (as the prints do) actors, courtesans, and genre scenes (*Plates 75 and 76*). Outstanding among these and remarkable for the plastic conception of its modeling is the figure of an actor dating from the earliest phase of Imari production in the late seventeenth century (*Color Plate 3*). Other designs that have always fascinated Westerners are those showing Dutch merchants with their ships and their (to the Japanese) exotic costumes (*Plates 77 and 78*).

Early Imari wares were either blue and white (*Plate 79*) or colored with enamels (*Plates 80 and 81*), among which red was the most prominent color, so that they were referred to as Aka-e or Red Picture wares. Other colors used were green, blue, yellow, purple, black, gold, and silver. The porcelains decorated in this colorful manner are called *nishikide*. The production of the seventeenth century that is most highly prized is known as Ko-Imari or Old Imari, a term which is today loosely employed to include all the wares made prior to the Meiji Restoration. Since the demand for these old wares is so great, they are being imitated in large quantity though unfortunately inferior quality. Since none of them have signatures and the inscriptions are simply decorative adaptations of Chinese reign names or auspicious pictographs such as *fuku* (good luck) or *ju* (long life), it is upon the quality of the glaze, color, and design that collectors must rely in distinguishing between the early wares and their later imitations. During the eighteenth century, the middle Edo period, Imari continued to be of fine quality (*Plate 82*); in fact, some of the pieces from this age are very beautiful in design and technically superior to the very early pieces. But by the nineteenth century the quality of Imari ware had declined sharply, the colors becoming gaudy and the designs overelaborate and tasteless (*Plate 83*), and by the Meiji period (1868–1912) Imari ware had become little more than a cheap commercial product sold to the rich parvenus and eager but undiscriminating Western collectors. The large ornate plates and vases so often

seen in Western collections invariably come from this last decadent phase of Imari production. Today the Arita kilns produce the most ordinary of commercial wares and rather poor imitations of the older ones.

The most refined and elegant of all Japanese porcelains is Kakiemon, also made in Arita at the Nangawara kiln. The name is believed to derive from *kaki*, the Japanese word for persimmon, the color of which fruit the Kakiemon potters wished to imitate. (A *kaki* tree standing in the yard of the Kakiemon homestead is still pointed out to the visitor today.) The founder of the line of Kakiemon potters, which still exists and is in its thirteenth generation, was Sakaida Kizaemon (1596–1666), known as Sakaida Kakiemon I. Though it is believed that he invented the new method of enamel decoration employed by the Kakiemon potters around the middle of the seventeenth century, some scholars have doubted this, pointing out that no authentic early pieces have survived. The only record giving some clue to the date of the first colored porcelain indicates that the first Kakiemon presented the local daimyo with a piece of enameled ware in 1646, but this may have been an isolated example, and it is generally believed that the production of colored porcelain on any appreciable scale did not take place until 1670 or 1680. Actually, with the exception of two dishes dated in the eighth and the twelfth years of Genroku (1695 and 1699)—attributed to Shibuemon (uncle of the sixth Kakiemon) and decorated with patterns resembling the ornate brocade ones of the Old Imari wares—no dated or signed examples of Kakiemon exist. It is therefore very difficult to reconstruct the early history of the factory. Fortunately, excavations are now being carried on at the old site, and these will no doubt shed much new light on these problems.

Two further points in evidence against a mid-seventeenth-century date for Kakiemon are worth noting. The first is that the typical Kakiemon designs are derived from the Chinese porcelains of the K'ang-hsi period (1662–1722), and this precludes a date before 1670. The second is that the registers of the Dutch East India Company record the export of only blue-and-white ware during the early period of the company's activity, and even as late as 1664—two years before the death of the first Kakiemon—no Kakiemon or *nishikide* Imari ware was being exported. The truth of the matter seems to be that the first Kakiemon learned the technique of making red decorations from China through the help of the Imari merchant Toshima, who had visited Nagasaki—at that time the only port permitted to have dealings with foreign countries. It seems therefore very unlikely that the founder of the family himself was responsible for making the highly developed and sophisticated porcelains that go by the name of Kakiemon.

Japanese scholars usually group the work of the first four members of the family together, for the first Kakiemon actually outlived the second, and the third did not live much longer. The work of these first four potters cannot easily be told apart, since they were all working at the same time in the same workshop. (This, by the way, is still the custom, for three generations of Kakiemon are at present working

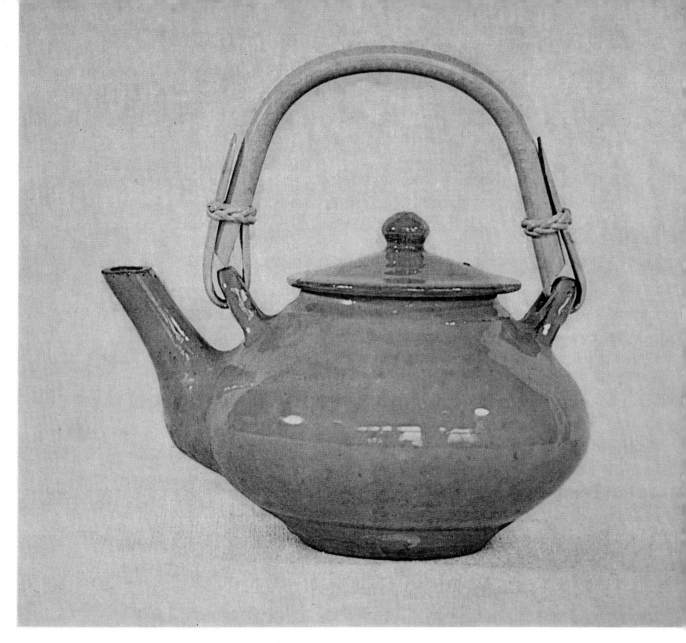

Color Plate 10. Onda teapot. Showa period. Collection
of the author.

in Arita side by side.) These early wares are very charming and elegant, but the Japanese consider the more finished and gorgeous products of the fifth to the eighth generation of potters to be the best output of the kiln. After that, it is generally conceded that the porcelains declined, although they preserved the traditional designs. The present Kakiemon, the thirteenth in line, makes very fine copies of the old wares that are at times difficult to distinguish from the originals, and commercial wares are produced in his shop as well. His son, who will be the fourteenth of his family to devote his life to ceramic manufacture, is at present experimenting with bold individualistic designs in keeping with the spirit of the modern art movement but will no doubt, when his time comes, continue the tradition of his family.

After its introduction to China and Europe, Kakiemon porcelain became so popular that the potters of Ching-tê Chên and almost all the leading European factories were soon producing their own versions of this ware. Since the Kakiemon potters in their turn were copying Chinese and Western designs and producing export ware, a lively exchange of porcelains and influences was in progress at the time. In contrast to Imari wares, often made in large quantities for daily use and for export, Kakiemon porcelains were always of the very best quality and were already considered the choicest by August the Strong. This was largely due to the fact that, whereas Imari wares were produced by common workmen—often on a mass-production basis in order to make them as cheap as possible—Kakiemon porcelains were always made individually by expert craftsmen, and the designs on them were often made by real artists such as Kano Tanyu, who drew the picture of the tiger amidst the bamboo that became so popular with the Meissen potters. The shapes used were those of dishes, plates, wine bottles, and decorative figures known as *okimono* which represented elegant ladies rendered with great refinement and technical skill (*Color Plate 4*). In contrast to Imari wares, Kakiemon is modest in scale and delicate in execution. The body is a very pure white, and the colors are brilliant and clear, while the body of Imari is of a coarser quality, and the colors are often cloudy and impure. Although Imari designs were at times used by the Kakiemon potters, it should nevertheless be possible to distinguish these two types of Arita ware since they differ so markedly in the quality of their workmanship. This difference has from the earliest times also been reflected in the different value attached to them, the one being rare and expensive, the other common and cheap. In fact, good Kakiemon ware is now difficult to come by, and choice pieces are considered important cultural assets of the Japanese nation. Even in modern times Kakiemon made by the present members of the family is relatively expensive, while modern Imari made with chemical colors and with the help of moulds can be found in any curio shop.

The glory of Kakiemon, however, does not exist so much in the quality of the porcelain or the glaze, which certainly has been equaled by other Japanese kilns, as in the beauty of the designs. Executed by true artists, the enamel paintings applied

over the glaze are of a grace and elegance not to be found in any other Japanese porcelains (*Plates 84 and 85*). They are perhaps closest to the Chinese *famille-verte* flower and bird designs of the K'ang-hsi period, but they show a Japanese adaptation of these decorations (*Plates 88 and 89*). Whereas the Chinese designs are usually rich and cover the whole surface of the vessel, the Japanese are much sparser and more suggestive, leaving much of the body free and limiting the drawing to a few irregular shapes (*Plates 86 and 90*). The figures and landscapes are usually in Chinese style, in contrast to the Japanese scenes preferred by the Imari potters—a fact that illustrates the preference for Chinese culture among the aristocracy (*Plate 91*). Most popular were all kinds of flowers, plants, and trees (*Plates 87 and 92*), like the so-called three friends of the cold season: pine, bamboo, and plum, which stand for longevity and endurance; seasonal flowers like the peony, paulownia, and chrysanthemum; and animals like the tiger, symbolizing strength, and the legendary phoenix and dragon, believed to inhabit the sky. Most typical, perhaps, are the designs showing a bird seated on a branch with some flowers, rendered against a plain white background. The colors used in these designs are red, blue, green, yellow, black, gold, and occasionally silver—all of them applied over the glaze. Even the blue, which in Imari wares is underglaze cobalt or indigo, is usually overglaze color. In contrast to Imari ware, the gold is used sparingly and for delicate coloristic effect rather than sumptuous display.

Another important Japanese porcelain made in Arita is the Nabeshima ware produced at the Okawachi kiln. It was called Nabeshima after the daimyo of Saga, for whose family it was made. During the Edo period it was never sold commercially but was reserved for the use of the lord and for gifts to his friends. Only after the Meiji Restoration (1868) was it sold on the open market and imitated at other places, but by that time its quality had deteriorated. The older Nabeshima ware was made with very great care and is considered to be technically the best porcelain ever made in Japan. Founded in 1722, the kiln flourished especially during the eighteenth and the early part of the nineteenth century and still exists today. However, it is generally agreed that Nabeshima ware declined with the Tempo period— that is, after 1830. It was produced by members of the Imaemon family, which exists in the twelfth generation today. During all these years the same types of designs have been in use, but the connoisseurs consider the wares made by the fourth to the seventh Imaemon the best. In the early days, up to ninety percent of the output was discarded in order to assure perfection, and even now only about half is actually used. Although today's output lacks some of the freedom and freshness of the old wares, the present members of the family try to preserve the traditional methods and designs, and they achieve astonishingly faithful and excellent results.

Of the several types of porcelain made by the Nabeshima potters, the most typical and most celebrated were the Iro-Nabeshima or Colored Nabeshima wares.

Other kinds were the blue-and-white porcelains, the celadons (which are considered the best of this genre made during the Edo period), and the plain white wares. Most of these were intended as tableware, the most characteristic being plates with a high base known as *takadaizara*. Other shapes include flower vases, water bottles, censers, paperweights, brush boxes, and toilet sets. So as to assure uniformity, moulds were usually employed in the manufacture of these wares. In contrast to Imari ware, which often was large in scale, Nabeshima, like Kakiemon, was usually small and always in a most refined and aristocratic taste. The quality of the porcelain is excellent: pure white in body with a slight bluish tinge. The colors, too, are of great refinement and beauty, and they blend together very harmoniously. The main colors, besides blue underglaze, are red, green, and yellow, with black and purple sometimes added.

The outstanding feature of Nabeshima ware is the unique beauty of the painted designs. Although the early ones were influenced by Kakiemon and the Aka-e ware of the Chinese imperial kilns of the Yung-chêng period (1723–35), typical Iro-Nabeshima of the second half of the eighteenth century was very Japanese in character and completely original. The designs are probably closest to those used by the dyers and weavers of the time, especially on silk fabrics dyed in the Yuzen style. Technically too, Nabeshima has some unique characteristics, for the designs were first drawn on thin tissue paper and then in underglaze blue lines—not in black, as was customary at other kilns. The overglaze colors were added later after a preliminary firing. Another unique characteristic of Nabeshima is the comb pattern running around the base: the mark by which it can usually be recognized.

Although all the Nabeshima wares except the plain white ones have pictures, it is of course among the Iro-Nabeshima that the finest pictorial designs are found. The painters particularly favor all kinds of fruits and vegetables (*Color Plate 5*) and all kinds of flowers (*Plates 93 and 94*) rendered in a very simple and decorative manner that employs only a few large forms without the ostentation of the Imari designs or the sophistication of the Kakiemon ones. As in textile patterns, the forms are flattened out and arranged in a decorative way to cover most of the surface of the plate or dish (*Plates 95 and 96*). Other designs show winter landscapes in the typical style of the Kano school, waves, bamboo fences, and all kinds of trees and plants (*Plates 97 and 98*). At times purely ornamental designs are employed, showing scrolls (*Plate 99*) or conventionalized floral or leaf ornaments (*Plates 100 and 101*). The feeling expressed by these Nabeshima designs is always subdued and refined in a very Japanese way; so it is not surprising that many Japanese particularly like these wares.

While the wares produced in the Arita district dominated the scene in Kyushu and western Japan, in eastern Japan Kutani ware was the outstanding porcelain of the Edo period. In contrast to the refinement and perfection of the former, the Kutani porcelains were rough and coarse, with impure grayish bodies and dull

luster. The designs have none of the grace and elegance of those found in the Arita wares but are virile and powerful, reflecting the more vigorous and somber character of the people in this section of Japan. It is precisely in this strength of shape and design that the peculiar appeal of Kutani ware lies, and some Japanese critics find this ware the most characteristically Japanese of all the porcelains produced in the island empire.

The early history of the Kutani kilns is rather obscure. Tradition has it that a potter by the name of Goto Saijiro went to the Arita district by order of his lord, Maeda Toshiharu, the ruler of Daishoji in what is now Ishikawa Prefecture. Since the secret of making porcelain was closely guarded, he had to come in disguise and marry the daughter of his master in order to gain the confidence of the Arita potters. After ten years of intensive study and work, he mastered the technique and returned to his native place, where he established a kiln in the mountain village of Kutani not far from Kanazawa on the Japan Sea side of Honshu. The years of his apprenticeship are believed to have been from 1642 to 1657, and the first period of activity at the Kutani kilns lasted not more than one generation—that is, until about 1690. These early Kutani wares are known as Old Kutani or Ko-Kutani in contrast to the later wares made in imitation of them during the nineteenth century, which are regarded as inferior in quality and design. It is occasionally difficult to distinguish between them, but, generally speaking, the older ones are not as pure in their body, show a bolder brush stroke, and are heavier and more forceful. The colors, too, are sometimes different, for the later ones are vitreous and shiny, their purple tends towards black, the yellow is lighter and less pure, and, above all, the green is less deep and vibrant. The design in the later wares tends to be more crowded and less well placed. Another problem that Ko-Kutani wares raise is that of their frequent resemblance to Old Imari wares in color and design. This is particularly true of certain early bottles (Plates 102 and 103). In fact, there are some pieces on which Japanese scholars simply cannot agree, some of them believing these to be Old Kutani, others claiming that they are Old Imari, so close is the resemblance.

The most impressive of the Old Kutani pieces are the large plates, but numerous other shapes such as saké bottles, jars, cups, teapots, vegetable dishes, and incense burners were produced at the kiln. What makes them impressive is the vigor of their potting and the beauty of their color and design. Several different styles may be distinguished, some of them following the Chinese models of the late Ming and early Ch'ing periods, with bird and flower designs and landscapes (Plates 104 and 105), others being close to Ko-Imari in both design and color, and still others exhibiting a highly original style in which green predominates (Color Plate 6). This last group, known as Ao-Kutani or Green Kutani, represents the strongest and boldest of all Japanese porcelains. In the Ao-Kutani ware the entire body is covered on both sides with a deep-green glaze upon which strong and simple designs show-

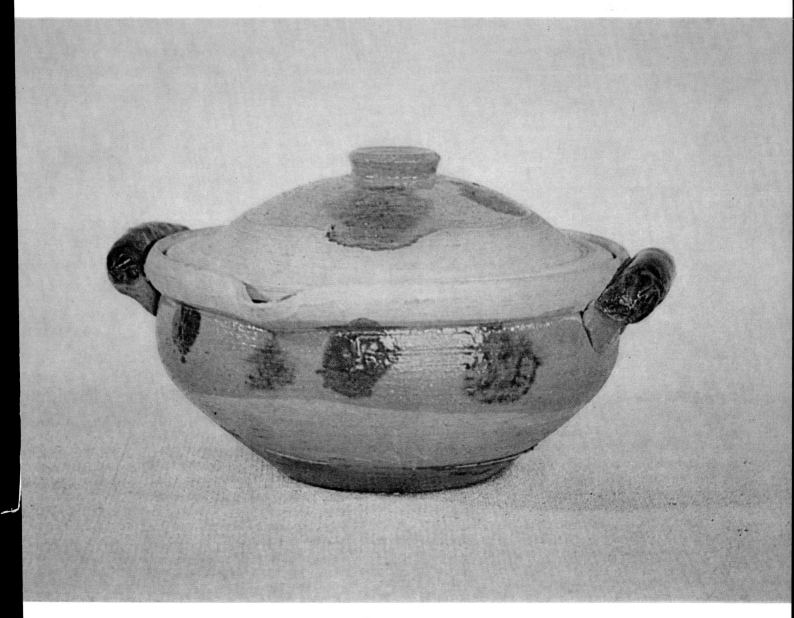

Color Plate 11. Shiraishi casserole. Showa period.
Collection of the author.

ing fruit, flowers, fans, and other decorative motifs are carried out in black, purple, and yellow. The deep, vivid green, the blackish purple, and the chocolate brown are especially beautiful and very characteristic of this ware in their brooding and somber, yet intense, quality. This same feeling of virile strength is found even in the wares modeled after Chinese and Arita porcelains and in the blue-and-white Kutani.

Among the designs found on the old wares from the Kutani kiln, the most beautiful are those showing birds and flowers. Particularly fine are the plates showing peonies and butterflies *(Plate 106)* and lotuses and herons *(Plate 107)*. These circular pictures are often framed with ornamental border designs resembling textile patterns *(Plates 108 and 109)*, and on yet other plates a decorative geometric design covers the whole surface *(Plates 110 and 111)*. The designs are always bold and the colors dark, in contrast to the more graceful and colorful designs of the Arita potters. Even the shapes employed by the Kutani potters seem rather heavier and more solid, in keeping with the spirit of these wares *(Plates 112 and 113)*.

The second phase of Kutani took place during the nineteenth century after the kiln had been revived in 1823 under the patronage of the wealthy merchant and amateur of the arts, Yoshida. The later history of the ware is very complex, and many different kilns located in Ishikawa Prefecture in the neighborhood of Kanazawa were active in ceramic production. In fact, Kanazawa, along with Seto and Arita, became one of the great ceramic centers of Japan. A multitude of different wares was now produced in the district, varying all the way from fine porcelains to rough pottery and from close imitations of Ko-Kutani to new types of porcelain that had no similarity at all to the earlier wares. The best of the Yoshidaya wares, as they are called, are considered to be very fine and are made with great care, although their overelaborate design indicates their later origin *(Plates 114 and 115)*. The best known of the later Kutani wares was probably the *kinrande* or gilded porcelain, first developed at the Miyamotoya factory and perfected by Iidaya Hachiroemon, and therefore known as Hachiro-de. These porcelains were decorated entirely in red and gold in the Chinese manner and proved very popular both in Japan and abroad. Other well-known Kutani wares were those painted in the Kano style after designs by Kano Morikage, who lived in that province. However, none of the later Kutani wares recaptured the strength and the beauty of the earlier examples. During the late nineteenth century the Kutani productions declined even further, and crowded, vulgar designs became the rule *(Plate 116)*. In modern times the Kutani kilns turn out nothing but mass-produced industrial porcelains without any aesthetic appeal or distinction.

The three kilns in the Arita district and the Kutani kilns are usually regarded as the chief Japanese porcelain centers. During the late Edo period, however, when the country prospered and porcelain was used more widely, many new kilns began to spring up. For common use, blue-and-white wares became very popular, and old

ceramic centers such as Seto and new ones such as Mikawachi in Nagasaki Prefecture and Hirasa in Kagoshima Prefecture excelled in them. Since the Mikawachi ware was exported from the port of Hirado, it is better known as Hirado ware. It is remarkable for the pure white of its body and the excellence of its workmanship. In addition to fine blue-and-white wares, Hirado is well-known for its rather naturalistic decorative pieces, especially those representing animals (*Plate 117*). Among the numerous other kilns working in Kyushu at that time was the Nagayo kiln, located in Nagasaki Prefecture, which excelled in three-color ware made in imitation of Chinese porcelains (*Plate 118*). All of these wares show a great deal of skill and technical perfection, but when it comes to strength and beauty of design, they are no match for the wares produced by the older kilns during the early and the middle Edo period.

Yet another center of porcelain manufacture during the late eighteenth and especially during the nineteenth century was Kyoto, which prior to that time had been primarily known for enameled pottery. The man responsible for this development was a wealthy dilettante, Okuda Eisen (1753–1811), who, after retiring from business, had devoted himself to his hobby, ceramics. He admired the Chinese wares of the Ming dynasty and was able to make beautiful reproductions of what the Japanese call *gosu aka-e* wares—that is, porcelains with underglaze decorations in cobalt and bright overglaze designs in red and green. The scenes represented are usually birds and flowers or floral designs rendered in a very fluid and inspired manner (*Plates 119 and 120*). But even more important than his actual output was his influence, for under his guidance the Awata kiln in Kyoto turned entirely to the making of porcelains, and such famous nineteenth-century potters as Nin'ami Dohachi and Aoki Mokubei were his pupils.

Mokubei (1767–1833) was the very essence of the China-oriented literati of the time. He was a scholar, a poet, and a painter as well as a potter, and he excelled in all these pursuits. His output was far more extensive than that of Eisen, and it included pottery as well as porcelain, showing a tremendous virtuosity. In fact, it has often been said that it is next to impossible to tell his productions from those of his Chinese models. His Ming-style three-color wares, celadons, enameled porcelains, blue-and-whites, and above all his imitations of the so-called Cochin-China wares, are well made but lack originality and any peculiarly Japanese quality (*Plates 121 and 125*). It would therefore appear that Mokubei, although very famous in Japan, made little contribution to the development of a native Japanese ceramic tradition.

Dohachi (1783–1855), on the other hand, developed a typically Japanese style that was deeply indebted to the Korin school, especially the designs of Kenzan. His most famous work is a porcelain bowl decorated both inside and out with splendid renditions of blooming cherries and red maples. The bold drawing—white for the blossoms, red for the maples, brown for the tree trunks, and green for the

younger maple leaves—and its delicate gold outlines give the bowl a unique beauty *(Plate 124)*. Several versions of this design exist, but Dohachi's output was by no means limited to this type of ware. He was a prolific potter who made Raku ware as well as Shigaraki and Iga pottery, Korean and Chinese pieces. Most of these wares were intended for the tea ceremony and were highly valued by the tea masters. He was also well known for his incense burners in the form of human and animal figures and for his *okimono*. His influence was widespread. He founded the Sanyo kiln in Kagawa Prefecture (Shikoku) and visited the Mushiage kiln in Okayama Prefecture, the Takamatsu kiln in Shikoku, and the Kairakuen kiln in Wakayama Prefecture, exerting a great influence on all of them. In fact, the influence of Kyoto ware made itself felt throughout the country and reached as far as Koto in Saga Prefecture and the island of Awaji, where outstanding Kyoto-style ware was made by the potter Mimpei *(Plate 122)*.

Closer to the Chinese tradition were Eiraku Hozen (1795–1854) and his son Eiraku Wazen (1823–96). Hozen's particular forte was the imitation of Ninsei tea bowls and gilded porcelains *(Plate 126)*. It has often been said that of all who followed Ninsei, Hozen was the only one who equaled his master. His designs, however, are more gorgeous, employing rich gold and red and rather naturalistic animal and floral forms. His son followed in his footsteps but added a new type of design that attempted to imitate the pattern of dyed cloth *(Plate 123)*. Most of his and his father's life was spent in Kyoto, but both of them also worked at other places, spreading the influence of Kyoto ware to other parts of the country. With his death the great tradition of Japanese porcelain manufacture came to a close, and contemporary production, with the exception of the work of a few potters such as Tomimoto, either imitates the past or is industrial in scope.

Plate 68. Ko-Imari decanter with European brass fixtures. Early Edo period. Collection of the author.

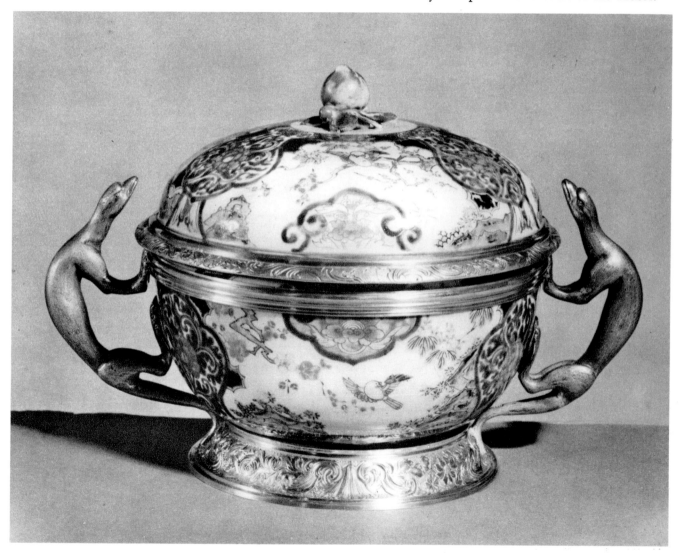

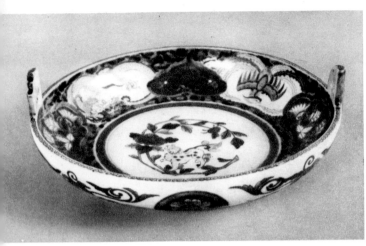

Plate 69. Imari covered bowl with English silver mounting. Middle Edo period. Klejman collection, New York.

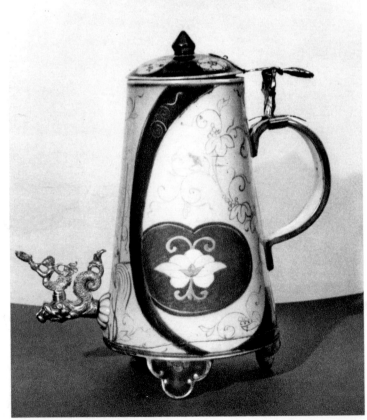

Plate 70. Imari dish. Middle Edo period. Soro collection, Rome.

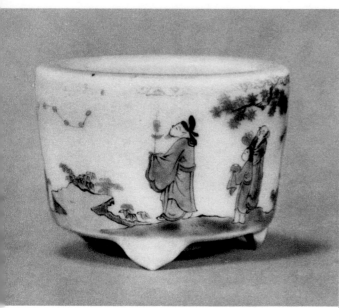

Plate 71. Imari dish. Middle Edo period. Soro collection, Rome.

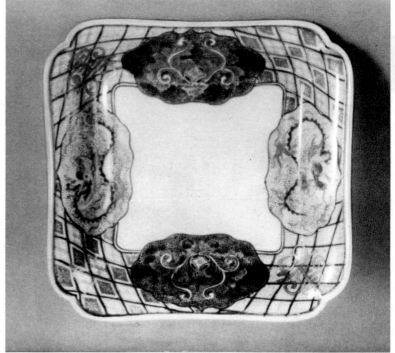

Plate 72. Imari incense burner. Late Edo period. Collection of the Marquis d'Ajeta, Rome.

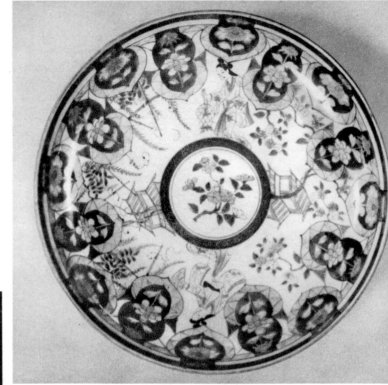

Plate 74. Ko-Imari dish. Early Edo period. Tokyo National Museum.

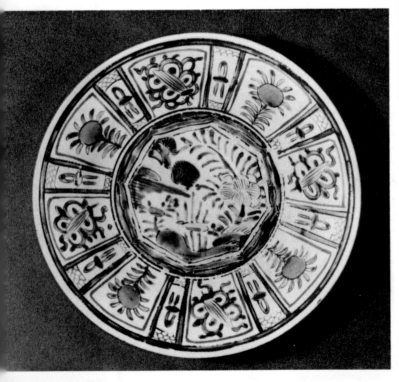

Plate 73. Ko-Imari bowl. Early Edo period. Collection of Kinoshita Yasuo, Tokyo.

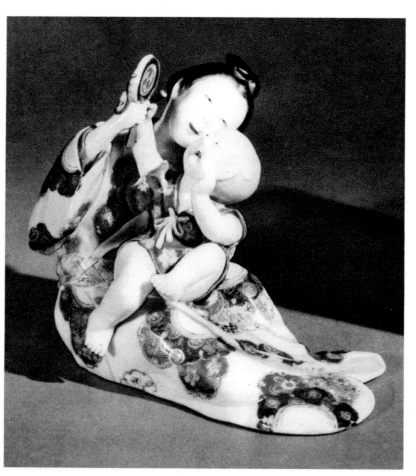

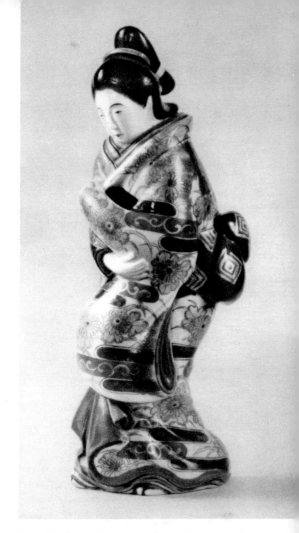

Plate 76. Imari figurine. Late Edo period. Collection of Takasu Teruhisa, Arita.

Plate 75. Imari figurine. Middle Edo period. Klejman collection, New York.

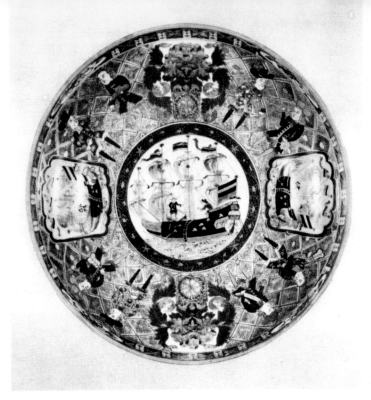

Plate 77. Imari dish picturing Westerners and their ships. Middle Edo period. Collection of Kato Shoji, Tokyo

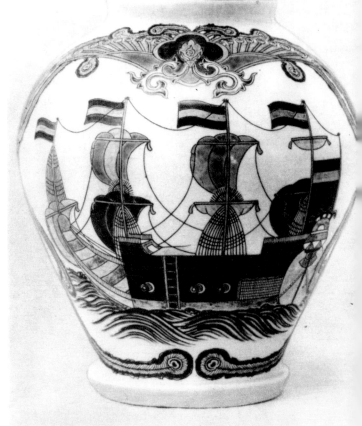

Plate 78. Imari jar. Middle Edo period. Collection of Nakao Kunio, Nagasaki.

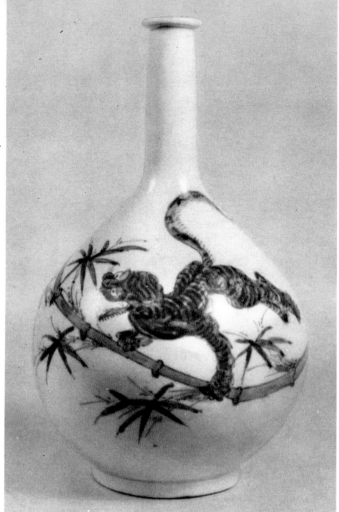

Plate 79. Imari *sometsuke* bottle. Early Edo period.
Collection of Kinoshita Yasuo, Tokyo.

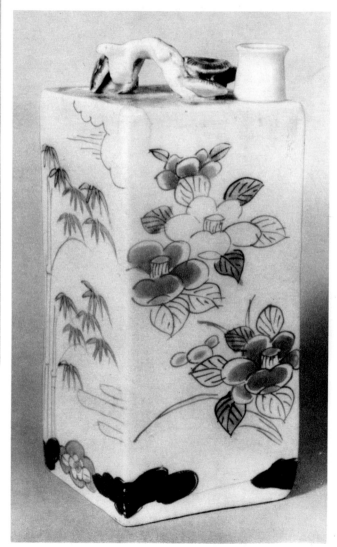

Plate 80. Ko-Imari bottle. Early Edo period. Collection
of Yokokawa Mimbu.

Plate 81. Ko-Imari bottle. Early Edo period. Collection of Takasu Toyoji, Tokyo

Plate 82. Imari bottle. Middle Edo period. Soro collection, Rome.

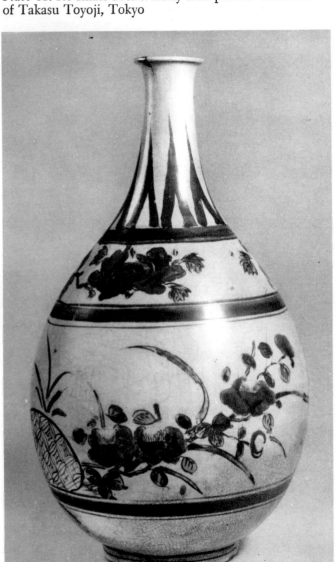

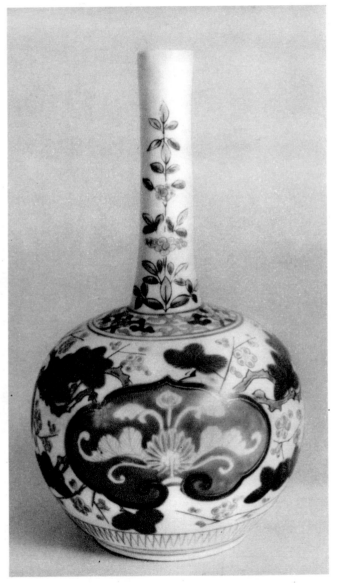

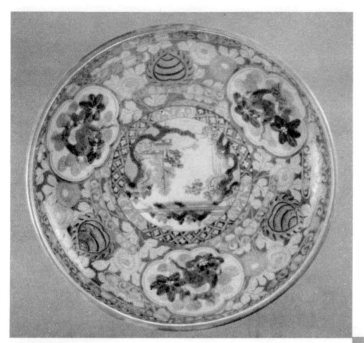

Plate 83. Imari plate. Late Edo period. Collection of the Marquis d'Ajeta, Rome.

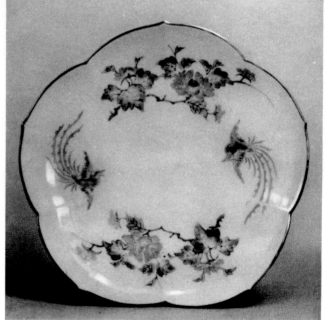

Plate 84. Kakiemon dish. Middle Edo period. Private collection, Japan.

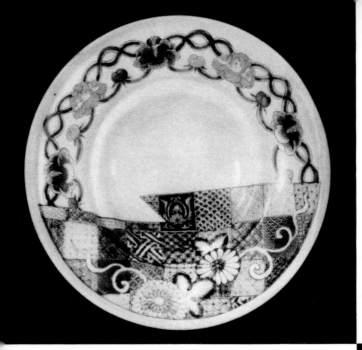

Plate 85. Kakiemon dish by Shibuemon. Early Edo period. Collection of Yamada Sanjiro, Tokyo.

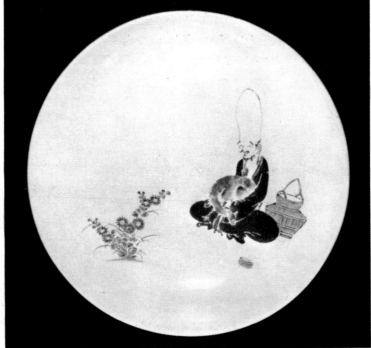

Plate 86. Kakiemon dish with Jurojin design. Middle Edo period. Collection of Shiobara Matasaku, Tokyo.

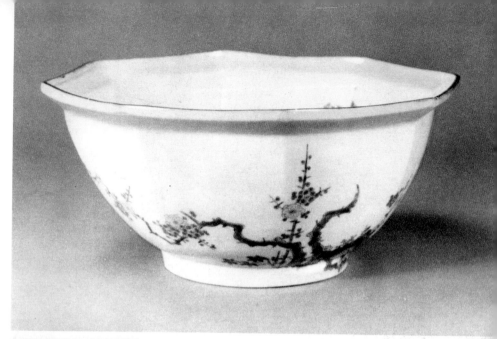

Plate 87. Kakiemon bowl. Middle Edo period.
Collection of the Marquis d'Ajeta, Rome.

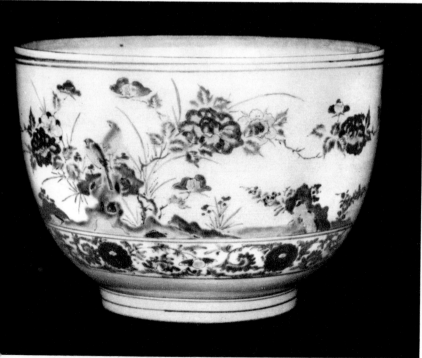

Plate 88. Kakiemon bowl. Early Edo period.
Collection of Shiobara Matasaku, Tokyo.

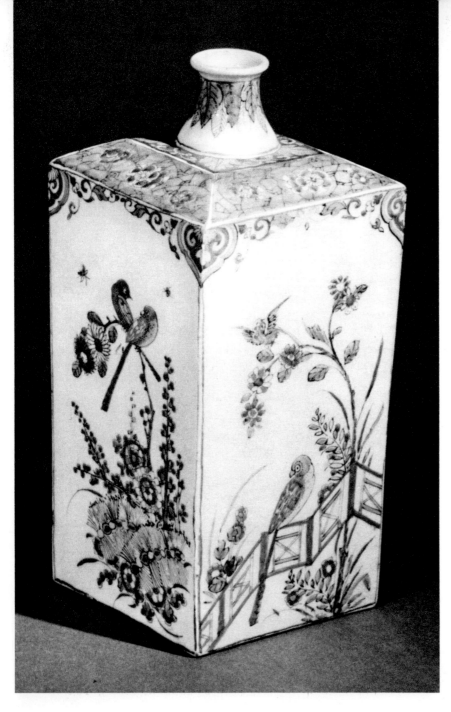

Plate 89. Kakiemon bottle. Middle Edo period. Klejman collection, New York.

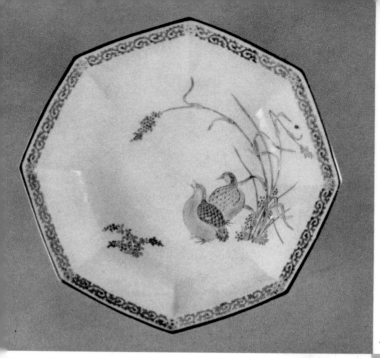

Plate 90. Kakiemon plate. Middle Edo period. Collection of the Marquis d'Ajeta, Rome.

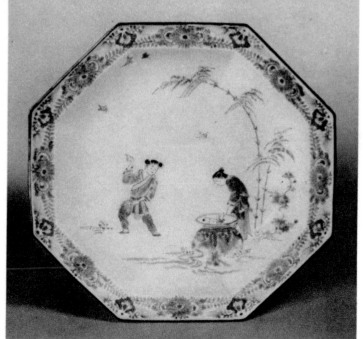

Plate 91. Kakiemon dish. Early Edo period. Soro collection, Rome.

163 *Porcelain*

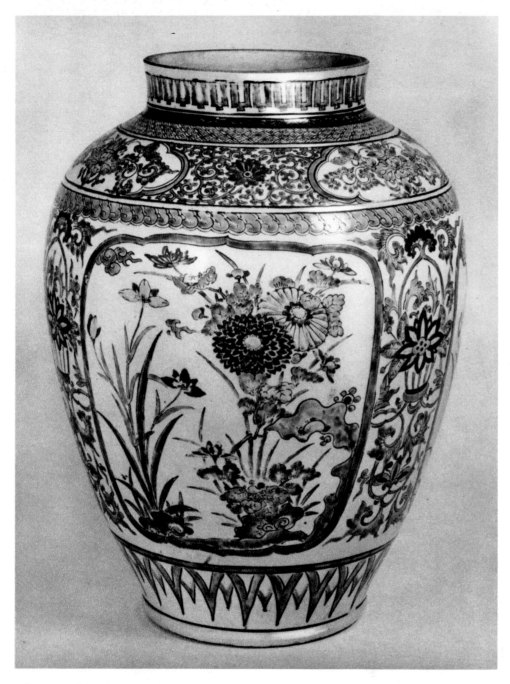

Plate 92. Kakiemon jar. Early Edo period. Freer Gallery of Art, Washington.

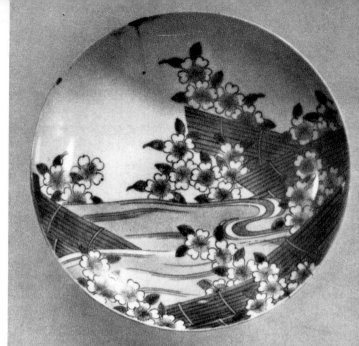

Plate 93. Nabeshima dish. Middle Edo period. Tokyo National Museum.

Plate 94. Nabeshima plate. Middle Edo period. Collection of the Marquis d'Ajeta, Rome.

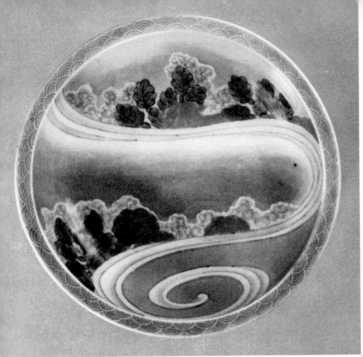

Plate 95. Nabeshima plate. Late Edo period. Collection of the Marquis d'Ajeta, Rome.

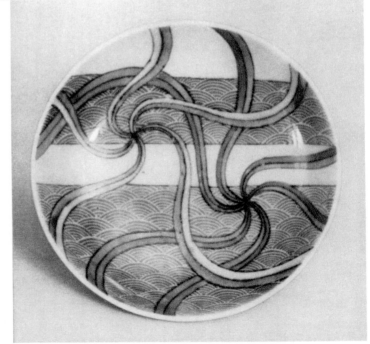

Plate 96. Nabeshima plate. Middle Edo period. Soro collection, Rome.

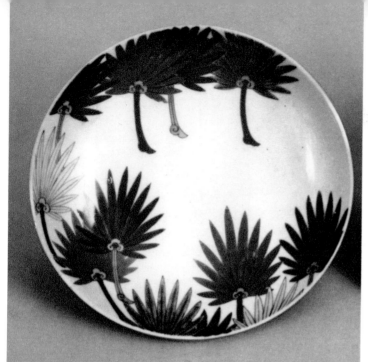

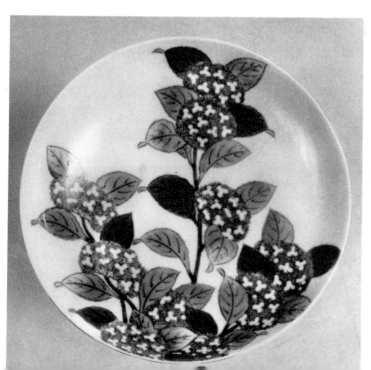

Plate 97. Nabeshima plate. Late Edo period. Soro collection, Rome.

Plate 99. Nabeshima dish. Middle Edo period. Tokyo National Museum.

Plate 98. Nabeshima plate. Middle Edo period. Soro collection, Rome.

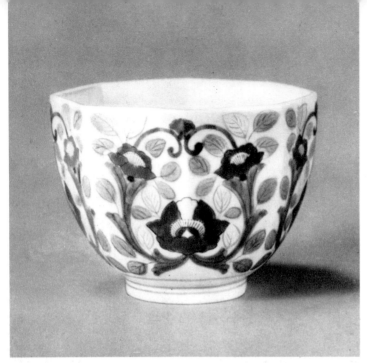

Plate 100. Nabeshima bowl. Late Edo period. Collection of the Marquis d'Ajeta, Rome.

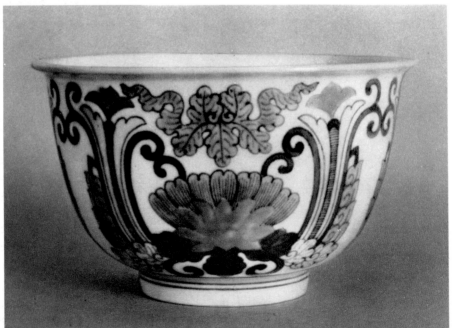

Plate 101. Nabeshima bowl. Middle Edo period. Soro collection, Rome.

Plate 102. Ko-Kutani bottle. Early Edo period. Freer Gallery of Art, Washington.

Plate 103. Ko-Kutani bottle. Early Edo period. Collection of Hammachi Mosaku, Tokyo.

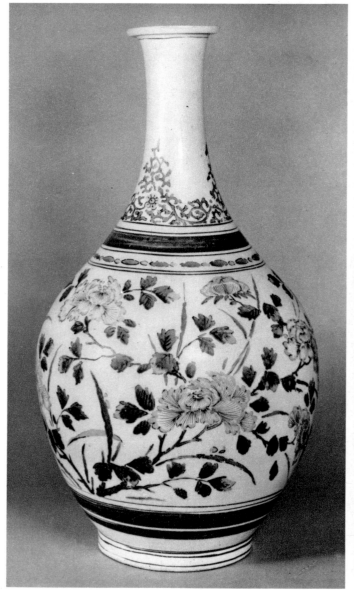

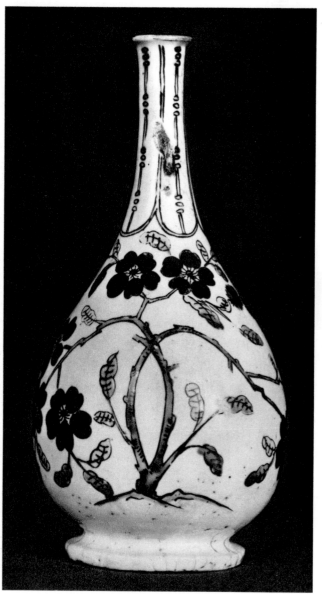

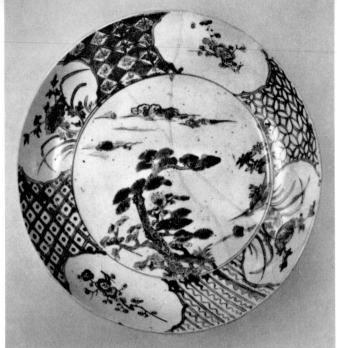

Plate 105. Ko-Kutani dish. Early Edo period. Private collection, Japan.

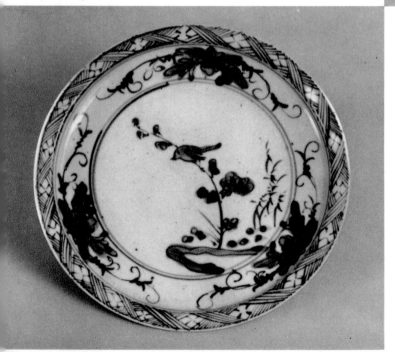

Plate 104. Ko-Kutani dish. Early Edo period. Soro collection, Rome.

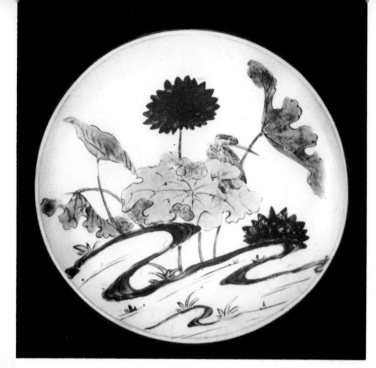

Plate 107. Ko-Kutani dish. Early Edo period. Collection of Yamada Setsuko.

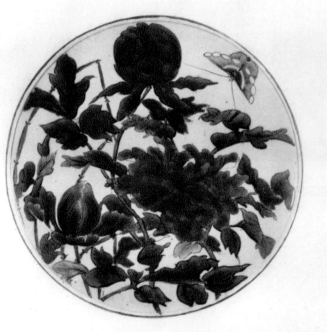

Plate 106. Ko-Kutani dish. Early Edo period. Tokyo National Museum.

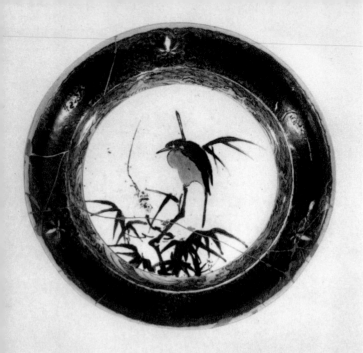

Plate 108. Ko-Kutani dish. Early Edo period. Sato collection, Tokyo.

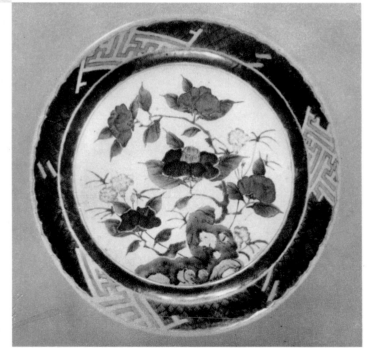

Plate 109. Ko-Kutani dish. Early Edo period. Kochu-kyo collection, Tokyo.

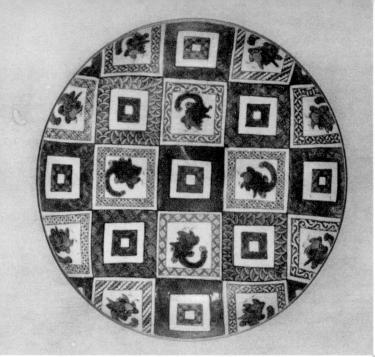

Plate 110. Ko-Kutani dish. Early Edo period. Maeda collection, Tokyo.

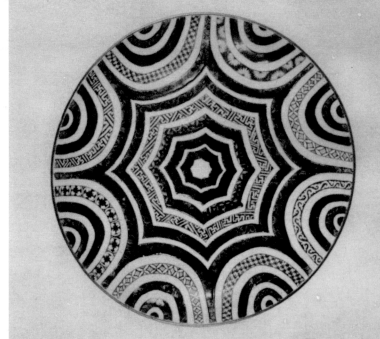

Plate 111. Ko-Kutani dish. Early Edo period. Collection of Tanabe Takeji.

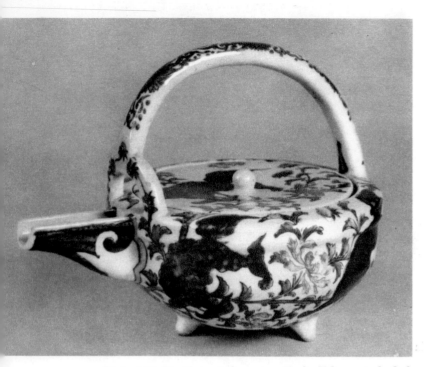

Plate 112. Ko-Kutani decanter. Early Edo period. Collection of Hosokawa Goritsu, Tokyo.

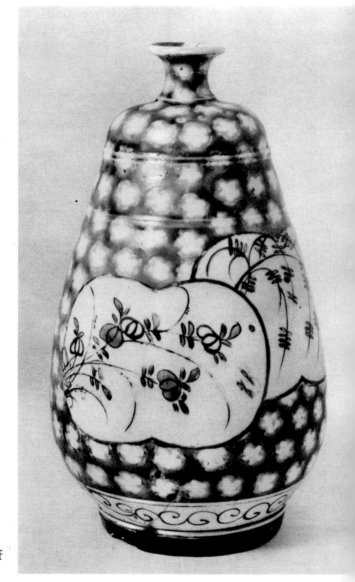

Plate 113. Ko-Kutani bottle. Early Edo period. Museum of Fine Arts, Boston.

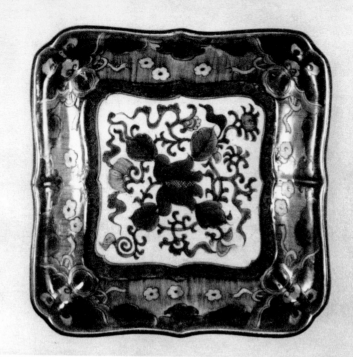

Plate 114. Yoshidaya Kutani dish. Late Edo period.
Private collection, Japan.

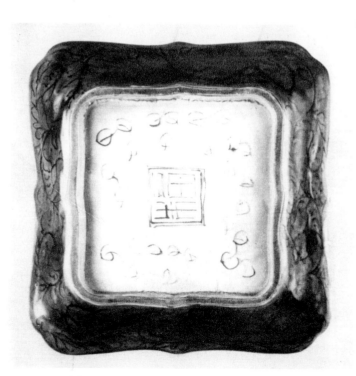

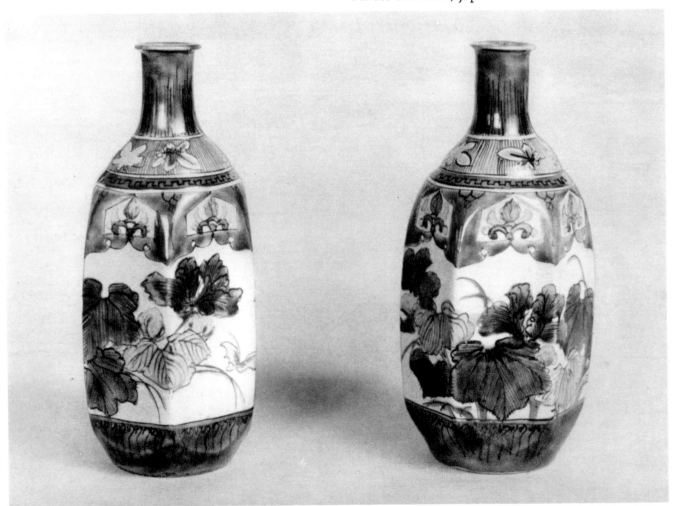

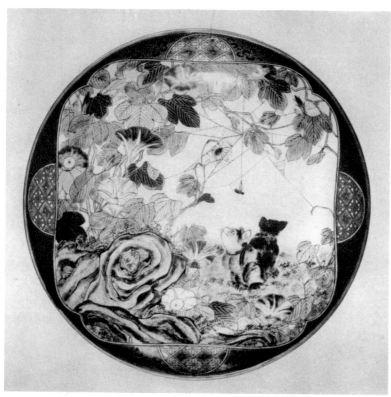

Plate 116. Kutani dish. Meiji period. Collection of Itaya Kashichi.

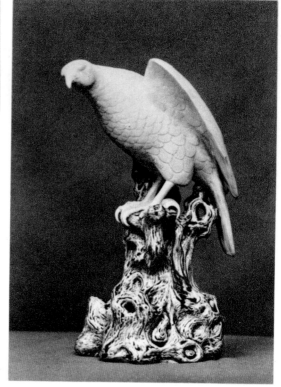

Plate 117. Hirado figure of a hawk. Late Edo period. Museum of Fine Arts, Boston.

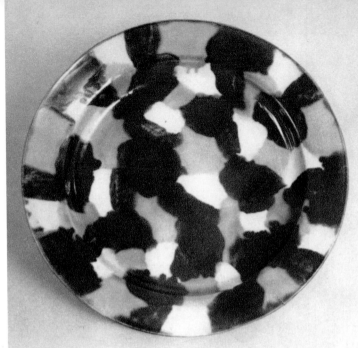

Plate 118. Nagayo plate. Middle Edo period. Soro collection, Rome.

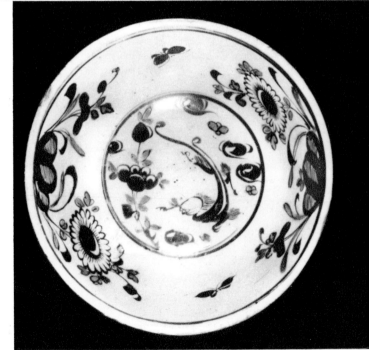

Plate 119. Dish by Eisen. Middle Edo period. Collection of Nagaya Mataro.

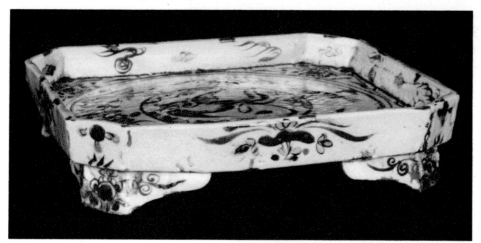

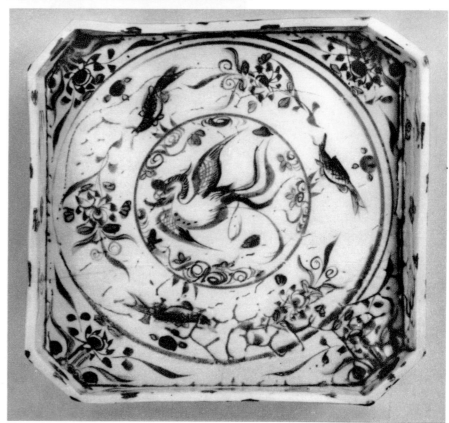

Plate 120. Square dish by Eisen.
Middle Edo period. Collection of
Okochi Masatoshi, Tokyo.

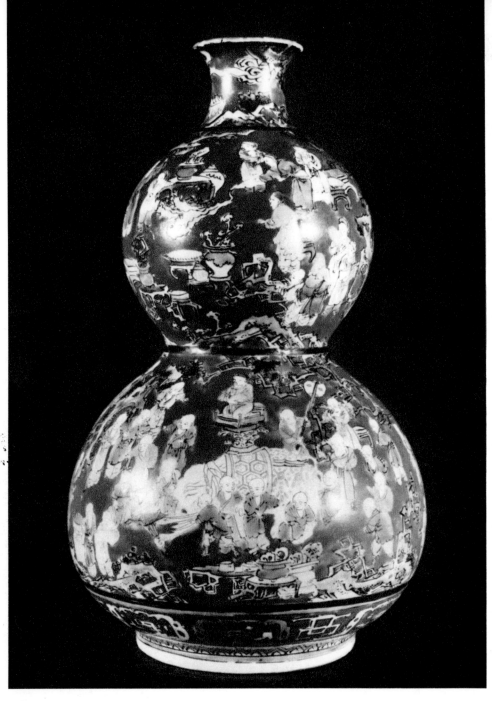

Plate 121. Vase by Moku-
bei. Late Edo period. Ralph
M. Chait Galleries, New
York.

The Ceramic Art of Japan

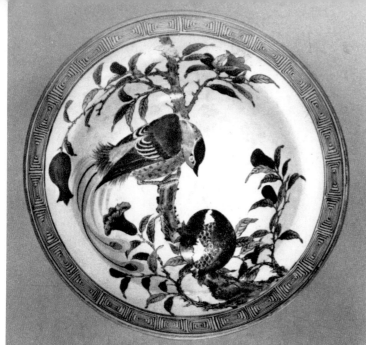

Plate 122. Awaji dish by Mimpei. Late Edo period. Collection of Okochi Masatoshi, Tokyo.

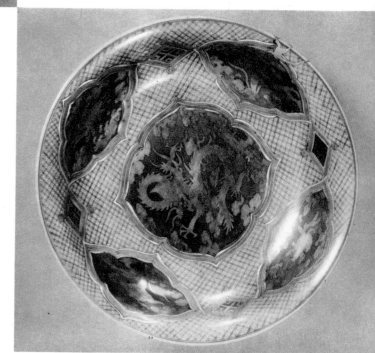

Plate 123. Dish by Wazen. Meiji period. Private collection, Japan.

181 *Porcelain*

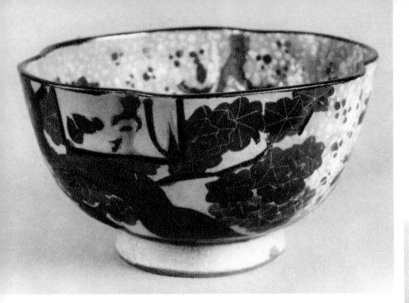

Plate 124. Bowl by Dohachi. Late Edo period. Tokyo National Museum.

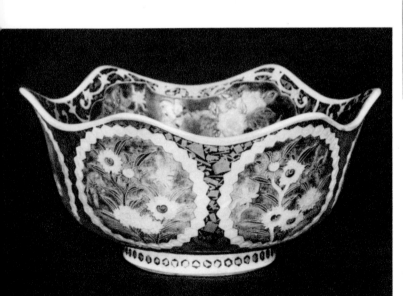

Plate 125. Cochin teapot by Mokubei. Late Edo period. Tokyo National Museum.

Plate 126. Bowl by Hozen. Late Edo period. Collection of the Seikado Bunko, Tokyo.

8 The Pottery of the Edo Period

WITH THE establishment of the Tokugawa shogunate and the transfer of the seat of power to Edo (the modern Tokyo), a new period of peace and prosperity commenced. This age, lasting for two and a half centuries (1615–1868), was therefore a very important one for the growth of the Japanese ceramic industry. In fact, practically all Japanese ceramics found in Western museums and owned by Western collectors come from this period. Now for the first time the common people were able to afford ceramic wares in their daily lives, and the result was an unprecedented growth in the output, first, of pottery and, later on, also of porcelain. The Edo period as a whole might well be divided into three phases. The first, covering the seventeenth century, culminated in the Genroku period (1688–1703), an age known for its love of gorgeous decoration which continued and further developed the style of the Momoyama period and witnessed the origin of Japanese porcelain manufacture. The second phase, known as the middle Edo period and spanning the eighteenth century, saw a tremendous expansion of the ceramic industry, accompanied by a lowering of quality. The third phase, starting with the beginning of the nineteenth century and ending with the Meiji Restoration of 1868, is called the late Edo period and is marked by a decline in pottery making and a phenomenal development of the porcelain industry, not only in the traditional center of Arita but also at Seto and Kyoto. This cheap mass-produced porcelain replaced pottery, at least in the urban centers, and completely revolutionized the Japanese ceramic industry.

To give a complete account of all the many kilns that were active during this long period would be next to impossible. Professor Morse, who attempted to do just that in his comprehensive catalog of Japanese pottery in the Boston Museum, furnished an instance of not being able to see the forest for the trees. Including all

the local potteries and amateur productions, there are at least ten thousand kilns, some of them producing several different types of ware and most of them using no potter's seal or other identification. Even if one were to treat only the main kilns whose output is recorded and can be identified with ease, there would still be hundreds of different wares involved, the classification of which would be of interest only to the specialist in the field of Japanese ceramics. For the purposes of this study, even such a limited treatment would prove confusing because of the similarities that exist among the outputs of the various kilns and the variety of wares made by individual kilns. It therefore seems better in this context to restrict the discussion to some of the most important kilns and to the kinds of pottery considered to be outstanding productions of this age that the collector is likely to encounter. These kilns and wares will be taken up by their geographical location, since this seems to be the most convenient way of classifying pottery made at a time when local rulers were exerting a strong influence on the industry of their realms.

The most important development in the production of pottery during this age was no doubt the emergence of Kyoto as a great center of ceramic manufacture rivaling, and in some respects even replacing, the traditional center of Seto. The early history of Kyo-yaki, as Kyoto ware is called, is uncertain, but the diary of an early seventeenth-century priest, Horin, indicates that Seto potters had come to Kyoto and opened a kiln at Awata in the eastern outskirts of the city at the foot of Higashiyama. It is today impossible to identify any early examples of this ware, but from the descriptions remaining to us it would appear that these early Kyo-yaki potters made tea jars in the Chinese style popular at Seto and tea bowls in the Korean style. At the same time a method of color glazing with a lead color agent had been introduced from China. It was the application of this new technique of color glazing for overglaze enameling that led to the development of a distinctly new type of ware that reflected the aristocratic culture of the ancient capital. Soon other kilns were founded in addition to the one at Awata: at Kiyomizu, Yasaka, Otowa, and Mizoro. But it was not until the famous potter Ninsei arrived on the scene that Kyoto ware was developed fully and became established as one of the chief types of Japanese ceramics. The very fact that this development should be due to the influence of one man indicates yet another important aspect of Kyo-yaki: namely that for the first time ceramics were not produced by anonymous craftsmen but by self-conscious artists who signed their output and showed marked individuality.

Ninsei, whose family name was Nonomura, was a native of the Tamba district, in which pottery had been made since the earliest times. From there he came to Kyoto after spending several years in Seto in order to study ceramic techniques there. Early works of his in the Seto style still exist. The exact dates of his life are a matter of dispute, and we know relatively little about him, although it is believed that his most active period as a potter comprised the fifth and sixth decades of the

seventeenth century, when he worked at the Omuro kiln in Kyoto. He was a painter as well as a potter, and he was greatly interested in techniques of enamel decoration as used by the potters of Arita and of Ming and Ch'ing China. A book of his that deals with various methods of glazing was handed down to his follower Kenzan and has been preserved. His most important contribution to Japanese ceramics was that he applied to pottery the gorgeous color enameling previously used only for porcelains—an innovation that was much admired at the time and has exerted a tremendous influence on the Japanese ceramic industry. Best known among his works is a group of large tea jars with brilliant-colored designs of flowers and trees reflecting the decorative style of the Momoyama period and the technique of the textile and lacquer artists. The two most beautiful among these are one showing wisteria blossoms, now in the Nagao Museum (*Plate 127*), and another showing flowering plum branches, now in the Tokyo National Museum. The designs, executed in gold, silver, and bright reds and greens, create a gorgeous effect. Most of Ninsei's work was intended for the tea ceremony—for example, elegantly fashioned and sumptuously decorated tea bowls and incense burners (*Plates 128 and 129*). There can be no doubt that Ninsei was a master when it come to developing this colorful and decorative style of Japanese pottery, but one would not have to be a purist to feel that the emphasis on pictorial decoration, as seen in his jar with the depiction of a mountain temple rendered in a very naturalistic style, lacks the strength and simple beauty of Raku ware (*Plate 130*).

The culmination of Kyo-yaki came with Ninsei's follower Ogata Kenzan, who is regarded by most critics as Japan's greatest ceramic artist. Certainly he was a very original and typically Japanese potter who owed nothing to Korea and China but developed a style all his own. Born in 1663 into a rich merchant family of Kyoto as the younger brother of the famous artist Ogata Korin, Kenzan studied poetry and the Noh drama, calligraphy and painting, the tea ceremony, and Zen philosophy before he took up pottery. It was under the inspiration of Ninsei, who had his Omuro kiln close to where Kenzan had settled, that he turned to pottery. That he actually worked under Ninsei is not certain, but we do know that he studied Ninsei's technique and that Ninsei's book on ceramics was in his possession. It was in 1699, when he was already thirty-four years old, that he took up pottery seriously and established his kiln under the sponsorship of Lord Nijo in Izumi-dani at Narutaki, not far from Ninsei's Omuro kiln in the northwestern outskirts of Kyoto. The work done during this early phase of his career, known as the Narutaki period, is considered his best and is avidly sought by collectors. Later his fortunes ebbed, and he had to sell his home at Nijo-dori, which loss forced him to move to the city and use the facilities of the Awata kilns. For this reason his early work shows his creative genius at its best, for financial independence enabled him to live only for his art, while his later work was done mainly for commercial purposes and suffered accordingly. At the end of his life, when he was nearly seventy years old, he moved to Edo

and built a kiln at Iriya. In this last decade of his life a new flowering of his artistic creativity took place, and his very late work is considered equal to his earlier masterpieces. Kenzan died in 1743 at the age of eighty, leaving behind an artistic legacy that was to have a profound influence on Japanese ceramics.

Kenzan's unique contribution to the development of Japanese ceramics lay first of all in his designs. Trained as a painter and calligrapher and in general a man of cultural refinement, he brought to his craft a richness of imagination and an artistic sensitivity which are unrivaled by any other Japanese potter. Through his brother Korin he had a profound understanding of the decorative tradition of the Koetsu-Sotatsu school, and he combined this with the perfection of color glazing that his master Ninsei had taught him. The results are works that, for color and design, are unsurpassed. Most of them are intended for use in the tea ceremony: articles such as water jars, tea jars, tea bowls, incense containers, incense burners, charcoal braziers, flower vases, plates and other dishes, and particularly the square dishes known as *sara*—a favorite with Kenzan because they lent themselves so well to painting and calligraphy *(Plate 131)*. Most of his productions consist of a soft ware similar to Raku and decorated with iron color over a white slip or with bright enamels *(Color Plate 7)*. His style is very free and bold, making use of colorful flat designs in the manner of the Korin school *(Plate 132)*. Especially effective is his use of calligraphy and black or brown brush painting against a white ground or in white on a dark ground *(Plate 133)*. His favorite motifs were taken from nature: flowers, grasses, trees, waterfalls, and flowing rivers *(Plate 134)*. Typical of these are his paintings of snow and bamboo representing winter, of the autumn grasses of the Musashino plain, of plum blossoms signifying spring, and of waves and waterfalls suggesting coolness in summer *(Plate 136)*. Of great interest also are some plates created jointly by the two brothers, Kenzan making the ware and doing the calligraphy and Korin painting the picture—for example, the celebrated design showing the god of longevity Jurojin, one of the seven gods of good luck *(Plate 137)*.

Because Kenzan was very productive and because his activity spanned a period of five decades, a great many of his pieces have no doubt been preserved. Since he became very famous, however, and enjoyed great popularity, many more pieces bearing his signature were made by his numerous followers and imitators. A further complication arises from the number of successors, who called themselves Kenzan II, III, IV, V, and VI. The most famous of these is the fifth Kenzan, Miura Kenya (1821–89), who had a kiln at Mukojima in Tokyo. His style is in the tradition of the first Kenzan but lacks the inspired quality of the master *(Plates 138 and 139)*. The sixth and last Kenzan, who worked in the northern suburbs of Tokyo, is also well known because he was the teacher of the famous English potter, Bernard Leach. Interestingly enough, none of these potters were direct descendants of Ogata Kenzan, who did not have a son, but were merely ceramists who worked in the Kenzan style and

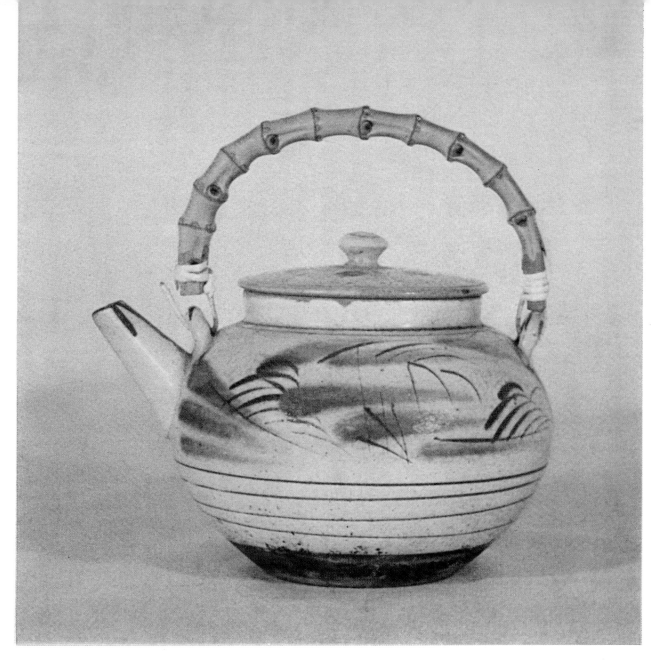

Color Plate 12. Shigaraki teapot. Showa period.
Yuasa collection, Tokyo.

regarded themselves as his followers. The second Kenzan was actually a son of Ninsei named Ihashi. All of them copied the shapes, designs, colors, and signature of the master, with the result that thousands of supposed Kenzans have flooded the market. As Bernard Leach points out, most of the so-called Kenzan wares in Western collections bought in Japan during the Meiji period are probably the works of the sixth Kenzan, who lived in poverty and obscurity in the slums of Tokyo and whose humble productions are today displayed as genuine masterpieces in the leading museums of Europe and America. Some of the works now attributed to the school of Kenzan are of very high quality (*Plate 140*), while others are definitely of inferior quality and reflect the taste of a later age (*Plate 135*). In fact, the situation is so confusing and the material so abundant that even the Japanese experts are often uncertain whether a given piece should be considered genuine or not, although there are of course individual pieces whose artistic excellence and history make it certain that they can be assigned to the master.

Kenzan's influence extended far beyond the line of potters who took his name. The entire school of Kyoto ceramists came under it, and local kilns in other places imitated his wares, as is well illustrated by the products of the Sanyo kiln in what used to be called Sanuki Province (now Kagawa Prefecture) in Shikoku (*Plate 142*). Among his many followers in Kyoto, the most outstanding was Nin'ami Dohachi, who, as we have seen in the last chapter, was one of the most prominent potters of the late Edo period. His most celebrated designs were the *unkin* or cloud-and-brocade patterns, "cloud" standing for cherry blossoms and "brocade" for autumn maples. Unlike the later Kenzans, Dohachi did not copy the style of the master blindly but used it creatively in a new and original way both in pottery and in porcelain.

The tradition of Ninsei and the Kyoto school was carried on mainly by the potters of the Kiyomizu and the Awata kilns. Their best wares come largely from the eighteenth century—the middle Edo period—and are today referred to as Ko-Kiyomizu or Old Kiyomizu (*Plate 143*). Numerous kilns were used by these Kyoto potters, the most important among them being Omuro, Awata, Kiyomizu, Mizoro, and Otowa (*Plate 144*). During the late Edo and Meiji periods, the Kiyomizu kilns began to specialize in enameled porcelains, while the Awata kilns continued to make enameled pottery in the Ninsei tradition. Among the most famous of the Awata-district kilns making these wares were Kinkozan, Hozan, and Taizan, examples of whose products are often seen in Western collections (*Plate 141*). In contrast to the contemporary pottery of other kilns, these wares exhibit the elegance and refinement of the Kyoto tradition. Saké bottles, vases, incense containers and burners, teapots, and teacups are most common, as well as ornamental figures. The most popular designs were those derived from nature: cherry branches, bamboos, pines, and all sorts of flowers and grasses. The decorations are executed in colored enamels—mainly blue, green, and gold, although red, white, and silver are also used.

The glaze used in these wares is yellowish white and has a fine crackle. A very different ceramic tradition was carried on during the entire Edo period by the Raku family. In contrast to the decorative enameled wares associated with Ninsei and Kyo-yaki, the Raku potters, although also located in Kyoto, continued to work in the subdued and vigorous style of their ancestors. Among the numerous artists working in the Raku style by far the most illustrious was Hon'ami Koetsu, who had been a pupil of Donyu (Nonko), the third Raku. Hon'ami's masterpiece is the tea bowl called Fuji-san (Plate 145), which is now classified as an important cultural treasure of the Japanese nation. The bowl is remarkable not only for its very simple but strong shape but also for its unique design: the upper part covered with white glaze and the lower half with a dark gray representing the mist at the foot of sacred Mt. Fuji.

The influence of Raku ware also spread to other centers, the most important branch kiln being the one at Ohi, in Kanazawa, founded in 1666 by one Chozaemon. The ware produced there is quite similar to Raku, although it is redder and denser. The color of the glaze is usually a light brown or reddish tone, but black and white glazes are also used (Plate 146). Yet another kiln founded by Raku potters is the one at Horaku, located near Nagoya and established in 1820. The output of this kiln was also of the Raku type—both the red and the dark-brown or black variety. The later productions of the kiln were marked by the use of lacquer to cover part of the exterior of the vessel, but the best wares made by the Horaku potters (whose family name was Toyosuke) were the early-nineteenth-century tea bowls that were sometimes ornamented with attractive designs of a very decorative type (Plate 147). Yet neither of these wares is regarded by connoisseurs as being equal to the productions of the Raku family of Kyoto, who continued to make their traditional wares throughout the Edo period.

Of the kilns in the vicinity of Kyoto, one of the most important was that of Asahi, not far from Uji, the famous tea-growing center. The name Asahi, which means morning sun, is believed to derive from the color of the ware—a color suggesting dawn. The Asahi kiln was founded in the early Edo period and became one of the favorite kilns of the great tea master, Kobori Enshu. Most of its products are tea vessels, and especially celebrated among these are the tea bowls, prized by the chajin for the beauty of their shape and color. Their style resembles that of the Korean wares of the Karatsu and Hagi kilns, but they are unique for their simple grace and refinement. Particularly beautiful is the color, which in the old wares is often a translucent green or blue of great subtlety through which the rather coarse brown body of the vessel may be seen. The Asahi kiln's production has continued into modern times, but the best work is that of the second half of the seventeenth century.

Another well-known kiln in the Kansai region is Akahada, located at Koriyama in Nara Prefecture. It was founded during the Momoyama period by potters from

Tokoname and was one of the seven kilns of Kobori Enshu. Tradition has it that Ninsei himself worked there. Its later history is rather confused, for it was closed and later reopened. The best output of its later period was made during the nineteenth century by Kashiwaya Buhei, better known as Mokuhaku (1799–1870). A great variety of pottery was produced at the kiln. The early examples, under the influence of Kobori Enshu, were tea-ceremony wares with grayish-white glaze in the tradition of Hagi and Takatori, but far more typical are the ceramics made in the Kyo-yaki manner of Ninsei. In fact, many of Mokuhaku's wares are actually replicas of Ninsei's celebrated pieces. His most original work, however, is found in his tea bowls with designs picturing Horai, the Taoist land of the immortals, and in his water jars with charming little pictures in a rather naïve and primitive style resembling that of the Buddhist Ingakyo scrolls of the Nara period (*Plate 148*).

In neighboring Mie Prefecture is Kuwana, near which Banko ware is made. The output of this kiln, like that of Akahada, is rather varied and includes such opposites as Raku and enameled Chinese-style porcelains as well as Shino, Oribe, and Karatsu. The most important productions of the kiln, however, were the wares in the Kyo-yaki style of Ninsei and Kenzan and the wares copying Western designs, some of them even imitations of Delft which had become fashionable in Japan during the eighteenth century, when this kiln was at the height of its activity. Although the Kyoto influence was strong, Banko wares preserve something of a rustic beauty that gives them their unique appeal. Most memorable are the handsome wine ewers with gracefully curving handles and projecting spouts (*Color Plate* 8). They are usually made of thick stoneware or semiporcelain, covered with a cream-colored glaze, and decorated with designs in bright red, green, indigo, and purple. The scenes depicted are usually Chinese landscapes with figures or legendary animals, but the border designs are Western in derivation. This combination of Chinese and Western elements is characteristic of the Ko-Banko or Old Banko productions, which are considered the best wares made at this kiln.

In contrast to Kyoto ware, which was often the product of artists who tried to express their individuality and signed their works with a seal, Kyushu pottery was mass-produced on a factory scale and intended for the use of the common people. The center of Kyushu pottery manufacture was the same as for porcelain: the province of Hizen, which is now divided between the prefectures of Saga and Nagasaki. This ware is usually referred to as Karatsu because it was exported from that port town, but it was actually made at a variety of local potteries of that district. Since most of these kilns were founded by Korean potters and since Kyushu was in close contact with Korea, the Korean influence was strong. The finest productions of these kilns were intended for the tea ceremony, and these reached their apogee during the Genna era (1615–23), at the very beginning of the Edo period. The great bulk of the ceramic output, however, was intended for daily use. Although Karatsu ware continued to be made right down to modern times, the com-

petition of porcelain led to its decline during the eighteenth and, even more, the nineteenth century, when porcelain was made on an industrial scale. Karatsu may be divided into many different categories and types, such as White Karatsu, Blue Karatsu (with a yellowish-blue glaze), Red Karatsu (which is highly oxidized), and Black Karatsu. Other types of Karatsu have the *hakeme* or brush-mark design or the Korean-style inlay known as the Mishima pattern. Best known of all are the painted or E-Garatsu wares with spirited abstract designs *(Plate 149)*. The finest of these were made during the early Edo period, but E-Garatsu is still being made in the town of Karatsu today. All of these wares show a strong Korean influence, but there is one type of Karatsu pottery that is specifically named Chosen (Korean) Karatsu and is characterized by the use of two different colors in the decoration *(Plate 150)*. The spirit of these wares is bold and simple, the shapes are strong, the bodies are rather coarse, the glaze is thick and uneven, and the colors are subdued *(Plate 151)*. Although they were popular for this reason with the tea masters, who valued their directness and their unpretentiousness, Karatsu wares also enjoyed great popularity with the ordinary people—so much so that all of the pottery of western Japan was collectively referred to as *karatsumono*, just as that of eastern Japan was called *setomono* after the other great pottery center of that time.

Many other kilns working in the Korean style have existed in Kyushu. The most famous are located in Kagoshima, and the pottery made there is called Satsuma ware after the old name of this prefecture. This ware is known in the West primarily through the overdecorated colored enamels of modern date that enjoyed great fame in Europe during the late nineteenth century. The original productions of the Satsuma kilns, however, were tea-ceremony wares in the Korean style of the Yi dynasty. In fact, the main kilns, such as Chosa, Naeshirogawa, Ryumonji, and Tateno, were actually founded by Korean potters who until quite recently preserved their national identity and mode of life. Of the great variety of wares produced by these kilns, the most important are the white-glazed wares known as Shiro-Satsuma, the black ones called Kuro-Satsuma, the *dakatsu* or snakeskin type with a double glaze of black over white, the inlaid wares, and the kind which is modeled on the Siamese wares of the Swankalok type. Many shapes are employed, but the best are considered to be the strong and dignified tea bowls *(Plates 152 and 153)*.

Among the other Kyushu kilns, Takatori, Agano, Yatsushiro, Utsutsugawa, and Shodai are perhaps the most remarkable, although many others could be cited. The early Takatori and Agano wares were very similar to Karatsu ware and in fact cannot be clearly distinguished from it, but they developed their own characteristics later on. The kilns, both located in what is now Fukuoka Prefecture, were celebrated for their tea-ceremony wares in the Korean style. Outstanding among the early wares are those with a thick, creamy white glaze and heavy forms *(Plate 154)*. The mature style of Takatori is best represented by the tea jars and water containers with beautiful black-brown *temmoku* glazes or combinations of the white

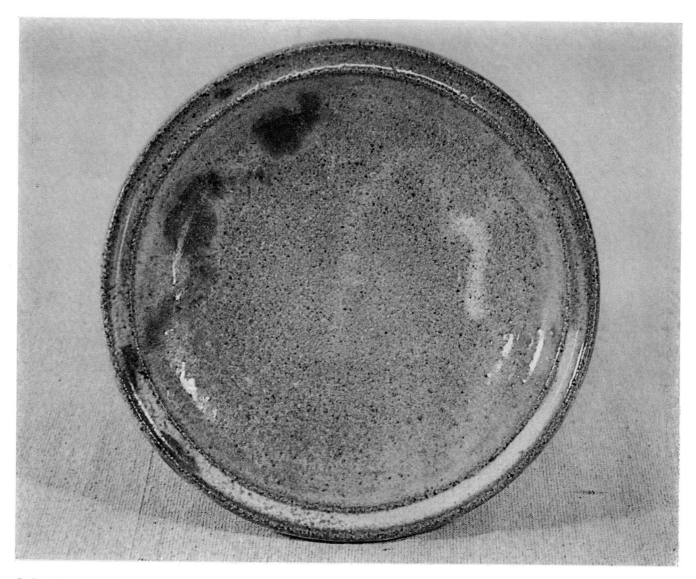

Color Plate 13. Hongo plate. Showa period. Collection of the author.

and the dark glaze (*Plate 155*). The early Agano wares also show the creamy white glaze, although often with a greenish tinge, or dark-brown glazes (*Plates 156 and 157*), while the later ones are marked by a bluish-green glaze. Both of these kilns still exist, but they have declined greatly.

Yatsushiro, in Kumamoto Prefecture, was originally founded by Agano potters but later developed its own style. It was noted for Mishima-type wares with inlay in white and at times also in black. The designs, following Korean models, show flying storks and floral patterns of great elegance and beauty (*Plates 158 and 159*). On the other hand, Utsutsugawa, located near Nagasaki, specialized in white brush-mark drawings of attractive fruit and flower patterns (*Plate 160*). The most modern in feeling is the pottery produced by the Shodai kiln in Kumamoto Prefecture, which employs white glaze splashed on the surface of the vessel in a very free, spontaneous manner that recalls the style of some of our modern abstract painters (*Plate 161*).

Another center of ceramic manufacture, the San-in district, was located on the Japan Sea side of the main island of Honshu. Facing Korea, this region had from the earliest times been under the influence of cultural importations from the Asiatic mainland, and it is therefore not surprising that the pottery too should show a markedly Korean influence.

The most important center of ceramic production in western Japan was Hagi, in Yamaguchi Prefecture, with branches at Matsumoto and Fukagawa in the same prefecture and related kilns also working in the Korean style at Fujina and Raku-zan, near Matsue in Shimane Prefecture. Like so many Japanese kilns, Hagi was founded by Korean potters who had been brought to Japan by Mori Terumoto, the lord of the region, when he returned from the Korean expedition launched by Hideyoshi. The early Hagi wares were used exclusively for the tea ceremony and were not sold to the public. They resemble the pottery of the Yi dynasty, especially the Ido tea bowls. Always plain, they display beautiful glazes—yellowish green, milk white, and loquat color—and simple yet elegant forms (*Plates 162–64*).

Other types of ware made at the Hagi kilns are Oni Hagi or Devil Hagi, which has rough stones in its clay, and Hagi Koetsu, which resembles Raku ware. Rakuzan ware or Izumo ware, as it is also called, was originally an offshoot of Hagi, for the kiln was founded by Hagi potters who had been called to Matsue by Lord Matsu-daira in 1677. The output, at least originally, consisted largely of tea utensils, par-ticularly tea bowls in the Korean style (*Plate 165*). During later years, however, the kiln came under Kyoto influence, and elaborately decorated enameled ware was made. The Fujina kiln was founded in 1764 by the Funaki family, which is still active there. It, too, specialized in a Korean type of tea bowl that was outstanding for its beautiful bluish-green, white, and yellow-brown glazes and strong, elegant shapes (*Color Plate 9*).

In central Japan, Seto continued to be the most important center of ceramic

production, but in the east and the north there were few kilns except for a few local potteries like those of the Kenzan followers in Edo and the Soma kiln in Fukushima Prefecture, which became well known because of the galloping horse drawn for it by the famous seventeenth-century painter Kano Naonobu. In the Seto district all the various wares that had originated during the Momoyama period, such as Shino, Oribe, Ki-Seto, and *temmoku*, continued to be made during the Edo period. By middle Edo, however, the quality had begun to decline, and by the end of the period the Seto kilns had turned more and more to the manufacture of porcelains. Among the later productions the most vital are the ordinary kitchenwares such as *ishizara* (stone plates) and oil plates decorated with bold and free designs of grasses and landscapes *(Plate 170)*. At the same time the older tradition of Chinese-style *temmoku* was carried on by the descendants of the Kato family. Far more important for the Seto kilns, however, was the sojourn of Kato Tamikichi in Arita in 1801 in order to study porcelain manufacture. He remained there for four years and married the daughter of one of the local potters. After learning the technique of making porcelains, he returned to Seto in 1807 and began to make the blue-and-white ware known as *sometsuke*. The paste of these porcelains is somewhat coarser than that of Arita ware, and the glazes are more glassy, but this industry flourished and made Seto the leading ceramic center of Japan, a position that Aichi Prefecture (where Seto is located) still maintains today. Close to Seto was the Inuyama kiln, where beautiful enameled pottery with cherry and maple designs and bright floral patterns in red and green was produced during the late Edo period.

Many of the kilns that had already been active during the earlier centuries continued to produce fine ceramics into the Edo period. Of these the most typically Japanese, showing no marked influence from either Korea or China, were the traditional kilns at Bizen in Okayama Prefecture, Iga in Mie Prefecture, Shigaraki in Shiga Prefecture, and Tamba in Hyogo Prefecture. Among these, Bizen developed most markedly during this period, although it must be added that the early Bizen wares from the beginning of the Edo period are the best *(Plates 167–69)*. In addition to the unglazed bronze-colored ware that had been traditionally made at this kiln, Blue Bizen and White Bizen were introduced. During the eighteenth and the early nineteenth century the Bizen potters also produced incense burners and decorative figures modeled in a naturalistic style that used to enjoy great popularity with Western collectors. However, the detailed realism and the slick surface of these works made them far less satisfactory examples of the potter's art than the beautiful tea bowls, bottles, and vases made at this kiln. Another later development was the appearance during the nineteenth century of a smoother and finer type of ware known as Imbe after the main pottery town of the district. At Iga and neighboring Shigaraki the climax had also been reached during the seventeenth century when Kobori Enshu advised Lord Todo in matters pertaining to the tea ceremony.

The eighteenth-century production, with its crude forms and its thick and spontaneously applied bluish-green natural glaze, was often still fine *(Plate 166)*, but by the nineteenth century these wares had declined and lost much of their strength and beauty. The Tamba kiln, which has continued down to the present day, was also active during the Edo period, producing rather plain ware with a dark-brown or white glaze. Most of these wares were made for use by ordinary people, the most popular being the pepper jars and the wine bottles with long, narrow necks.

The kilns discussed here manufactured but a small portion of the thousands of wares made during the two and a half centuries that the Edo period comprised. It seems better, however, to emphasize those regions and centers that stand out rather than to lose oneself in a wealth of detail that would confuse more than enlighten. Furthermore, every collector and scholar will repeatedly run into many examples of Japanese pottery—often quite attractive—that cannot be placed with any certainty if their history and provenance are not known. Style, technique, clay, and glaze may give a clue to the expert, but even these may prove misleading, for the style of a famous potter may have been imitated in many places. Even glazes and clay might have been brought to other kiln sites, or visiting potters, as well as amateurs, might be found working at kilns not usually associated with them. If it has been impossible for Japanese scholars to straighten out the confusion surrounding such well-known figures as Ninsei and Kenzan, to whom a great deal of study and research has been devoted, it is clear that many less well-known figures and kilns, most of them using no seal or signature, will always remain somewhat of a mystery. This, however, should not prevent us from enjoying their output.

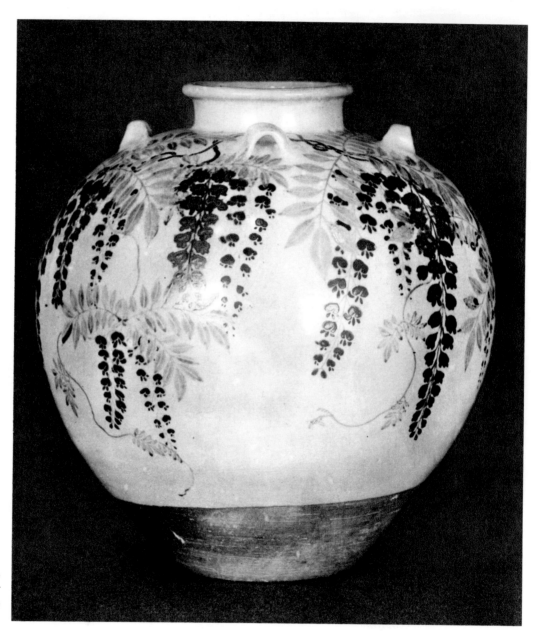

Plate 127. Jar by Ninsei. Early Edo period. Collection of Nagao Kinya, Tokyo.

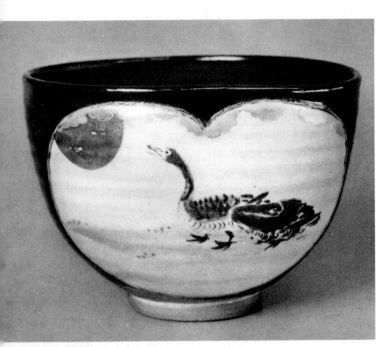

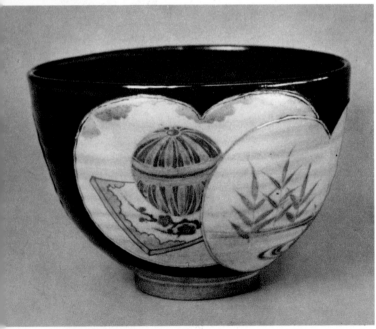

Plate 128. Tea bowl by Ninsei, Early Edo period. Collection of Tokusawa Kunitaka, Tokyo.

Plate 129. Tea bowl by Ninsei. Early Edo period. Tokyo National Museum.

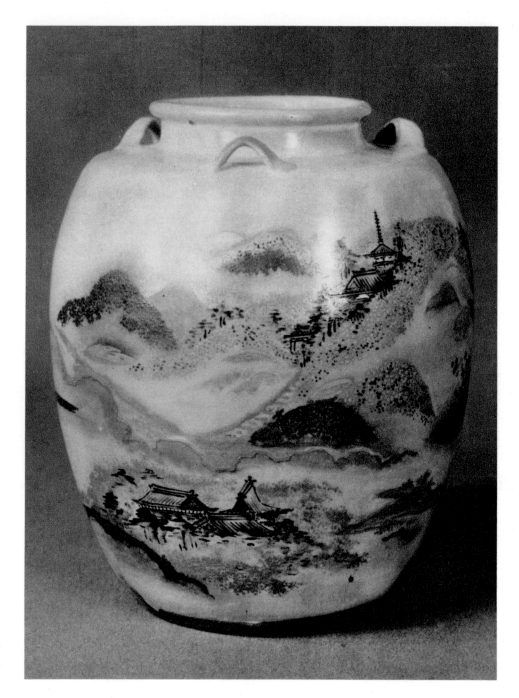

Plate 130. Jar by Ninsei. Early Edo period. Nezu Museum, Tokyo.

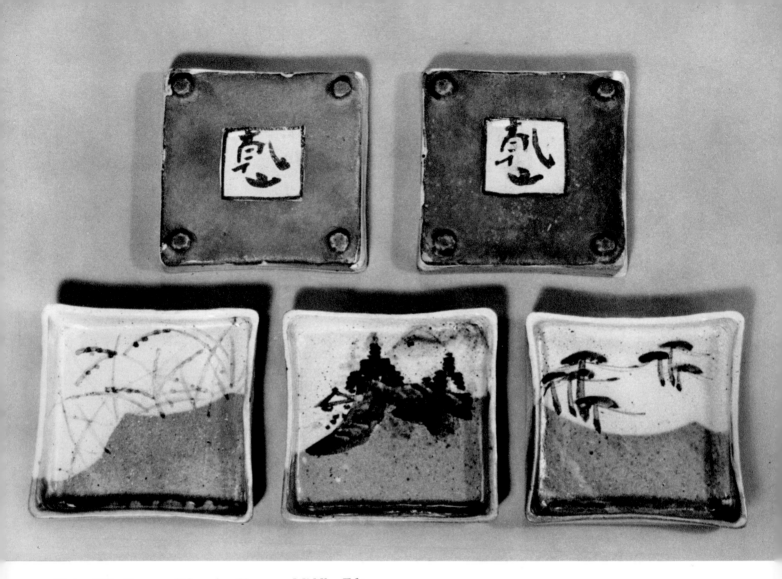

Plate 131. Square dishes by Kenzan. Middle Edo period. Kushi collection, Tokyo.

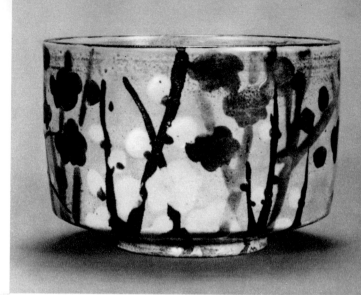

Plate 132. Tea bowl by Kenzan. Middle Edo period. Collection of Takeuchi Zenji, Tokyo.

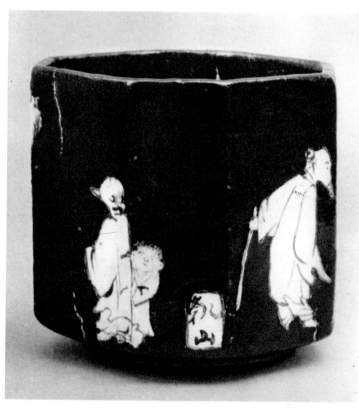

Plate 133. Tea bowl by Kenzan. Middle Edo period. Collection of T. Rosenberg, New York.

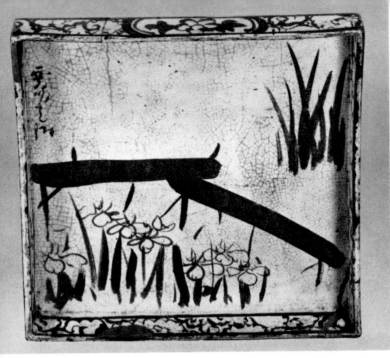

Plate 134. Square plate by Kenzan. Middle Edo period. Freer Gallery of Art, Washington.

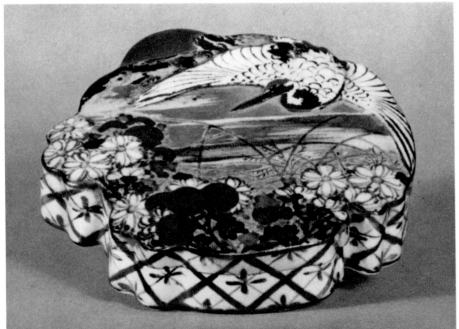

Plate 135. Incense box in style of Kenzan. Late Edo period. Freer Gallery of Art, Washington.

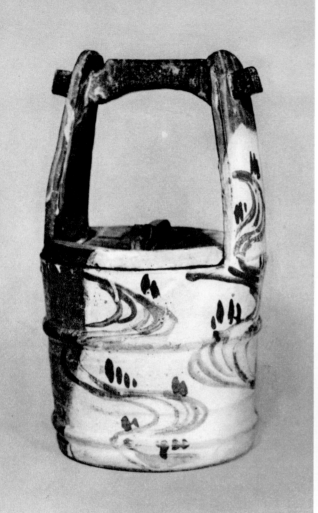

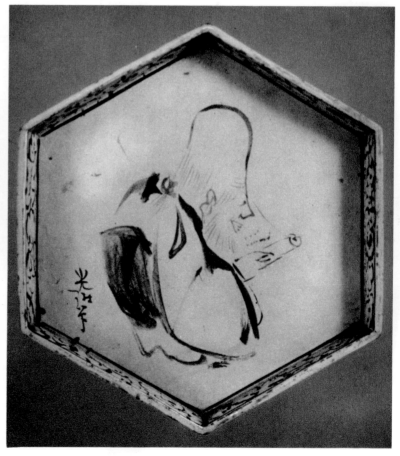

Plate 136. Water jar by Kenzan. Middle Edo period. Itsuo Museum, Osaka.

Plate 137. Plate by Korin and Kenzan showing Jurojin. Middle Edo period. Collection of Okura Shichiro, Tokyo.

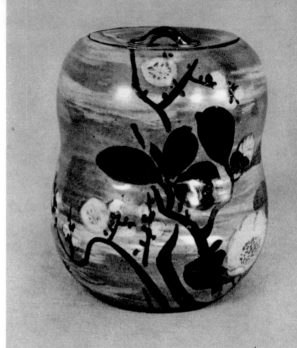

Plate 138. Water jar by Kenya. Late Edo period. Tokyo National Museum.

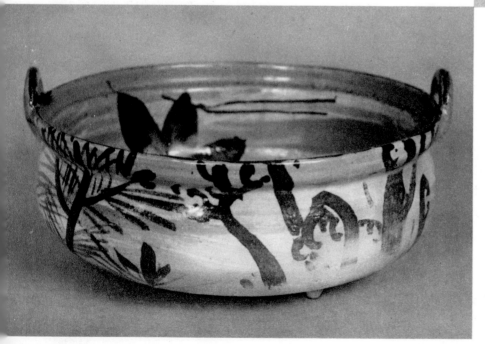

Plate 139. Basin by Kenya. Late Edo period. Tokyo National Museum.

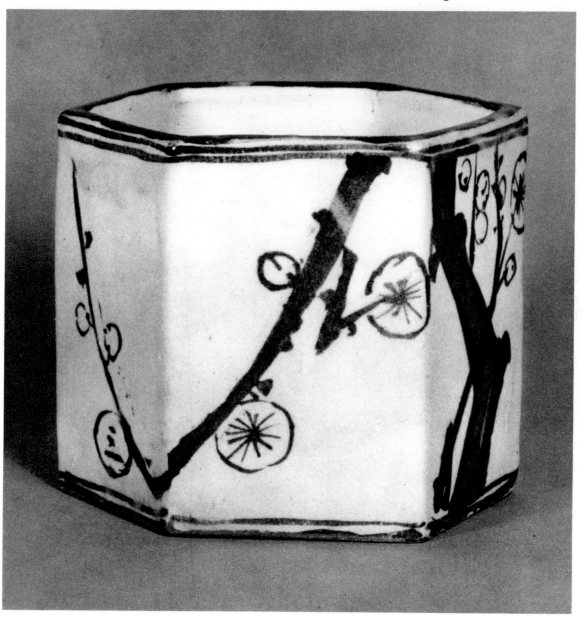

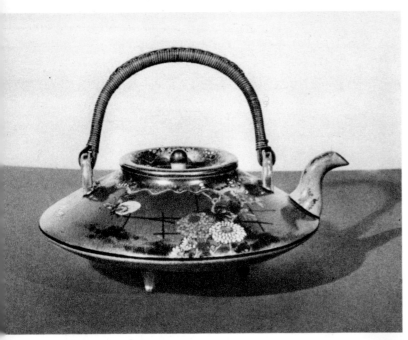

Plate 141. Awata decanter. Meiji period. Collection of the author.

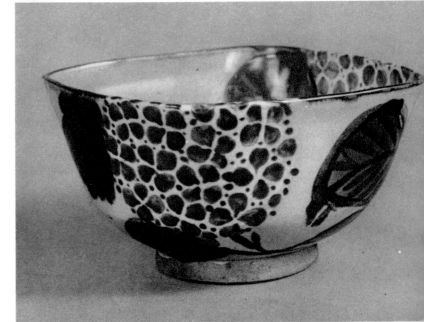

Plate 142. Sanyo bowl. Middle Edo period. Tokyo National Museum.

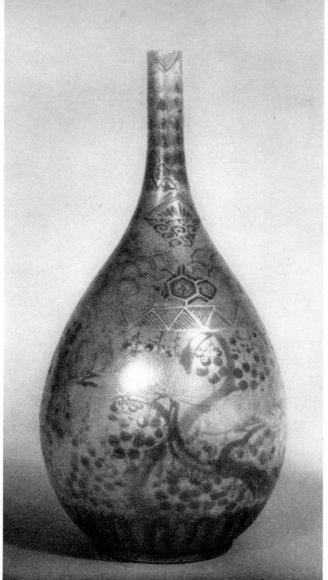

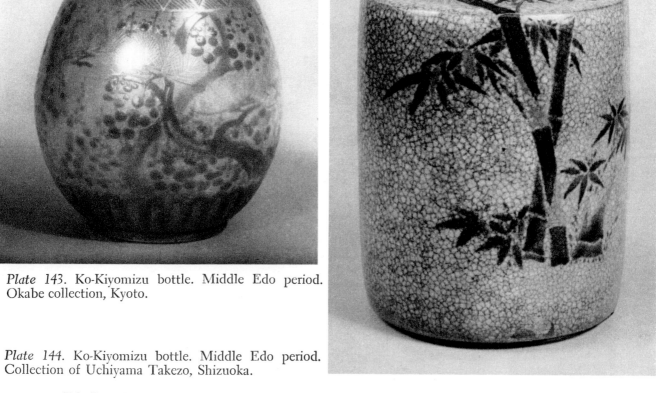

Plate 143. Ko-Kiyomizu bottle. Middle Edo period. Okabe collection, Kyoto.

Plate 144. Ko-Kiyomizu bottle. Middle Edo period. Collection of Uchiyama Takezo, Shizuoka.

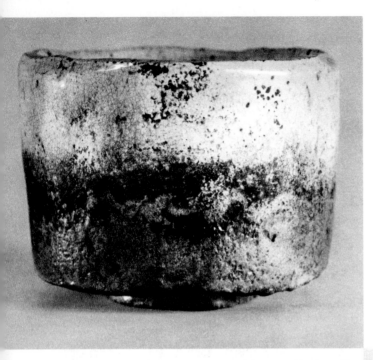

Plate 145. Raku tea bowl by Kōetsu: "Fuji-san." Early Edo period. Collection of Sakai Tadamasa, Tokyo.

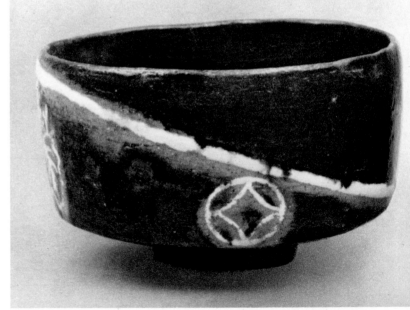

Plate 146. Ohi tea bowl. Late Edo period. Collection of T. Rosenberg, New York.

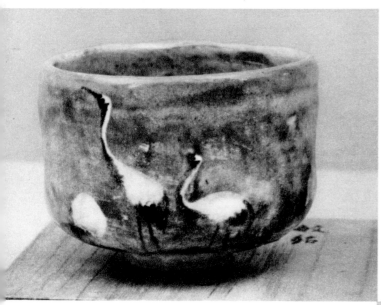

Plate 147. Horaku tea bowl. Late Edo period. Collection of T. Rosenberg, New York.

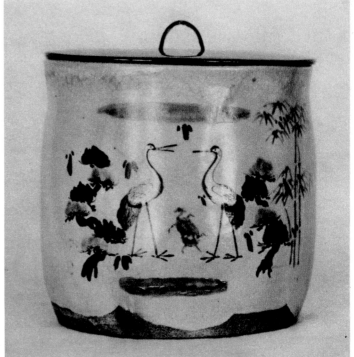

Plate 148. Akahada jar by Mokuhaku. Late Edo period. Collection of Hirukawa Daiichi, Kyoto.

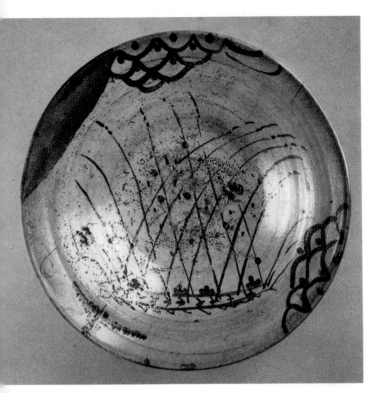

Plate 149. E-Garatsu bowl. Early Edo period. Private collection, Japan.

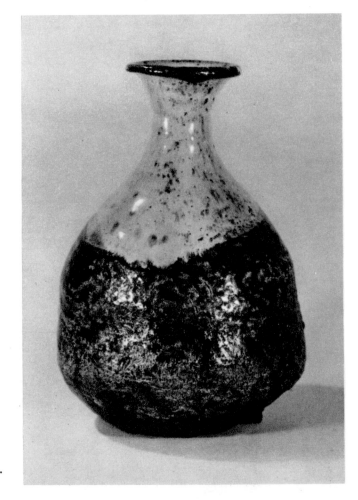

Plate 150. Chosen Karatsu bottle. Middle Edo period. Itsuo Museum, Osaka.

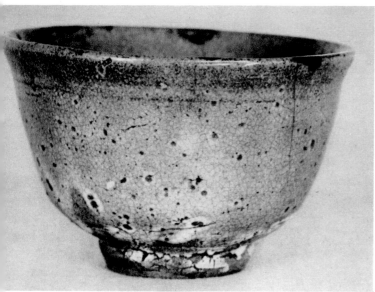

Plate 151. Karatsu tea bowl. Middle Edo period.
Collection of Kondo Shigeya.

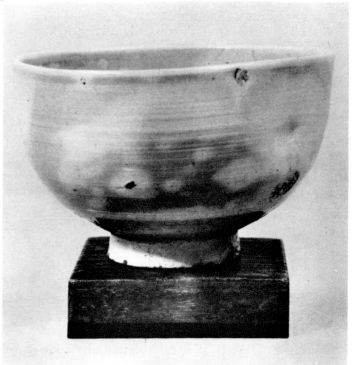

Plate 152. Satsuma tea bowl. Middle Edo period.
Collection of T. Rosenberg, New York.

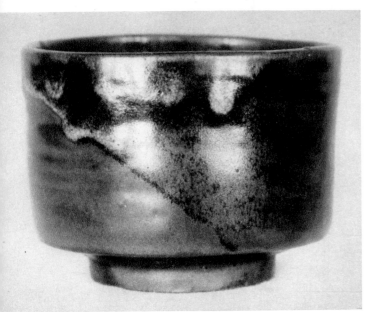

Plate 153. Satsuma tea bowl. Early Edo period. Collection of Todoroki Han, Tokyo.

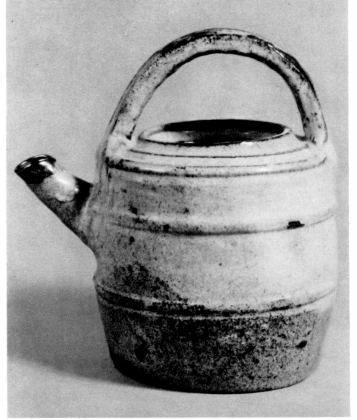

Plate 154. Takatori water pitcher. Early Edo period. Private collection, Japan.

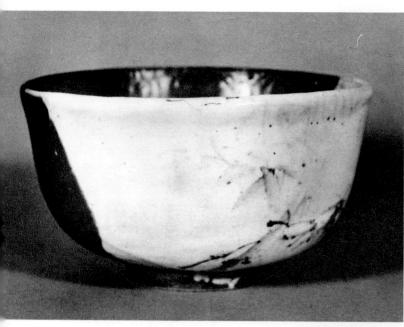

Plate 155. Takatori tea bowl. Middle
Edo period. Itsuo Museum, Osaka.

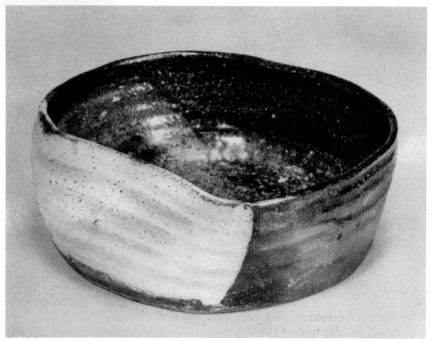

Plate 156. Agano bowl. Early Edo
period. Private collection, Japan.

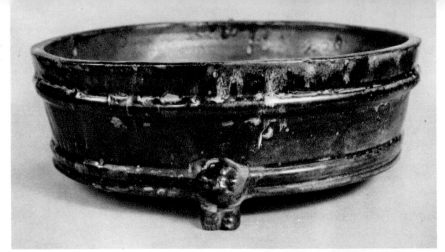

Plate 157. Agano water basin. Early Edo period. Collection of Shirakibara Katsuhiko, Oita.

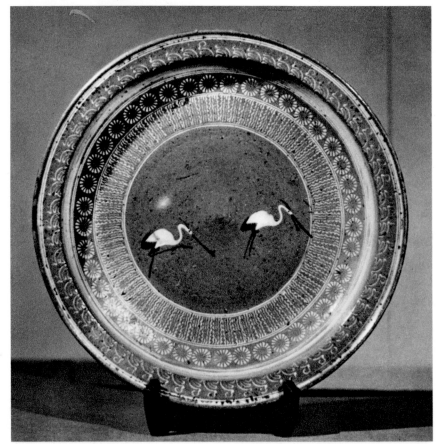

Plate 158. Yatsushiro plate. Middle Edo period. Collection of the author.

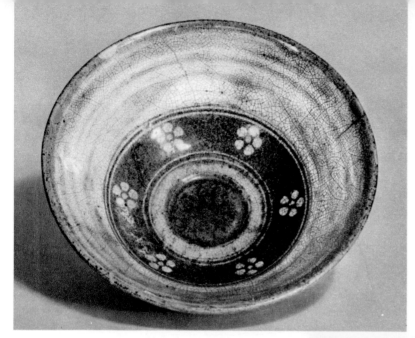

Plate 159. Yatsushiro tea bowl. Middle Edo period. Museum of Fine Arts, Boston.

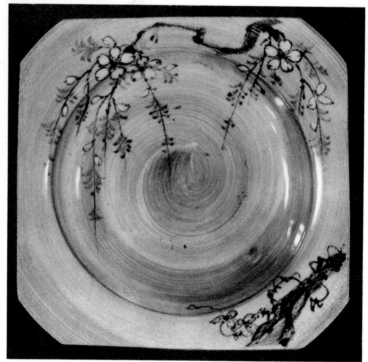

Plate 160. Utsutsugawa dish. Middle Edo period. Collection of Nakao Kunio, Nagasaki.

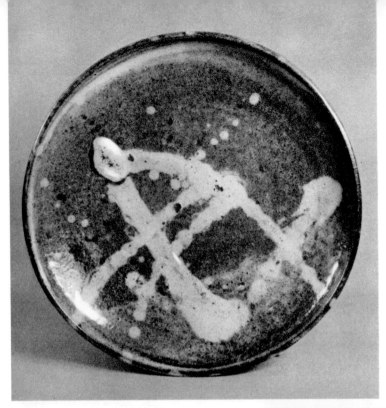

Plate 161. Shodai dish. Early Edo period. Tokyo National Museum.

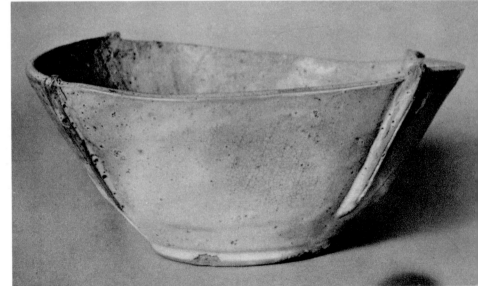

Plate 162. White-glaze Hagi dish. Early Edo period. Tokyo National Museum.

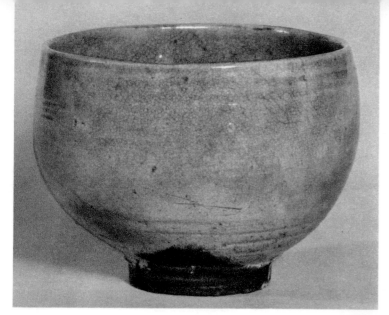

Plate 163. Hagi tea bowl. Middle Edo period. Freer Gallery of Art, Washington.

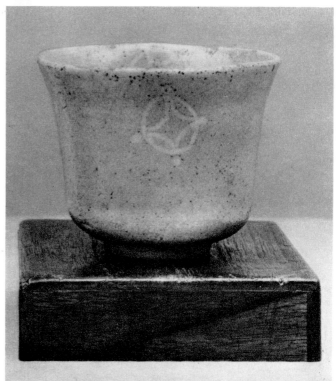

Plate 164. Hagi tea bowl. Late Edo period. Collection of T. Rosenberg, New York.

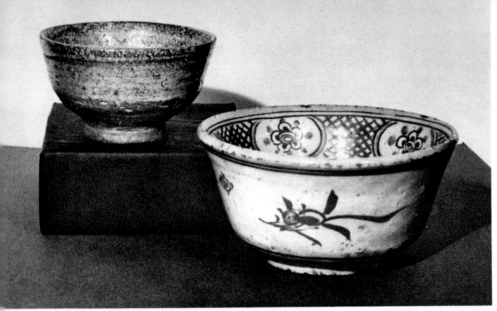

Plate 165. Left: Izumo tea bowl. Middle Edo period. Right: Inuyama tea bowl. Late Edo period. Collection of the author.

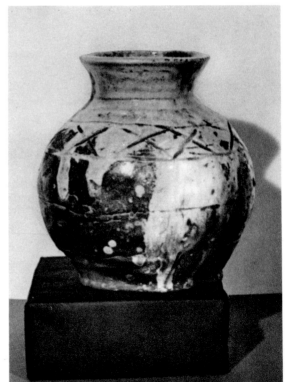

Plate 166. Iga jar. Middle Edo period. Collection of the author.

Plate 168. Bizen figure of Hotei. Early Edo period. Collection of Yamamura Toyoshige.

Plate 167. Bizen flower vase. Early Edo period. Collection of Tachibana Oshio.

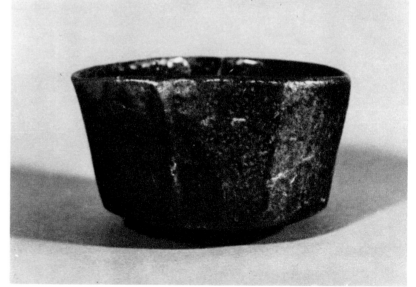

Plate 169. Bizen tea bowl. Middle Edo period. Itsuo Museum, Osaka.

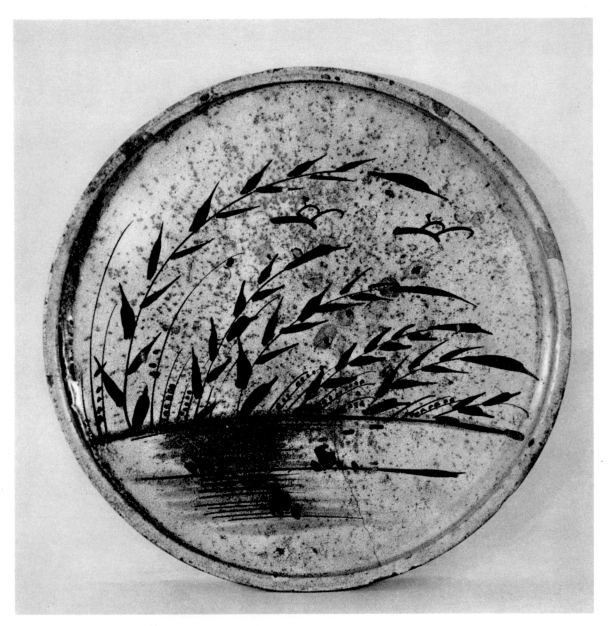

Plate 170. Seto oil plate. Late Edo period. Fogg Art
Museum, Harvard University.

9 Japanese Folk Pottery

AS THE condition of the common man improved during the years of peace and prosperity of the Tokugawa regime, a significant development was the emergence of folk pottery as an adjunct to the ceramics made for the aristocracy and the well-to-do merchant class of the cities. This pottery was a true people's art created for the everyday needs of the ordinary people in provincial towns and villages during a time when industrial mass production was not yet available. Some of the folk potters were humble craftsmen supplying the local demand; others were simply farmers working as part-time potters when their labor was not required in the fields. Because of this, their output had a simple beauty and a solid strength that made it very different from that of kilns working for the houses of the cultured and the sophisticated. The oldest of these folk wares go back to the early Edo period—that is, the middle of the seventeenth century—but most of the ordinary wares were made during the nineteenth century, and some fifty folk kilns are still active today.

Sometimes these coarse kitchen wares for the peasants were made alongside refined porcelains, as at Hongo in Fukushima Prefecture, or tea-ceremony utensils, as at Nishi-shimmachi in Fukuoka Prefecture. Other kilns, such as the famous one at Onda, were from the start intended as folk kilns and have a long history of making common wares. Naeshirogawa in Kagoshima Prefecture, on the other hand, was originally founded for the making of tea-ceremony wares for Lord Shimazu of Satsuma but later excelled in common black wares known as *kuromon*—in contrast to the more refined white ware or *shiromon* made at the same kiln. But whatever the origin and history of any particular folk kiln, they are all alike in one respect: they do not produce masterpieces by name potters intended for the homes of the rich, and admired for their originality and elegance, but crude utensils of earthen-

ware and stoneware, the work of anonymous craftsmen, intended for the daily use of the common people.

In keeping with this the shapes employed are traditional ones designed for utilitarian purposes. They are often large, rough pieces such as big water jars, *miso* or saké containers, kneading bowls, and lipped basins. Other kitchenwares found are pottery dishes, plates, casseroles, teapots, and saké bottles. Technically, too, they are crude and simple, the result of traditional manufacturing processes and the use of decorations that are never elaborate. Most common among them is the employment of poured or running glaze and white slip. The glazes are usually subdued in color, black, brown, yellow, green, and white being the most common. Ash glaze is of course the most ancient, but tin and iron glazes are often found, and in some places lead glaze is employed. Particularly beautiful is the bluish-white iron glaze seen in the productions of the Tohoku kilns, notably the Naraoka pottery in Akita Prefecture. The black glazes favored by the potters of the Kagoshima area are also outstanding for their deep and strong color.

These folk wares, which are so popular today among the lovers of Japanese ceramics and enjoy extensive sales not only among the rural people of the remote mountain villages but also among the urban intelligentsia of Tokyo, Kyoto, Osaka, and New York, were for many years despised and looked down upon by Japanese and foreigners alike. It would have seemed ludicrous indeed to men like Bowes and Brinkley if they had been told that a later age would prefer these rough articles to the gorgeously decorated enameled wares from Satsuma and Kyoto. But such has been the change in taste that their very plainness and crude strength now make them seem preferable to the ornate wares the Meiji period loved. This appreciation of Japanese folk pottery parallels the discovery of the beauty of primitive art, folk art, and children's art in the twentieth century. In Japan, credit for this development is largely due to Yanagi Soetsu, the founder of the Japanese Folk Art Museum and the guiding spirit of the Japanese folk-art movement. Under his inspired leadership and through his numerous writings and talks, the hidden beauty of these ordinary objects was first pointed out to the public; and it is to his credit that this once neglected branch of Japanese ceramics now has the place of honor and respect it deserves. Today no discussion of contemporary or traditional Japanese ceramics can fail to take into account the rich heritage of folk pottery, which is in fact the finest such tradition surviving in the world today. Even if it should die out, the wonderful collection formed by Dr. Yanagi in the Mingeikan in Komaba, Tokyo, will be a lasting monument to this great art.

Among the many different kinds of common wares produced in Japan, the best known are probably the oil plates or *aburazara*, which were made at Seto during the late Edo period up to the beginning of Meiji, when kerosene lamps replaced the oil lamps of an earlier age. These *aburazara* are flat saucers that were formerly placed inside the lamp or *andon* (and are therefore also known as *andonzara*) to

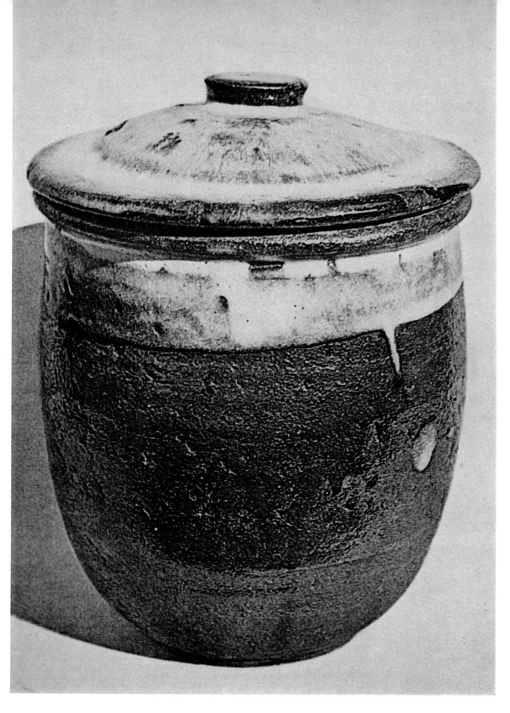

Color Plate 14. Naraoka jar. Showa period. Mingeikan, Tokyo.

catch the oil dripping from the burning wick. Originally they were square in shape, but the later ones—artistically the best—are round, usually about seven inches in diameter. They were manufactured mainly at Seto, which had long been a center for common wares of all types. Here they were known as *getemono* or ordinary, crude ware, in contrast to the *temmoku* tea wares and blue-and-white porcelains also produced there. *Getemono* were real folk pottery produced by unknown craftsmen in huge quantities and sold very cheaply throughout the country. Some were made in traditional styles such as Shino and Oribe, but most of them were just simple flat plates with a projecting rim, made of coarse grayish clay covered with a creamy glaze. The feature that gives them their artistic distinction is the designs painted on them with bold brush strokes in a very free and inspired style *(Plate 171)*. The subjects are usually trees, grasses, flowers, birds, landscapes, and human figures *(Plates 172 and 173)*. Although they were done by mere artisans and in large quantities on a mass-production basis, the drawings are often of real beauty, showing the greatest economy of means yet achieving a telling effect.

Closely related to the oil plates are the stone plates or *ishizara*. These are crude, heavy stoneware intended for use in the peasant kitchens of the region between Kyoto and Edo. The center of their manufacture was also at Seto, and, like the *aburazara*, they were the cheapest, most ordinary wares made by common artisans and were not looked upon as works of art. One worker could make as many as three hundred of them in one day, and the designs, too, were drawn rapidly on a mass scale. These kitchen plates were made primarily during the late eighteenth and the early nineteenth century, and their manufacture began to decline during the Meiji period, when cheap industrial production replaced them. They vary in size from seven to fifteen inches in diameter, but most of them are between ten and fifteen. Although they are quite similar to the oil plates in body and glaze, they are heavier and thicker, in keeping with the rugged use to which they were put. They are painted with designs executed in *sunae-gosu*, the natural cobalt found near Seto, or in the iron black known as *oni-ita*. Most remarkable is the variety of motifs with which they are decorated. Trees and flowers are among the favorites: willows rendered in a few fluid strokes or wisteria with beautiful drooping lines *(Plate 174)*. But every aspect of nature is found: all kinds of animals, fish, human figures, and plants. Landscapes are also seen and, rarely, calligraphy. Here again it is surprising to think that these lovely drawings, filled with life and rendered with such mastery, were produced in huge quantities by humble artisans, in many cases by old women and children.

The finest among contemporary as well as older folk pottery comes from Kyushu, which has traditionally been a center of Japanese ceramic production and, because of its comparatively isolated position, is less affected by the competition of the big industrial centers. At the southernmost point of Kyushu, in Kagoshima Prefecture, where the famous Satsuma ware comes from, there are at least two folk kilns of

importance: Ryumonji and Naeshirogawa. Both of these produce common wares along with other types of pottery, but it is the former which today are outstanding among the ceramic products of this district. The shapes are simple and purely utilitarian in character, but they possess great beauty (*Plate 176*). Since the kilns were founded by Koreans, they preserve the Korean tradition both in their forms and in their black iron glaze. Among the wares from Ryumonji the saké warmer with a small projecting spout and the low, flat *shochu* pot are the most remarkable. Other typical wares are the covered pots used for rice, which are decorated with drip glaze either in white, green, or brown. Of the two kilns, Naeshirogawa has preserved more vitality, and some observers consider it the best and most authentic folk kiln active in Japan today. Its most famous products are the *yama choka*, the rough pot used by woodcutters for cooking rice or soup, and the *hira choka*, intended for warming *shochu* (an alcoholic drink) and now also used for tea. Each has three feet, a cover, and ears, while the latter also has a spout. The glaze is usually black *temmoku*, but persimmon, light brown, or celadon may also be found. The shapes employed vary, but all are simple and designed to fit the daily life of the common people of this region.

The very essence of true folk art is found in the output of the kilns in the mountain villages of Onda and Koishibara. Here exists a very old tradition of pottery, going back to the seventeenth century. But unlike the kilns in Kagoshima, those of Onda and Koishibara were never intended for the production of tea-ceremony ware, for they were run from the start by local farmers producing utensils solely for their own use. Only in modern times, after the excellence of these wares had been recognized by Dr. Yanagi and after Bernard Leach had visited the site, did the pottery of these kilns become famous and sought after, first in Japan and then also in England and America.

Onda is a tiny village not far from Hida in Oita Prefecture. Although there is only one kiln worked by nine families who are farmers as well, the output of Onda is remarkable both for its variety and for the beauty of its shapes and glazes. Most beautiful of all, perhaps, is the Onda teapot with its rounded body and lovely greenish-blue glaze—a vessel selected by the Museum of Modern Art in New York for its outstanding design (*Color Plate 10*). Next to command attention are the covered jars decorated with a beautiful drip glaze, often in white, green, brown, and yellow. The potters employ a variety of different techniques, such as comb drawing and chatter marks or finger and brush drawing, which greatly add to the interest of the surface texture and design.

Koishibara is located close to Onda and was originally its parent kiln, although it lies in Fukuoka Prefecture. The pottery output of this kiln is very similar to that of Onda, and it is often difficult to tell the two kinds of ware apart. The best pieces of Koishibara are the various jars and covered pots with their strong rounded shapes

and marvelous drip designs. The colors, memorable for their subtlety and beauty, are black, brown, green, gray, and white.

One folk kiln that is unfortunately no longer active today, although not long ago it was producing some of the most beautiful Japanese folk pottery, is Nishi-shimmachi, also located in Fukuoka Prefecture. Interestingly enough, its common wares were made in the same kilns and with the same clay as the Takatori tea-ceremony wares. The origin of Nishi-shimmachi ware can be traced to the importation of potters from Koishibara for the express purpose of making common wares. At the same time that they performed their task, the potters were learning from the Takatori potters, so that their output combined the rough and sturdy character of folk art with the elegance and perfection of a more refined tradition. The shapes are the familiar ones: saké bottles, kneading bowls, water jars, and all kinds of pots, but the glazes are unique: usually a warm green covering the body of the vessel and a drip glaze of brown, yellow, or white over it.

In the same prefecture is the Futagawa kiln, noted for its large kneading bowls used for making wax. These outsize vessels are covered with a white slip on which bold designs or pine trees are painted in powerful green and brown brush strokes. Equally strong are the large storage jars, the biggest of which are used for water and the smaller for food. These too are covered with a heavy white glaze, which is splashed over with a brown drip glaze and ornamented with wave patterns drawn with the fingers around the bottom of the jar. Unfortunately this kiln too has suffered a great decline in recent years and no longer makes these splendid jars.

Of all the Kyushu kilns, the crudest and therefore the closest to the spirit of the folk-art movement is Shiraishi in Saga Prefecture, near Kurume. Of this kiln's output, the objects most in evidence are the small unglazed earthenware pots and cups sold to travelers on the trains. Best from an artistic point of view are the lidded cooking pots decorated with galena lead glaze. These are fired at a very low temperature and are therefore quite soft and light. The colors are particularly beautiful, combining a brick-colored body with an orange and green glaze (*Color Plate 11*). Another type of folk ware made in Saga Prefecture is Takeo pottery, which has a long tradition going back to the early Edo period. The best of these wares are the large water jars with designs that resemble those of the Futagawa jars in their bold, inspired style and their subject matter of mountains, trees, and plants. Here again, works that were once ordinary are now rare collector's items. The only kiln in the Takeo district still active today is that of Kuromuta, once best known for its oil and saké bottles—strong and simple in shape and bold in design. The present-day products are much weaker, although they still possess the characteristics of the common wares.

Closely related to the Kyushu wares are those made at Tsuboya in Okinawa. The kilns produce a variety of shapes, including plates, bowls, and other dishes, but

these are not quite the equal of the older wares. The Tsuboya potters, like those at Kagoshima, often use a dark *temmoku* glaze to achieve strong and beautiful effects (*Plate 177*). Another type of ware made at these kilns displays a blue design in natural cobalt on a white ground. The drawing is remarkably sophisticated and fluent—sometimes purely abstract and at other times derived from floral forms. Here again, we have wares made for local consumption by ordinary people yet characterized by great beauty of form and design.

On the main island of Honshu the two best regions for folk pottery are the San'in district facing the Japan Sea and the Tohoku district in the north. Here, in relatively isolated and backward regions, the older tradition could continue, whereas the east coast, with its thriving industrial centers in which cheap porcelain was being made in factories, did not permit the survival of local kilns. The only real exceptions to this are Tachikui in the Tamba district, which has a very old ceramic tradition, and Mashiko, the pottery-making village in Tochigi Prefecture (not far from Tokyo), which, under the guidance of the famous contemporary potter Hamada Shoji, has become the center of the folk-art movement in pottery.

Of the kilns in the San'in district, those in Shimane Prefecture are the finest, some of them going back for several generations. The best of these is the Fujina kiln, located not far from Matsue. Others, like Kiami, which at one time produced beautiful iron-glaze pots and bowls, and Ho-onji, which once made excellent teacups, have declined in recent years. Fujina, during the nineteenth century, produced attractive tea bowls with a bluish-green glaze, together with all kinds of common wares with strong shapes and glazes of white, yellow, and bluish green. This tradition is now being kept alive by the Funaki family, but at the same time this kiln, as well as the neighboring Yumachi and Sodeshi kilns, is making a new type of pottery that cannot be classified as genuine folk art but is intended for the urban market and reflects the taste of the contemporary folk-art movement. The situation is similar in adjacent Tottori Prefecture, where there existed, not far from Tottori City, a traditional folk kiln that had been producing fine common wares in the Korean tradition. Here also, under the influence of the folk-art movement, a more commercial type of product is being made today—one that is no longer intended primarily for local consumption. Among the pottery made at this site the half-brown and half-green plates are outstanding.

In contrast to these kilns of the San'in district, the kiln located in the mountain village of Tachikui in Hyogo Prefecture has preserved much of its traditional character, although recently here too there has been a tendency to work for the Tokyo and Osaka markets rather than for the local populace. Both tea-ceremony and ordinary wares have been made in the Tamba district since early times, and the Tachikui kiln has a venerable history. Its products, many of them of very fine quality, include all kinds of common wares such as pots, jars, vases, bottles, and charcoal braziers. The best of these wares are those with deep black, white, or dark-

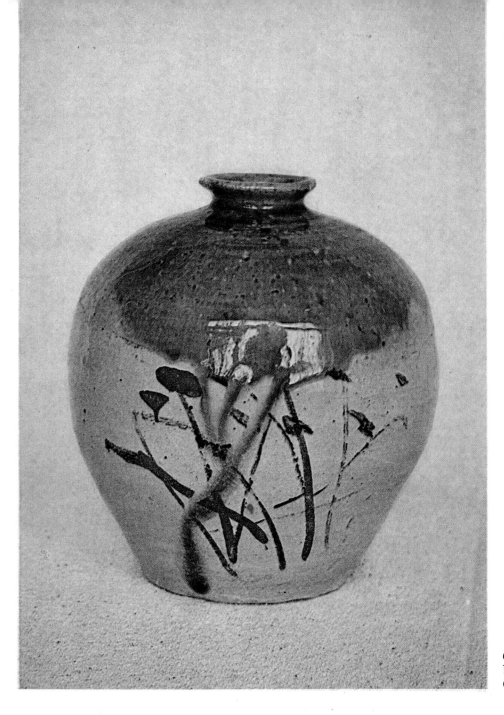

Color Plate 15. Oribe vase by Rosanjin. Showa period. Collection of the author.

brown glaze and simple, severe shapes (*Plate 178*). Most characteristic are the small jars with light-brown or iron-black drip glaze over a white ground (*Plate 179*). The most famous of the local products are the candle-shaped *tokkuri* or saké bottles on which subtle blue or black patterns are seen against a brown ground.

Two kilns in central Japan that today have ceased producing any aesthetically significant wares, although in the nineteenth century they were outstanding, are Shigaraki and Marubashira. The former, located in Shiga Prefecture, was already one of the great centers of Japanese ceramic production in ancient times and was famous for its tea-ceremony wares. It also produced fine common wares—notably beautiful teapots—at the Koyama kiln. Although these were produced in large quantity, they were truly artistic, displaying fine shapes and abstract designs painted on white ground with a few rapid strokes (*Color Plate 12*). Among the many other types of ceramics made at this site were beautiful oil plates (*Plate 180*) and large jars decorated with drip glaze. Marubashira, in Mie Prefecture, was famous for its lovely bluish-green teapots, which resembled the Onda ones but were even finer in color. Hisaka, in nearby Fukui Prefecture, is also a kiln for common wares. In former days it produced fine vessels ornamented with beautiful black-brown glaze and white drip glaze.

Although there are only a few folk kilns remaining in northern Japan, those located in the Tohoku district are among the most genuinely traditional ones surviving in the country today. The finest of these is Hongo, in what was known as the Aizu district and is now Fukushima Prefecture. This site has a long history of ceramic manufacture and is still very active, although only one of the many kilns there produces common wares. This pottery is outstanding for its unself-consciousness, its roughness, and the subtle beauty of its glaze. The most original pieces are the square drip-glaze bowls used for salting herring; in fact, their square shape makes them a rarity among Japanese ceramics. All of the Hongo wares are thick, heavy articles designed for kitchen use, and among these the plates are particularly handsome (*Color Plate 13*). The colors are a warm grayish blue, a rich dark brown, and a similarly rich green.

The only folk kiln in Miyagi Prefecture is Tsutsumi, near Sendai, and even it has declined, although it has a history that goes back over two hundred years. The most noteworthy of its ordinary wares are the large water jars with a heavy bluish-white drip glaze that forms beautiful patterns as it runs over the black glaze covering the body of the vessel. Another object made at Tsutsumi is a small pottery Shinto shrine similar to the ceramic temples found in ancient Chinese graves. Unfortunately this kiln too has ceased being an active maker of folk pottery and now devotes itself primarily to making ceramic pipe.

Of the other sites in the Tohoku district, Shinjo in Yamagata Prefecture, Naraoka in Akita, and Kuji in Iwate are the finest. Unfortunately the best of these, Naraoka, has ceased production in the postwar period, but excellent local wares

were made there until quite recently. The Shinjo kiln has a history of over one hundred years. Originally it made porcelains, but it later changed to the production of pottery and has specialized in rough kitchenware ever since. Besides some huge jars, the best of the Shinjo pieces are the strong and simple cooking pots with two ears and three small feet. Like so many northern kilns, Shinjo employs a beautiful iron glaze that runs towards whitish blue. This type of glaze, known as *namako-gusuri*, is found at its finest in the wares of Naraoka, near Akita City, where it is used with wonderful effect. The body of the vessel is usually covered with a brown or a green glaze over which the iron glaze is dripped, starting from the rim and running down the sides (*Color Plate 14*). The wares made at Kuji are the most simple of all these wares. The kiln, in fact, was started in order to make utensils for the people of this isolated district. Among its products are various items of kitchenware like bowls, pots, decanters, dishes, and plates covered with a rich dark-brown glaze called *ame* and a grayish-white glaze. They have no designs or drip, and it is in their simplicity that the appeal of these wares lies.

Of all the folk-art kilns in present-day Japan, the best known, especially among foreigners, is the one at Mashiko in Tochigi Prefecture, fifty miles north of Tokyo. Traditionally a center of folk pottery, for about a century it has been the source of water jars and salt pots with brown and persimmon glazes and of a teapot with a "window picture" made in imitation of the Shigaraki one. Mashiko's prominence today, however, is due not to these traditional wares, which in fact have declined in quality, but to the presence of the famous *mingei* potter Hamada and a group of his followers. Under his leadership Mashiko has become the center of the modern folk-art movement as far as pottery is concerned and has attracted potters from all over Japan and even from abroad. The wares produced in Mashiko can no longer be considered folk wares in the proper sense of the word, for they are produced neither by ordinary country people nor for the local market but by professional potters for the urban market, especially for the numerous folk-art enthusiasts in Japan and abroad. In actual fact this influence is both beneficial and regrettable at the same time, for while it helps to keep the folk kilns alive and accounts for some excellent pieces of pottery (*Plate 175*), it also undermines the true folk character of these kilns. This dual result may be seen in other places—notably the San'in district —which produce beautiful wares based on folk pottery but wares that nevertheless exhibit a high degree of finish and self-consciousness very different from the true *mingei* spirit. Yet it may well be that these kilns of the folk-art movement that use modern techniques of production and merchandising will prove hardier and better able to withstand the competition of industrial production than the purely folk kilns, which, as the peasants themselves switch to factory-produced porcelains, will lose their *raison d'être* and their economic base.

Japanese Folk Pottery

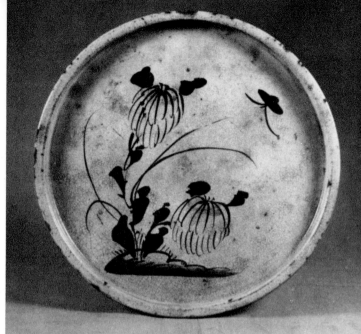

Plate 171. Seto oil plate. Late Edo period. Mingeikan, Tokyo.

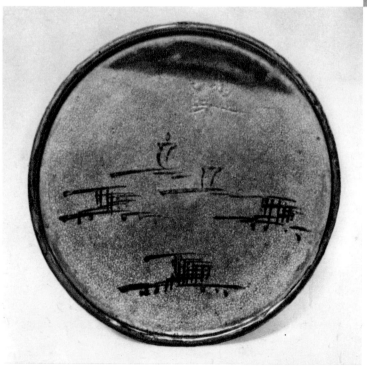

Plate 172. Seto oil plate. Late Edo period. Fogg Art Museum, Harvard University.

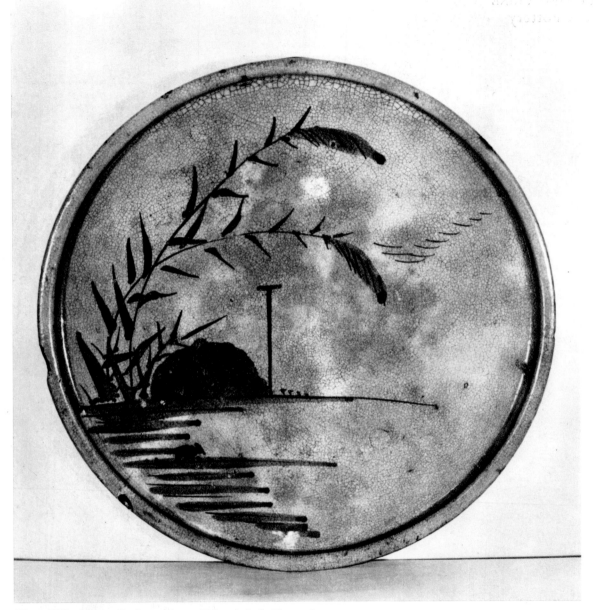

Plate 173. Seto oil plate. Late Edo period. Fogg Art
Museum, Harvard University.

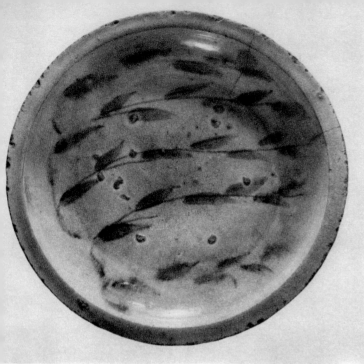

Plate 174. Seto dish. Late Edo period. Museum of Fine Arts, Boston.

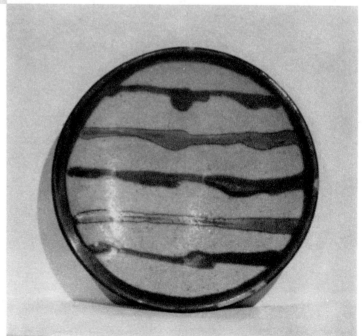

Plate 175. Mashiko plate. Showa period. Collection of the author.

237 *Folk Pottery*

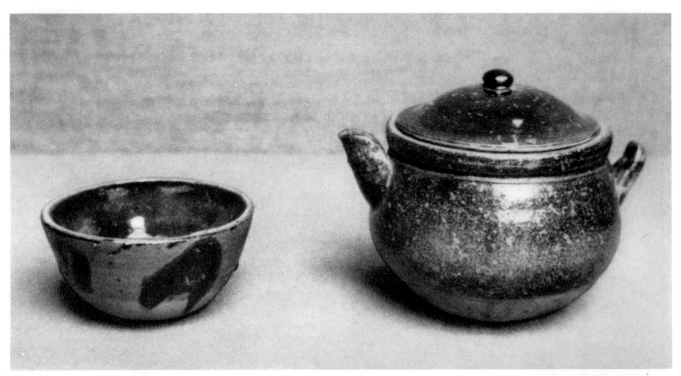

Plate 176. Naeshirogawa dish and pots. Showa period. Private collection, Japan.

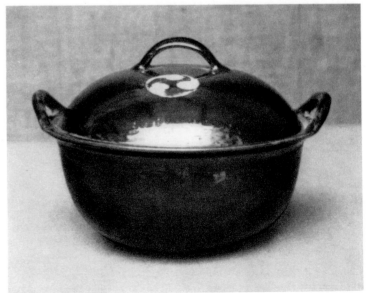

Plate 177. Tsuboya covered pot. Showa period. Private collection, Japan.

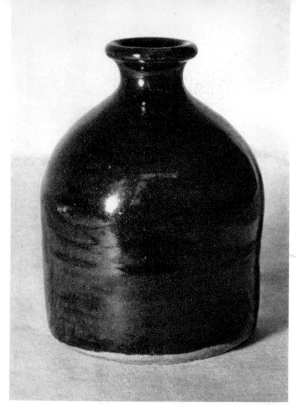

Plate 178. Tamba bottle. Showa period. Collection of the author.

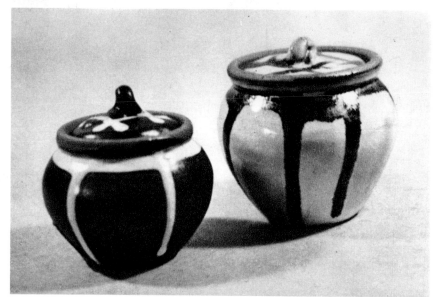

Plate 179. Tamba jars. Showa period. Collection of the author.

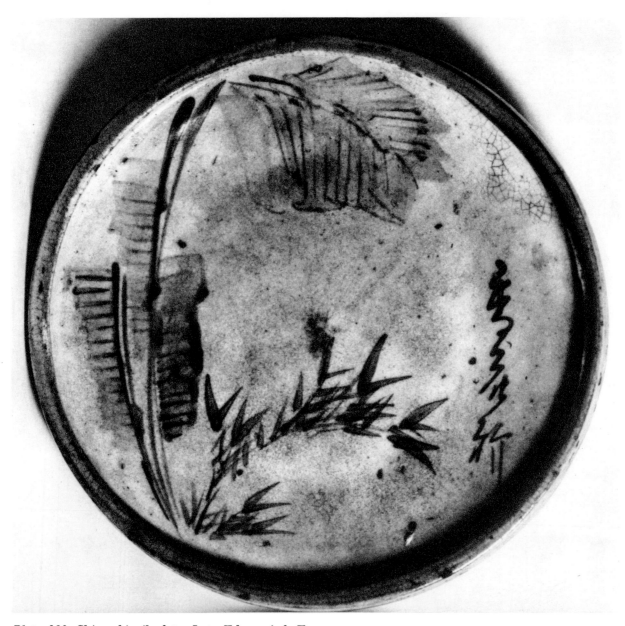

Plate 180. Shigaraki oil plate. Late Edo period. Fogg
Art Museum, Harvard University.

IO Contemporary Japanese Ceramics

MOST BOOKS on Japanese ceramics, like most general histories of Japanese art, end with the Meiji Restoration of 1868, as if the last hundred years of Japanese artistic productivity had nothing to contribute. True enough, the traditional art of Japan, as it had existed during the Edo period, when Japan was almost totally cut off from contact with the outside world, ceased to exist or was transformed with the advent of Meiji; but new and interesting developments have taken place in the wake of Japan's being opened to the West.

In the realm of ceramics the most important new departure was of course the establishment of the ceramic industry on a modern industrial basis. European techniques and production methods were introduced during the Meiji period, and European ceramic experts such as the German Dr. Wagener were called to Japan to reorganize the industry along modern lines. The result was a tremendous expansion of ceramic production, especially that of porcelain, for both domestic and industrial use. Japan soon became one of the great exporters of all types of wares, porcelain as well as enameled pottery. At the same time the local kilns continued to make ceramics, but they found it increasingly difficult to compete with the industrial output of the big factories.

The centers of this new manufacture were the same places where the making of ceramics had flourished in earlier times: first of all, Aichi and neighboring Gifu Prefecture—that is, the region around the modern industrial city of Nagoya—then Arita in Saga Prefecture, Kanazawa in Ishikawa Prefecture, Yokkaichi in Mie Prefecture, and Kyoto. Under the impact of Western culture, many of the wares produced at these factories were European in both shape and design, and much of the output was intended for export to the United States, the British Empire, and the countries of southeast Asia. Nevertheless, a great deal of the production for the

domestic market continued to employ traditional Japanese designs and shapes, although even these often showed some Western influence. At the same time certain companies—notably at Arita—imitated traditional wares like Imari, Kakiemon, and Nabeshima to satisfy the demand for good modern copies of the famous Edo-period porcelains. And, under the influence of the tea masters and the flower-arrangement *(ikebana)* teachers, there continued to be a great demand for utensils in both traditional and modern design to be used in connection with *cha-no-yu* and *ikebana.*

While these wares were being produced on a large scale by modern industrial methods, some potters continued to make artistic ceramics as well. During the Meiji period their output tended to be highly artificial, displaying virtuosity for its own sake rather than as an expression of an inner necessity. The Chinese and Japanese masterpieces of the past were imitated freely and with great skill, but the effect was unconvincing and lacked the spontaneity and expressive power of the originals. The centers of this activity were mainly Kyoto, the traditional seat of Japanese culture; Seto, the ancient pottery town; and Tokyo, the modern artistic center of the new Japan.

Among the many ceramic artists who enjoyed great fame at this time and were honored with prizes both in their native country and abroad, the one whose reputation has survived best is Seifu Yohei, who came from Kanazawa to Kyoto in 1844 and there established himself as the leader of the Kyoto school. His kiln was located in the Gojozaka district, where he made fine porcelains in the Chinese tradition. The bodies of these wares are of a very pure white, and the shapes show great skill and refinement *(Plate 181).* His glazes, too, displayed his superb technical mastery, for he was equally at home in producing monochromes, blue-and-white porcelains, and the brocade-style enameled wares. He was particularly celebrated for his delicate flower and plant designs executed in low relief on the surface of the vessels. Yet his work, in spite of this great versatility, lacked conviction and strength and was in this way very characteristic of the age.

During the past fifty years—the Taisho period (1912–26) and especially the present Showa period—the art of pottery in Japan has experienced a remarkable revival. This means neither that the trend toward cheap industrial production did not continue nor that the decline of the local kilns could be halted, but that new and healthy tendencies made themselves felt as well. Because of this, the ceramic output of contemporary Japan is rich and varied, and it would not be exaggerating to say that the Japanese are the most interesting and artistically creative potters in the world today.

Several trends can be observed in today's ceramic production, and among these there are three main categories. The first is the preference for traditional Oriental designs and techniques that follow both Japanese and Chinese models of an older period. This trend is especially strong in Kyoto, a more traditional city than Tokyo,

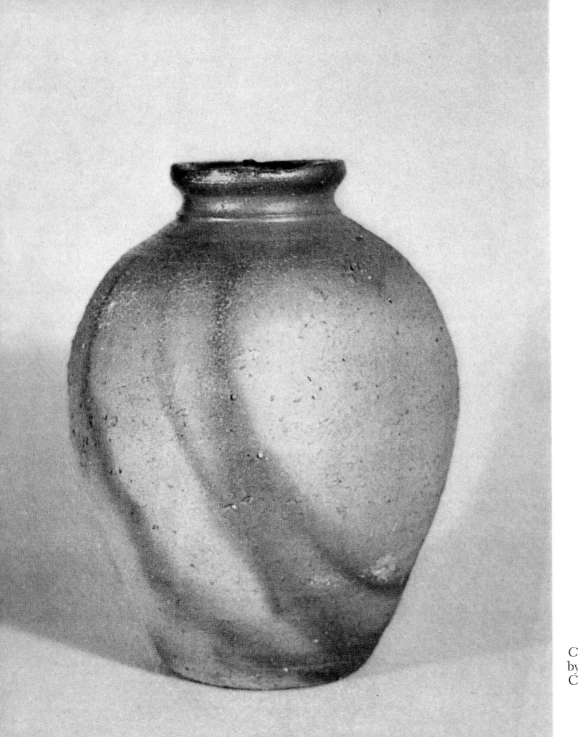

Color Plate 16. Bizen water jar by Fujiwara Kei. Showa period. Collection of the author.

but it may be found all over Japan among those who look to the past and tradition for inspiration. It must be added, however, that as the older generation dies, this tendency is bound to lose some of its appeal. The second tendency is the influence of the folk-art movement, which looks to Korean pottery of the Yi dynasty and to the local kilns for inspiration. This trend is particularly popular at present, when one can speak of a virtual craze for such folk wares. Japanese experts seem to differ as to how much of a future folk-art pottery has, but there can be no question that at the writing of this book it is the most influential and vital tendency in contemporary Japanese pottery. Finally there is an attempt on the part of certain potters to develop a new style that will be in keeping with the present age. They show the influence of modern Western art and look to Europe for their inspiration. Although less well established, this group includes many of the younger generation of potters and may well prove to express the dominant trend at some later date. Its members use elements of abstract painting and sculpture in their designs and shapes, reflecting the influence of men like Picasso and Arp. Their aim is to break away from tradition, to no longer be craftsmen who work in a style handed down to them by their predecessors, but to become individuals who express themselves freely and in a wholly original way, in keeping with their times and society. Many of them even discard traditional shapes and reject utilitarian forms altogether, creating instead free forms that are, strictly speaking, ceramic sculptures rather than bottles or vases. So far, their output does not seem to compare with that of the outstanding men of the two other groups, but since most of these potters are still young, it may well be that the future belongs to them. It must be added that, if this should happen, the great tradition of Japanese ceramics, as it has come down to us over the centuries, will have come to an end. Just as Japanese painters have taken up Western-style oil painting and are trying to transform it into something that will express their own national temperament, so it is possible that these modern individualistic potters will absorb what they have taken over from the West and assimilate it into their own culture. This, of course, is what the Japanese have done with other foreign influences over and over again in their history.

The greatest of the older generation of modern potters working in the traditional manner was Kitaoji Rosanjin (1881–1960), whose kiln was located at Kamakura, not far from Tokyo. Following the classical tradition of Oriental ceramics, Rosanjin was a conservative in the best sense of the term, for he preserved the finest in the old, infusing it with new life rather than merely imitating it. Something of his own extraordinary and eccentric personality was transferred to his wares, so that they never became mere academic copies of old pieces but were vital expressions of his own age and genius, even though firmly embedded in the artistic heritage of the Japanese ceramic tradition.

Rosanjin's favorite models were the tea wares of the Momoyama period, such as Shino, Oribe, Yellow Seto, and Black Seto. He was also very fond of the cruder

traditional wares, such as Bizen and Shigaraki, and worked in their style with great success. Of the great names in Japanese ceramics, he was most attracted by Kenzan, and he created strikingly beautiful wares resembling those of this famous artist of the Edo period. In addition to pottery inspired by the ancient Japanese styles, he also created superb porcelains in the Chinese tradition—notably fine blue-and-white pieces modeled after those of the Ming dynasty—as well as richly decorated *kinrande* porcelains with designs in red and green accented with gold. Although his porcelains show the mastery so characteristic of all his undertakings, it was in pottery rather than porcelain that he was most at home. This is indicated by the fact that he invariably turned to pottery rather than porcelain when he worked in his own individual style. Rosanjin was at his best, however, in making his own versions of the tea wares of olden times, as exemplified in a Shino bottle *(Plate 182)* and an Oribe vase with a bold abstract pictorial design *(Color Plate 15)*.

Among the potters who work in what is primarily a Chinese tradition, Itaya Hazan of Tokyo and Ishiguro Munemaro of Kyoto are the leaders. The former, born in 1872 and still active today, is essentially a Meiji man and in his early period absorbed some of the European influence that was so strong at that time, as is well illustrated by the work of yet another Meiji potter, Kato Yutaro *(Plate 183)*. But in his maturity Itaya turned to the great ceramic tradition of China for his inspiration. Among his later works his celadons—often with graceful flower designs in shallow relief—and his white porcelains are particularly memorable for the perfection of craftsmanship that they display *(Plate 184)*. Ishiguro, who is somewhat younger, shows no Western influence and is concerned solely with recapturing the glory of Sung ceramics. Within the framework of his ambition he is superbly successful, for his wares reflect the elegance and perfection of the old Chinese ware and are genuine masterpieces of form and design. His *temmoku* glazes are the finest made by any modern potter *(Plate 185)*.

Most of the potters who work in the Japanese tradition make wares intended for the tea ceremony, and it is this institution that is primarily responsible for the vitality preserved by the old styles even at the present time. Of these potters, the one whom the tea masters value most highly is Arakawa Toyozo, who has a kiln in Gifu Prefecture at the same site where Shino and Oribe wares were made during the Momoyama period. His speciality is a tea bowl in the Shino style *(Plate 186)* that resembles the best of the old wares but at the same time lacks some of the strength of the originals. In nearby Aichi Prefecture, too, the ancient tradition is being kept alive by two potters, father and son, who come from an old Seto family. They are Kato Tokuro and Kato Mineo. Their work is fashioned largely in the traditional Seto styles—Shino, Oribe, and Yellow Seto—but the younger Kato has in recent years also experimented with more modern styles *(Plate 187)*.

Of all the traditional centers of Japanese ceramic production, the one that has remained most faithful to the ancient techniques and shapes is Bizen, near Oka-

yama, where a number of excellent potters are active. Working in the same style as their ancestors and with the same local clay found near the pottery town of Imbe, these potters achieve results that equal the best wares of the Edo period and far surpass the Bizen wares of the nineteenth century. Their output is intended largely for the *cha-no-yu* devotees, and the shapes accordingly are mainly flower vases, tea bowls, water jars, and cake plates. The two outstanding men among these modern Bizen potters are Kaneshige Toyo and Fujiwara Kei, both natives of the district. They base their style upon the finest of the old wares but at the same time add something of the modern spirit as well *(Plate 188 and Color Plate 16)*.

The most famous of the potters working in the folk-art tradition is the Mashiko potter Hamada Shoji, who was born in Tokyo in 1894. His style represents a wonderful fusion of traditional Japanese folk pottery, Korean ceramics of the Yi dynasty, and English slip ware, which he saw when he was working at St. Ives in Cornwall with his friend Bernard Leach. Much of his early work shows very strongly his dependence on Korean ware, but in his mature work he has completely absorbed these various influences and has evolved a powerful style all his own *(Plate 189)*. His forms are strong and simple like those of the peasant wares he has studied and collected for many years. His pottery is mostly stoneware in soft warm colors—primarily rich brown, olive green, gray, and black *(Color Plate 17)*. The designs decorating them are executed in ash or iron glaze and are either taken from nature or are marvelously spontaneous abstract patterns *(Plate 190)*. Unlike the great potters of the past and his well-known contemporaries, he never signs his work. His purpose in this is to emphasize that his productions are not those of a name artist but of a humble craftsman interested not in personal fame but in an honest job. In keeping with this spirit he only rarely makes wares intended for the tea ceremony and prefers to produce articles for ordinary use: teapots and cups, plates and dishes, bottles and jars, as well as bowls and flower vases. However, this has not prevented his work from becoming well known and immensely influential. Nor has it prevented the man himself from becoming one of the most celebrated Japanese artists of his time. His fame, in fact, is not restricted to his native country, for he has also exhibited very successfully in England and America, and in 1952 he made a lecture and demonstration tour of the United States with his friends Yanagi and Leach. In 1955 the Japanese government, by designating him an Intangible Cultural Treasure of the nation, bestowed on him the highest honor it can give to an artist working in a traditional craft.

A close friend of Hamada's who, together with him and Yanagi, founded the Japan Folk Art Society, is the Kyoto potter Kawai Kanjiro, born in Shimane Prefecture in 1890. While Hamada's work is outstanding for its sturdy strength and beauty of form, Kawai's pottery excels in the quality and variety of its glazes and designs. A masterly technician and a bold experimenter, Kawai has worked with molds in making ink slabs, has imitated Chinese *temmoku* and celadon, and in

recent years has attempted modern abstract designs in relief not unlike those of Picasso and Miro. His finest work, however—and the work closest to the folk-art movement—is to be found in the jars and vases made in the thirties. In shape, these are based on Korean wares of the Yi dynasty, but they are wholly original in their designs. The dominant color is usually a subtle gray, a subdued brown, or a soft blue (*Color Plate 18*)—colors that give a quiet and peaceful feeling—and on this ground he paints beautiful abstract designs in a bold, expressive style. At other times he employs raised designs (*Plate 191*). Working with him in a similar style is his nephew Kawai Takeichi, who produces some very sensitive and attractive wares (*Plate 192*).

Another potter closely associated with the folk-art movement is Funaki Michitada of Matsue, in Shimane Prefecture, where his family operates the traditional kiln of Fujina. Deeply influenced both by English slip ware and by Korean pottery, Funaki often uses bright yellow or creamy white glazes with rich and lovely effect. His son Funaki Kenji works alongside him but in a bolder and more modern style. His best pieces are the plates, dishes, and tiles decorated with drawings of horses, fish, octopuses, roosters, and the like—all executed in a vigorous style (*Plate 194*).

The main center of folk-art pottery is Mashiko, where some thirty potters have settled since Hamada chose this country village in Tochigi Prefecture as the site for his kiln. Among the many gifted potters now working there who have more or less come under the influence of Hamada, his old friend Sakuma Totaro and his young pupil Shimaoka Tatsuzo are probably the best. Sakuma has produced fine folk pottery on a mass basis in a regular workshop, some of it especially memorable for the beauty of its design (*Plate 193*). Shimaoka stands out for the beauty of his glazes—particularly his olive gray and his pale grayish blue—and for the sturdy strength of his shapes (*Plate 195*).

But the greatest achievement of this ceramic center lies not so much in the excellence of a few masterpieces by its famous potters as in the high average of its productions. Each year thousands of cups, plates, jars, and vases that combine utility with beauty are made there—and simply labeled Mashiko ware (*Plate 196*). These are true folk-art wares made anonymously in the workshops of Mashiko, perhaps by Hamada's sons, perhaps in the kilns of Sakuma or Murata, perhaps by one of the many others who are active there. Other pottery centers have tried to rival Mashiko in this field, but not one of them has been able to equal the ware produced there.

Of the kilns that have recently turned to folk-art pottery, the most interesting is Tobe, near Matsuyama on the island of Shikoku. Interestingly enough, Tobe has a long ceramic history, first of making Karatsu-style pottery and then of producing Arita-type porcelains. In order to turn this kiln into a modern folk-art center, a designer who had studied folk art was invited from Tokyo. This designer employed Korean shapes derived from Hamada and abstract designs inspired by Tomimoto,

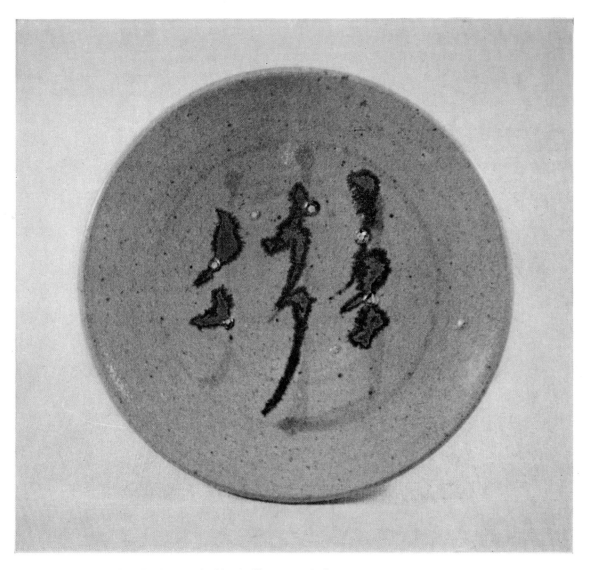

Color Plate 17. Plate by Hamada Shoji. Showa period.
Collection of the author.

who had visited the kiln. The result, though pleasing enough as modern pottery, can hardly be considered folk-art in any sense of the term *(Plates 197 and 198)*.

While Hamada is particularly famous for his shapes and Kawai for his colors, the third great potter connected with the *mingei* movement, Tomimoto Kenkichi (1886–1963), is outstanding for his beautiful calligraphic brushwork. Like the other two, he was a close friend of Bernard Leach, with whom he worked in 1911 and 1912. In fact, it was through Leach that Tomimoto first turned to pottery. His early work was deeply influenced by Korean pottery, for he employed crude shapes, simple glazes, and calligraphic designs. Later, however, he broke away from this folk-art approach and began working in the Chinese style, creating pure white porcelains decorated with designs in cobalt. It was in this genre that he produced his best works. In these a very refined and elegant drawing is combined with a highly developed ceramic technique, and this makes them perhaps the most accomplished wares produced in present-day Japan *(Plate 199)*. A native of Nara and later a resident of Kyoto, he expressed the refinement and sophistication of this ancient cultural center and turned against the *mingei* sentiment of his earlier work. In addition to the blue-and-white wares, he made enameled porcelains employing red, green, gold, silver, and other colors. Chief among these later works are the large plates showing delicate brush drawings on white or colored ground: drawings of landscapes, birds, flowers, or allover abstract floral patterns *(Plate 200)*. His ware is traditional yet highly original, and, like Hamada, he has been honored by the Japanese nation.

No one can predict what the future will bring, especially in a country like Japan, which is a society in transition—a society in which the old and the new, the traditional and the latest technological advances, exist side by side. But, looking back over the long and glorious development of Japanese ceramics since the days of the Jomon people, who many thousands of years ago produced what some critics have called the most artistic and original Neolithic wares, one cannot help believing that Japanese potters will still be active in years and centuries to come and that, with the unique artistic sensitivity that seems to be the peculiar gift of the Japanese nation, they will still be creating objects from clay that serve the dual function of being useful and giving delight.

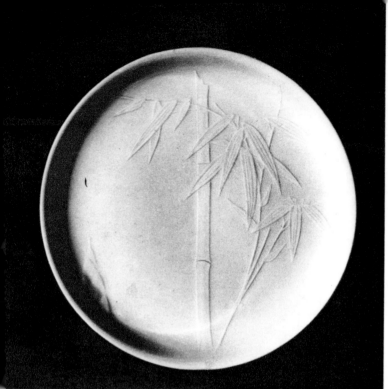

Plate 181. Dish by Seifu. Meiji period. Museum of Fine Arts, Boston.

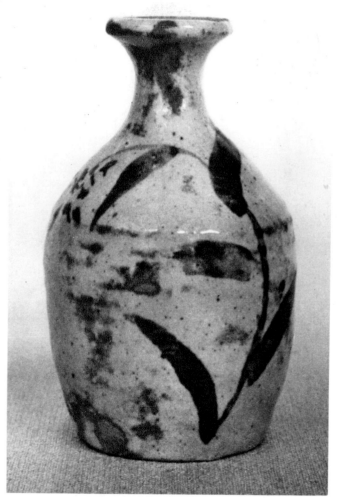

Plate 182. Saké bottle by Rosanjin. Showa period. Collection of the author.

253 *Contemporary Ceramics*

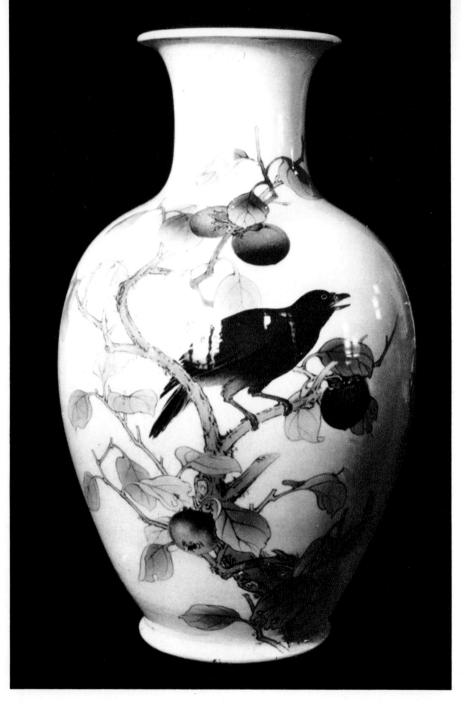

Plate 183. Vase by Kato Yutaro. Meiji period. Tokyo National Museum.

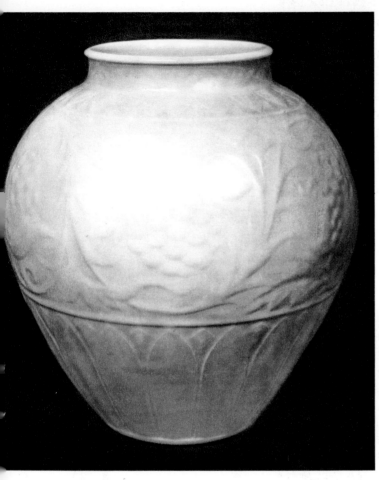

Plate 184. White jar by Itaya Hazan. Meiji period. Tokyo National Museum.

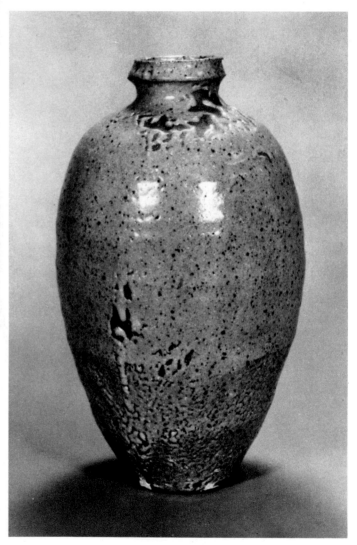

Plate 185. Vase by Ishiguro Munemaro. Showa period. Private collection, Japan.

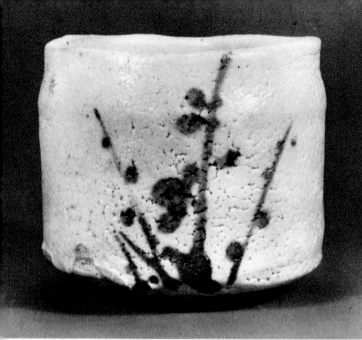

Plate 186. Shino tea bowl by Arakawa Toyozo. Showa period. Private collection, Japan.

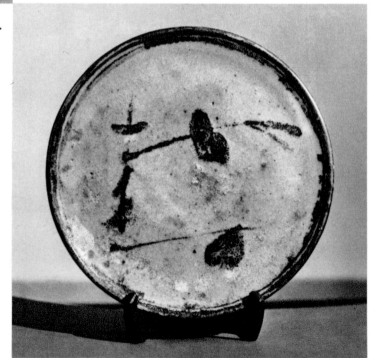

Plate 187. Plate by Kato Mineo. Showa period. Collection of the author.

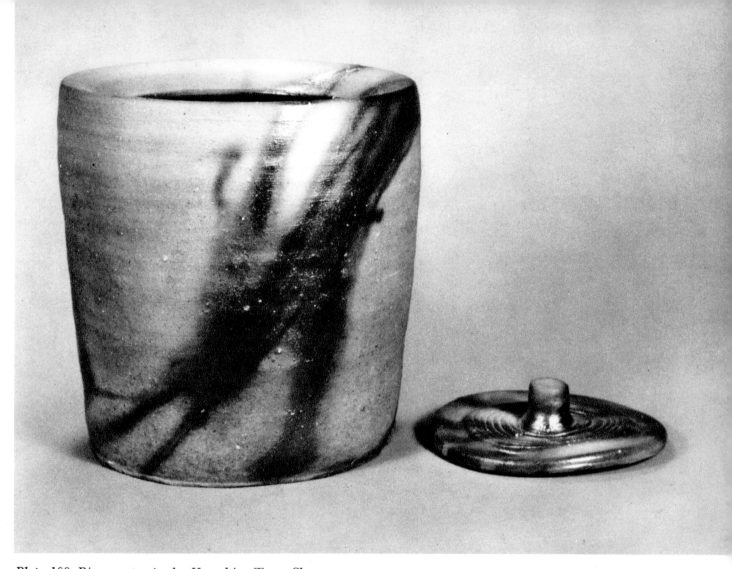

Plate 188. Bizen water jar by Kaneshige Toyo. Showa period. Private collection, Japan.

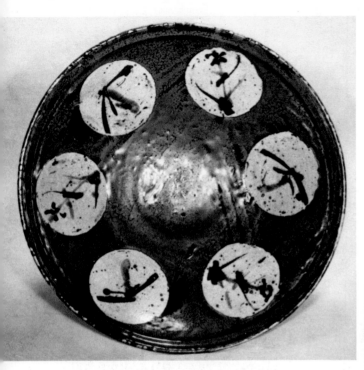

Plate 189. Dish by Hamada Shoji. Showa period. Collection of Hamada Shoji, Mashiko.

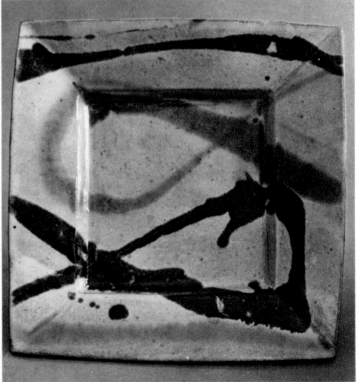

Plate 190. Square plate in *mingei* style by Hamada Shoji. Showa period. Private collection, Japan.

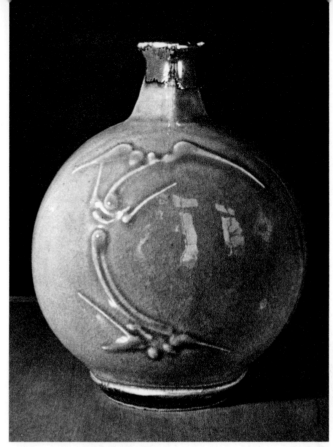

Plate 191. Bottle by Kawai Kanjiro. Showa period. Yuasa collection, Tokyo.

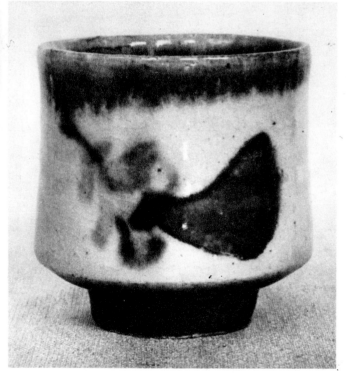

Plate 192. Teacup by Kawai Takeichi. Showa period. Collection of the author.

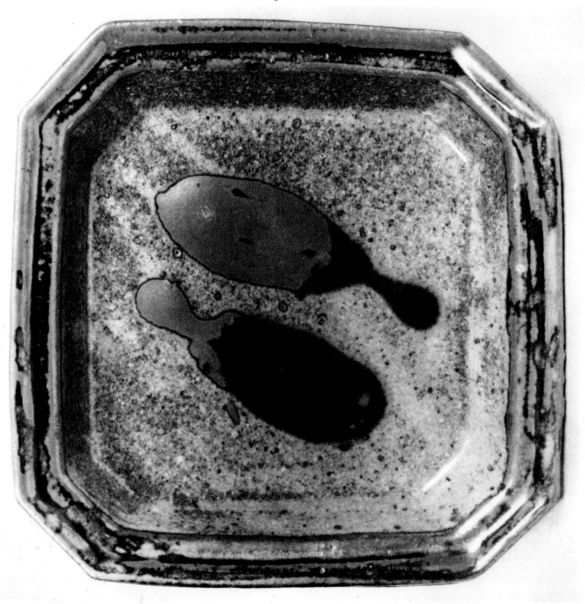

Plate 193. Square plate by Sakuma Totaro. Showa period. Collection of the author.

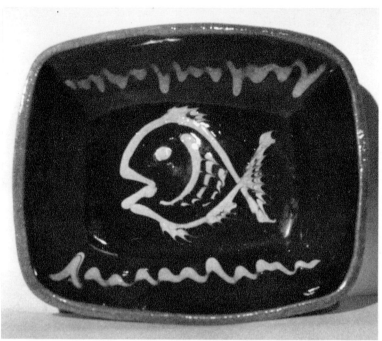

Plate 194. Dish by Funaki Kenji. Showa period. Collection of the author.

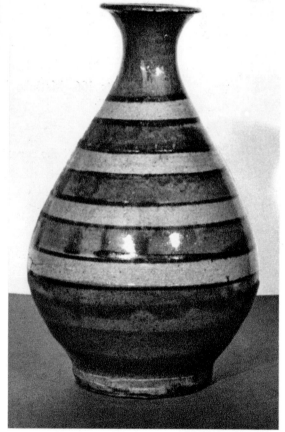

Plate 195. Bottle by Shimaoka Tatsuzo. Showa period. Collection of the author.

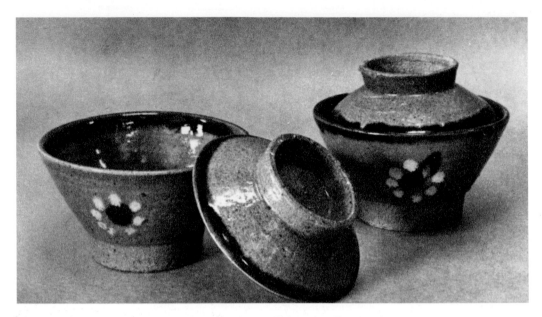

Plate 196. Mashiko bowls. Showa period. Private collection, Japan.

Plate 197. Tobe cups. Showa period. Private collection, Japan.

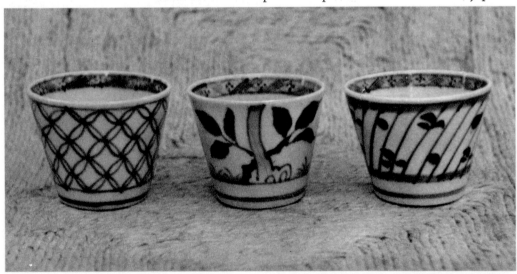

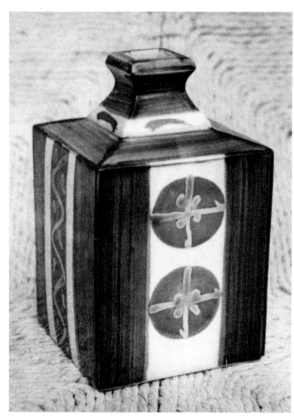

Plate 198. Tobe bottle. Showa period. Private collection, Japan.

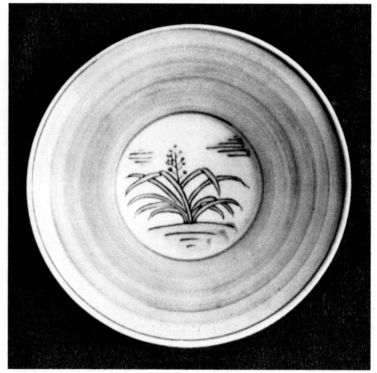

Plate 199. Plate by Tomimoto Kenkichi. Showa period. Kanazawa collection, Tokyo.

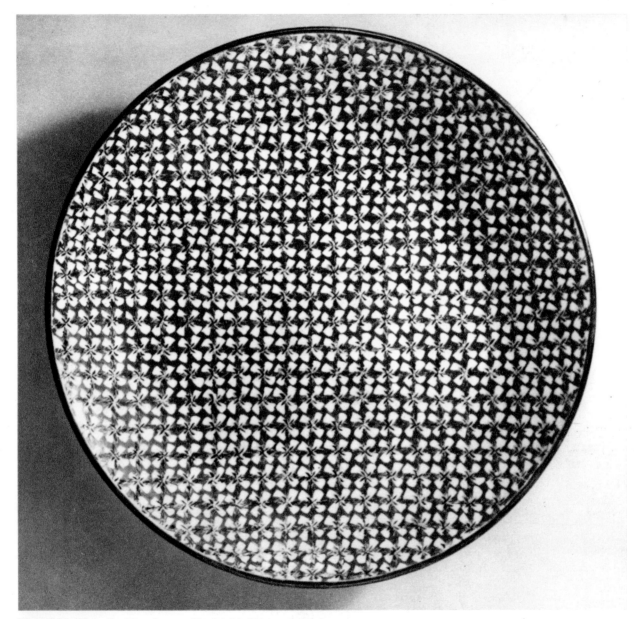

Plate 200. Plate by Tomimoto Kenkichi. Showa period.
Tokyo National Museum.

Bibliography

Audsley, G. A., and Bowes, J. L.: *Keramic Art of Japan*, London, 1875 (rev. ed., 1881)

Ballot, M. J.: *La Céramique Japonaise*, Paris, 1927

Bowes, J. L.: *Japanese Marks and Seals*, London, 1882

——: *Japanese Pottery*, London, 1890

——: A *Vindication of the Decorated Pottery of Japan*, London, 1891

Brinkley, F.: *Japan: Its History, Arts, and Literature*, Vol. VIII: "Keramic Art," Boston and Tokyo, 1901

Dingwall, K.: *The Derivation of Some Kakiemon Designs on Porcelain*, London, 1926

Feddersen, H.: *Japanisches Kunstgewerbe*, Braunschweig, 1960

——: *Japanisches Porzellan*, Braunschweig, 1960

Franks, A. W.: *Japanese Pottery*, London, 1880 (2nd ed., 1906)

Fukui, K.: *Japanese Ceramic Art and National Characteristics*, Tokyo, 1926

Gorham, H.: *Japanese and Oriental Pottery*, Yokohama, 1953

Jenyns, S.: "The Wares of Kutani," *Transactions of the Oriental Ceramic Society*, London, 1945–46

——: *Japanese Porcelain*, London, 1959

Kidder, J. E., Jr.: *The Jomon Pottery of Japan*, Ascona, Switzerland, 1957

Mew, E.: *Japanese Porcelain*, London, 1909

Miller, R. A.: *Japanese Ceramics* (after the Japanese text by S. Okuda, F. Koyama, S. Hayashiya, and others), Rutland, Vermont and Tokyo, 1960

Mitsuoka, T.: *Ceramic Art of Japan*, Tokyo, 1949

Morse, E. S.: *Catalogue of the Japanese Pottery in the Boston Museum*, Boston, 1901

Munsterberg, H.: *The Folk Arts of Japan*, Rutland, Vermont and Tokyo, 1958

Noma, S.: *The Art of Clay*, Tokyo, 1954

Orange, J.: *Bizen Ware, with a Catalogue of the Chater Collection*, Yokohama, 1916

Oueda, T.: *La Céramique Japonaise*, Paris, 1895

Pageant of Japanese Art (edited by staff members of the Tokyo National Museum), Vol. IV: "Ceramics and Metalwork," Rutland, Vermont and Tokyo, 1958

Pelka, O.: *Japanische Töpferkunst*, Leipzig, 1922

Plumer, J.: *Japanese Pottery Old and New*, Detroit, 1950

Rivière, H.: *La Céramique dans l'Art d'Extrême Orient*, Paris, 1923

Sekai Toji Zenshu (Ceramics of the World), Tokyo, 1955–58 (This work, written by the leading Japanese authorities in the field, comprises sixteen volumes, of which the first seven and part of the last are devoted to Japanese ceramics. A brief English summary is included.)

Volker, T.: *Porcelain and the Dutch East India Company*, Leyden, 1954

Yamanaka, S.: "Japanese Pottery Oil Dishes," *Eastern Art*, Vol. I, Philadelphia, 1928

Yamane, Y.: *Japanese Colored Porcelain*, Kyoto, 1953

Yanagi, S.: "A Note on Ishizawa," *Eastern Art*, Vol. III, Philadelphia, 1931

——: "Japanese Rural Pottery," *Japan Quarterly*, Vol. II, Tokyo, 1955

Zimmermann, E.: *Die alten Bestände von japanischen Porzellan in der Dresdener Porzellan-Sammlung*, Dresden, 1916

Index

NOTE: Numbers in italics indicate pages on which plates appear; all other numbers indicate text pages.